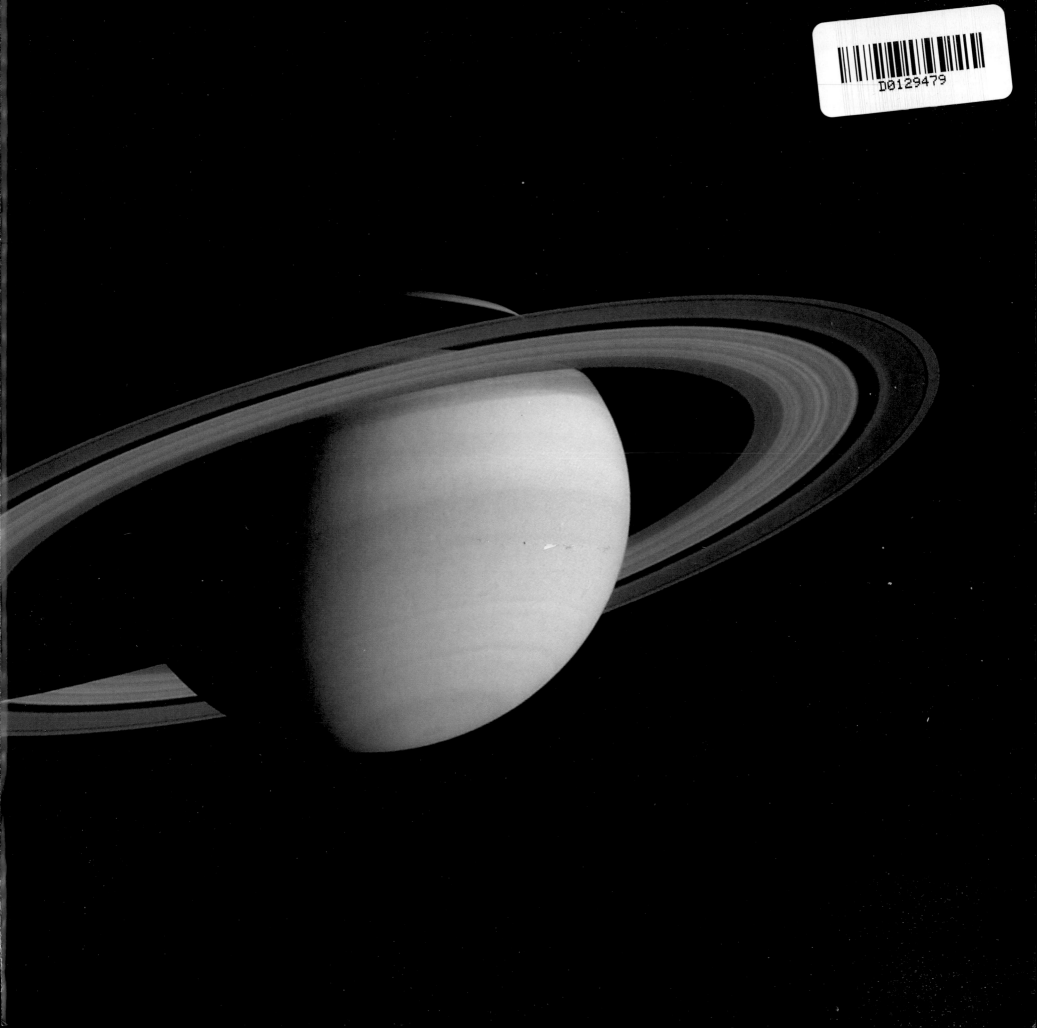

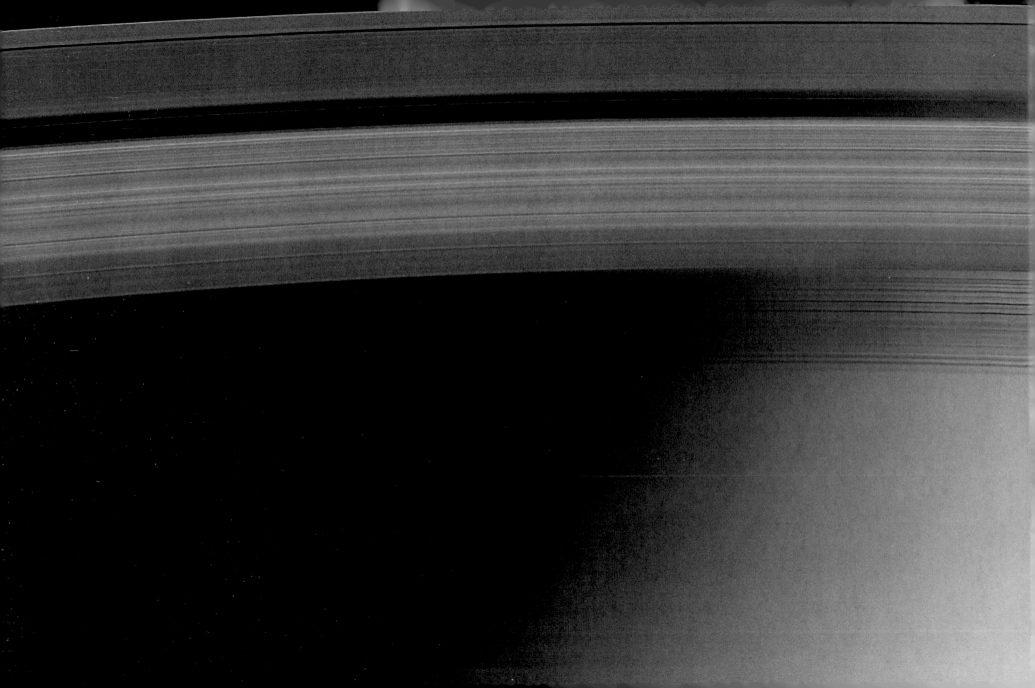

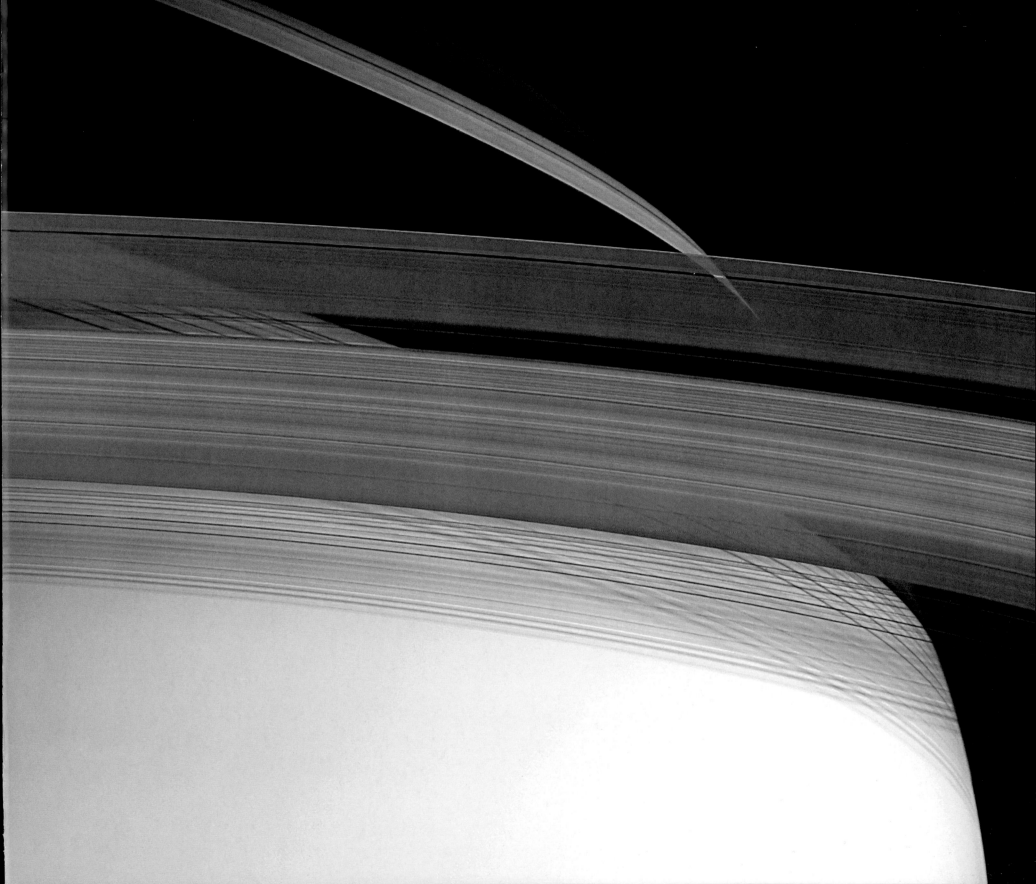

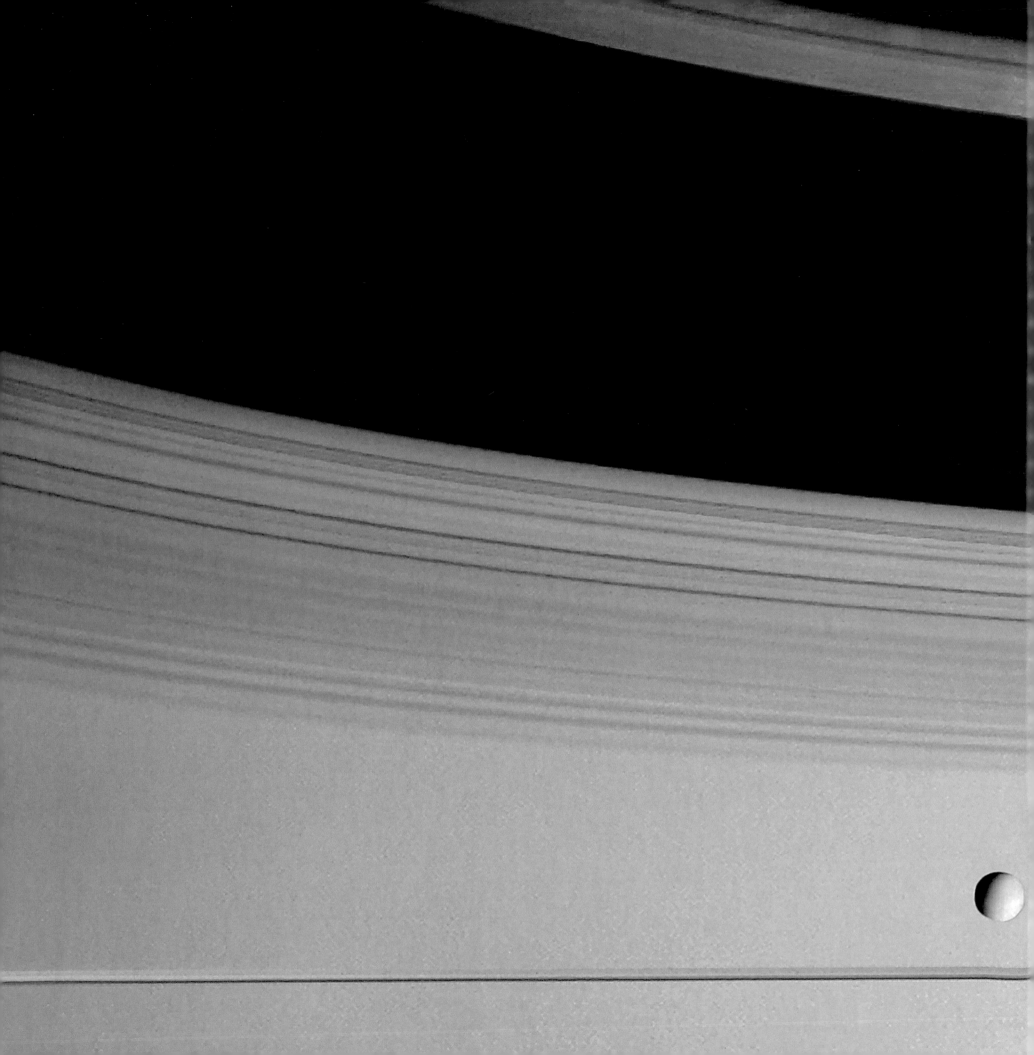

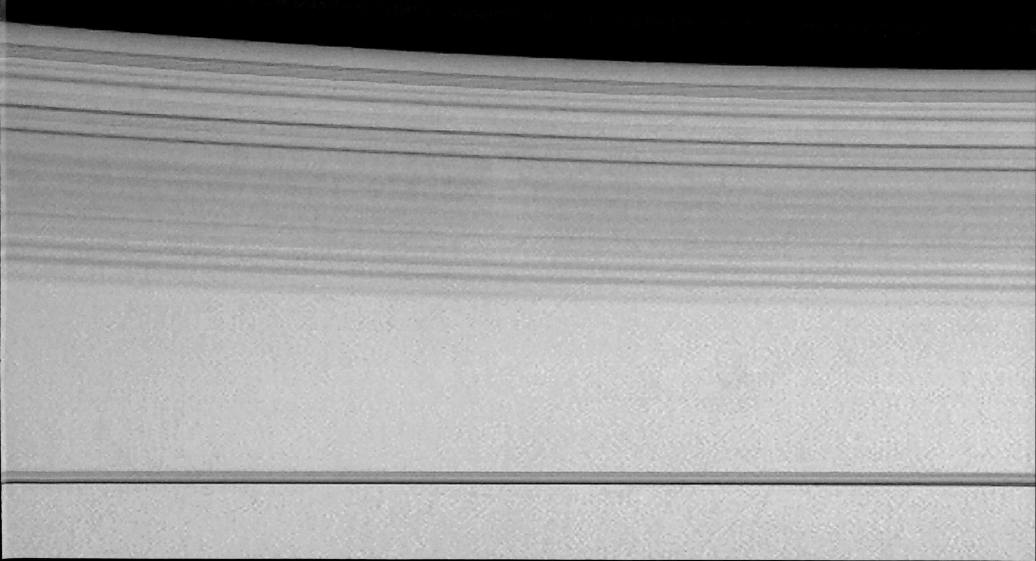

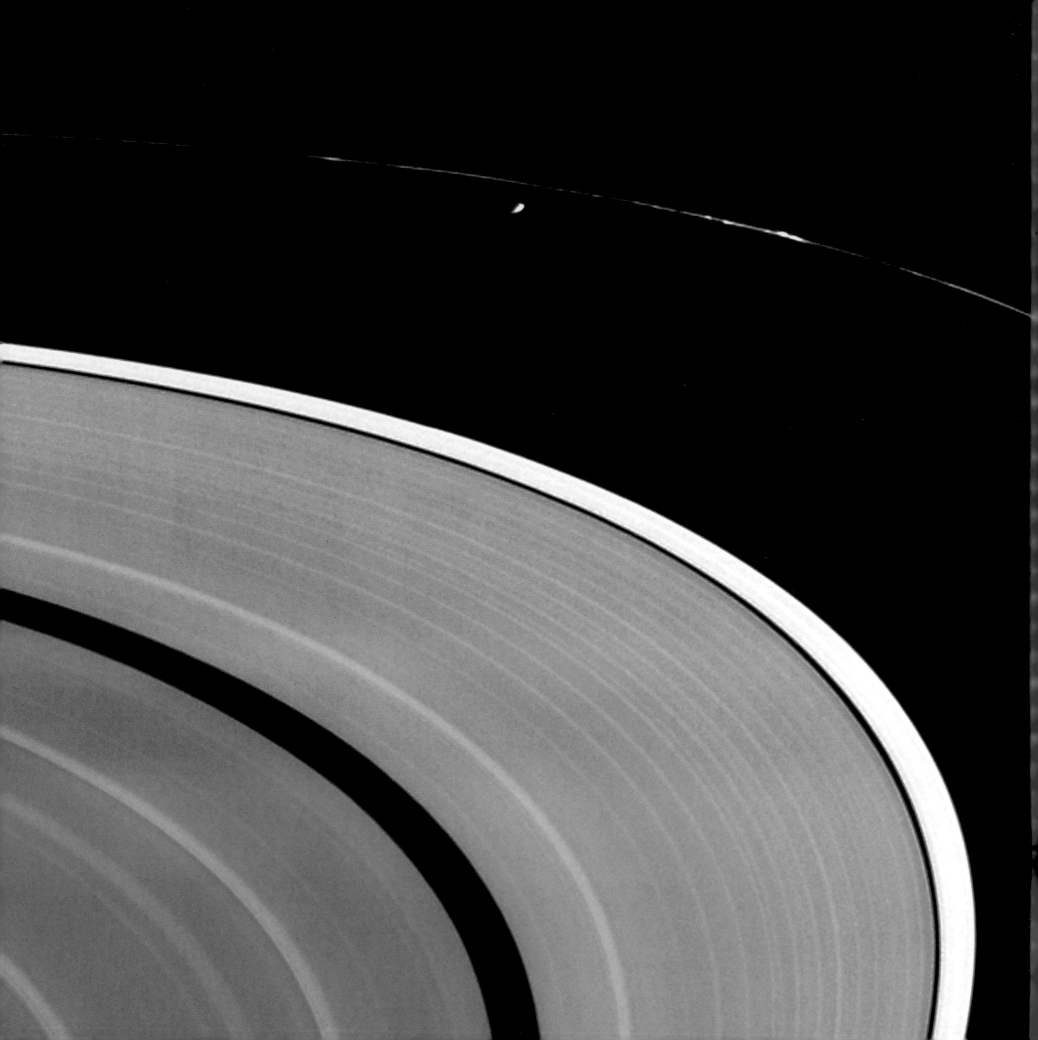

LAURA LOVETT | JOAN HORVATH | JEFF CUZZI

FOREWORD *Kim Stanley Robinson*

SATURN
A New View

ABRAMS, NEW YORK

page 1. Saturn's icy moon Dione and the tip of the rings

pages 2–3. Cassini views Saturn three months before arrival.

pages 4–5. Saturn's rings cast dark and light shadows on its northern latitudes.

pages 6–7. Dione floats above Saturn's nearly edge-on rings.

pages 8–9. Saturn's A and thin F rings, with ringmoon Prometheus

opposite: The sunlit crescent of moon Iapetus

following spread: Titan and Dione hang below the rings while Prometheus grazes them; Telesto is a speck beyond.

Project Manager & Designer: Laura Lovett
Editor: Eileen Campbell
Image Processing: Dr. Paul Geissler
Photography Production: Jon Zax, Lotuscolor

Compilation © 2006 Laura Lovett
Saturn Sublime © 2006 Kim Stanley Robinson
Saturn's Close-Up © 2006 Joan Horvath

Published in 2006 by Abrams, an imprint of Harry N. Abrams, Inc.

Printed and bound in Singapore
10 9 8 7 6 5 4 3 2 1

HNA ▌▌▌▌▌
harry n. abrams, inc.
a subsidiary of La Martinière Groupe

115 West 18th Street
New York, NY 10011
www.hnabooks.com

Library of Congress Cataloging-in-Publication Data

Lovett, Laura.
 Saturn : a new view / Laura Lovett, Joan Horvath, Jeff Cuzzi; foreword by Kim Stanley Robinson; Abrams.
 192 p. 28 x 28 cm.
 Includes index.
 ISBN-13: 978-0-8109-3090-2 (hardcover)
 ISBN-10: 0-8109-3090-0 (hardcover)
1. Saturn (Planet)—Pictorial works. 2. Saturn (Planet)—Ring system—Pictorial works. 3. Saturn (Planet)—Satellites—Pictorial works. I. Horvath, Joan C. II. Cuzzi, Jeff. III. Title.
 QB671.L75 2006
 523.46—dc22 2006003540

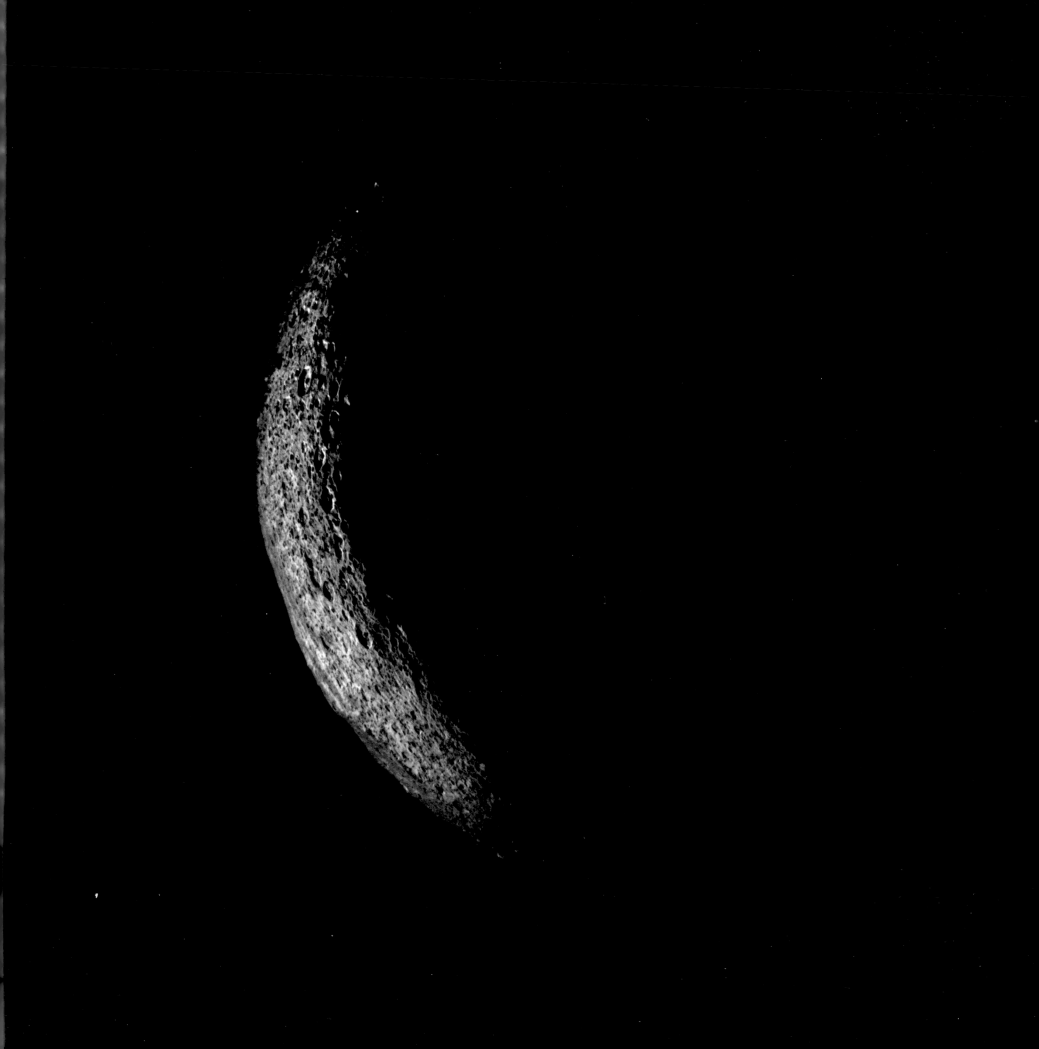

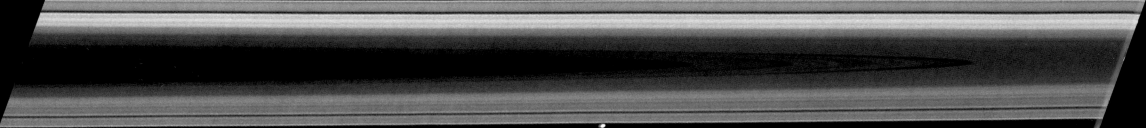

Contents

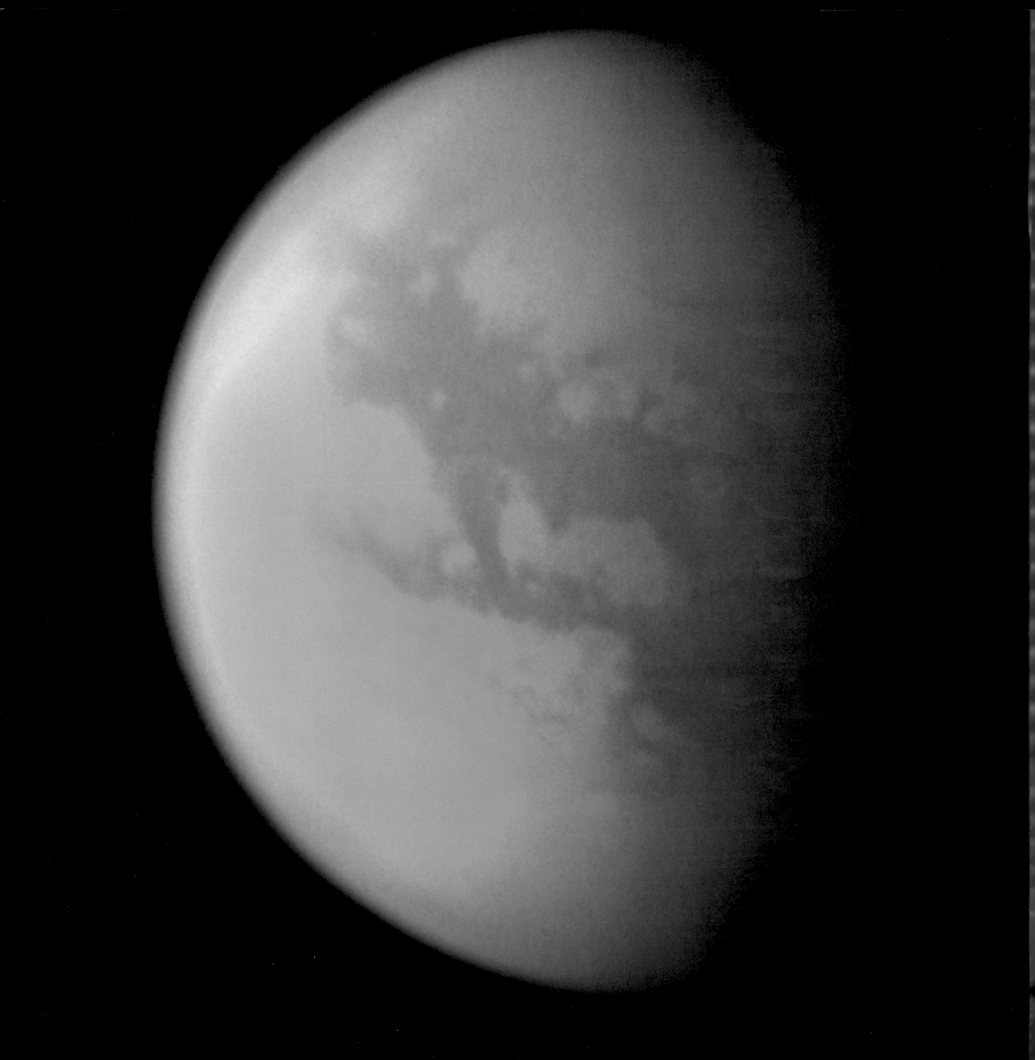

Saturn's moon Titan is about 40% the diameter of Earth. This false-color image pierces its hazy, reddish, hydrocarbon-rich atmosphere, giving a glimpse of surface features in shades of green and brown.

KIM STANLEY ROBINSON | # SATURN SUBLIME

At first sight these photos left me speechless. Our language was not made for Saturn, and for a time no words came to me. As Apsley Cherry-Garrard said, when trying to write about Antarctica: it beggared the language.

That response, a kind of prelinguistic *wow,* didn't last, as you can see looking at this page. We think in words, and so as I wondered over these images, words returned to me; the first ones— unearthly, otherworldly—for once simply literal in their application. After those, a kind of free-associated list, of attributes, responses, qualities—words such as: stunning, majestic, overwhelming, awesome, mind-boggling, simple, pure, round, concentric, curvaceous, big, ethereal, uncanny, powerful, elegant, massive, delicate, wonderful, majestic, glorious, beautiful, sublime.

◯ Can something be both beautiful and sublime? Edmund Burke wouldn't have said so; for him they were paired as opposites. The beautiful was concerned with clarity and formal order, the sublime with vastness and awe. If he could see these photos, however, I wonder if he would feel compelled to rethink things, because to me Saturn seems both beautiful and sublime. There are other contraries included in our response to Saturn; maybe this means it exists outside our categories, and requires its own otherworldly aesthetics.

The concept of the sublime arose in the eighteenth century, in an attempt to account for newly positive responses to parts of nature that had not been considered beautiful before. Thus mountains, which had been seen as drear wastelands, were reinterpreted as objects superb and magnificent, no matter how disorderly or dangerous. Burke's definition emphasized the sense of danger, making the sublime a kind of cognitive dissonance: our physical senses tell us we are in danger, while our rational mind decides we actually are not. Standing on a mountaintop, or at the rail looking over the drop of Yosemite Falls, we are in the space of the sublime. There is a dash of terror in it.

When we look at these photographs of Saturn, it is much the same, but at second hand. We sense that if we were with the camera in space, we would die; thus we feel a ghost of fear. But we also know that we are looking at photos in a book, and so are safe to appreciate their strange beauty.

The second-hand nature of this apprehension constitutes a new twist in the concept of the sublime, named in some theories of postmodernism "the technological sublime." This new term appears to refer to the feeling that comes over us when our primate brain recognizes that, by the standards of the savannah, we are experiencing something impossible, therefore dangerous, probably magical. Watching television, flying, driving a car: there are many examples of the technological sublime—so many that we are mostly habituated to the feeling and do not notice it. But it is there nevertheless, as the space that we almost always live in, which is our loss, as we are thereby cut off not only from ordinary savannah realities but also from the possibility of the true or primary sublime, which can be experienced only in real space and real time.

In any case, our visions of Saturn have fit this definition of the technological sublime from the very first moment telescopes were trained on the planet. After all, to the naked eye Saturn is only a bright star; but look through the tube of aligned lenses, and all of a sudden there it is, a startling little ringed ball, looking like a gem, or a pearl, or—like nothing else. Almost impossible to believe in. Even now, with these fantastically detailed new images, our response must be very similar to those first ones, and an excellent example of the technological sublime.

◯ Perhaps because of these somewhat contradictory and confused feelings, Saturn has so far proved easier to look at than to talk about. There are comparatively few science fiction stories that use it as a setting. The visitors from Sirius in Voltaire's *Micromégas* (1750) pass briefly by it; more substantially, in Isaac Asimov's *The Martian Way* (1952), humans attempting to inhabit an ultra-arid Mars transport some of the icebergs of Saturn's rings to the red planet to hydrate it. Kurt Vonnegut's *The Sirens of Titan* (1959) uses the big moon as a generalized backdrop, as does John Varley's *Titan* (1979). In the novelization of *2001: A Space Odyssey* (1968), Arthur C. Clarke made it clear that the black monolith found on the moon had come from Saturn's moon Iapetus. In my own novel *Icehenge* (1984), I describe a wealthy recluse whose spaceship home has been set in a Saturnian polar orbit, creating an ever-changing perspective, giving views based on the photos recently sent back by Voyager.

The best fictional portrayal of the Saturnian system I know of appears in Stanislaw Lem's novel *Fiasco* (1986), which begins with an astronaut's attempt to negotiate one part of the surface of Titan in a giant walker. It is a brilliant tour de force, and fortunately was written after science had provided enough information about Titan to enable Lem to invent a Titanic surface compatible even with the latest information from the Huygens lander. So the first great piece of Saturnian literature is already in existence.

Still, on the whole it is hard not to feel that Saturn has been mostly bypassed by fiction. This used to be true for Mars as well; from the time of Percival Lowell there was intense narrative interest, but early writers could not help presenting the red planet as a desert backdrop only. Only after Mariner and Viking did there come a whole fleet of Mars novels,

glorying in the new details. By analogy, in the coming years we may see a spate of new Saturn stories, celebrating the spectacular spacescapes Cassini has revealed. These more realistic narratives will remind us again that we live on a planet among other planets, each of them wonderful in its particular way; more wonderful than any world we could make up by the mere exercise of fancy.

◯ Indeed, the very word *planet* has the power to crash through many an older superstition, coming as it does from the newer paradigm or worldview that we call science. The photos in this book are scientific artifacts, created by scientific activities that cumulatively have given us various sorts of extrasensory perceptions and superhuman abilities. Mathematics, physics, astronomy, mechanics, photography, radio, rocketry, computers: all these endeavors and more were involved. It took humanity many centuries of collaborative work to make all the discoveries and inventions necessary to bring these photographs back to us.

Admittedly, many of these discoveries and inventions had at first more utilitarian purposes, usually to make us safer or more comfortable. They were as practical as sewage disposal, as horrible as war. But all along they had another aspect, being part of a quest to explore and understand the universe we find ourselves in. This aspect of science is a kind of religious impulse, in that it is a quest that binds us together (*religare*) as we perform collaborative acts of devotion, generation after generation. The devotionals consist of asking— What, by the application of our intelligence to the evidence of our senses, can we know? And by questioning reality in this intense and methodical way, we are sometimes rewarded with explicit, confirmable, new knowledge of the workings of the universe. When looking at these photos, for instance, it is striking how their contents seem to embody or illustrate the same natural laws that we used to get them in the first place. Our theories are thus doubly confirmed: both Cassini's trajectory and the gorgeous concentricities of Saturn's rings look like gravitation itself made visible, as in a physics class's wave tank.

So: we built the Cassini spacecraft—publicly funded, collectively owned, part of the communal achievement of the species—and cast it through the solar system on a quest. The quest succeeded; so more questions are created and these will call for further quests. It is a form of worship that could go on for thousands of years. Eventually we might even go to Saturn ourselves. It would be a kind of pilgrimage; it would be a sublime experience.

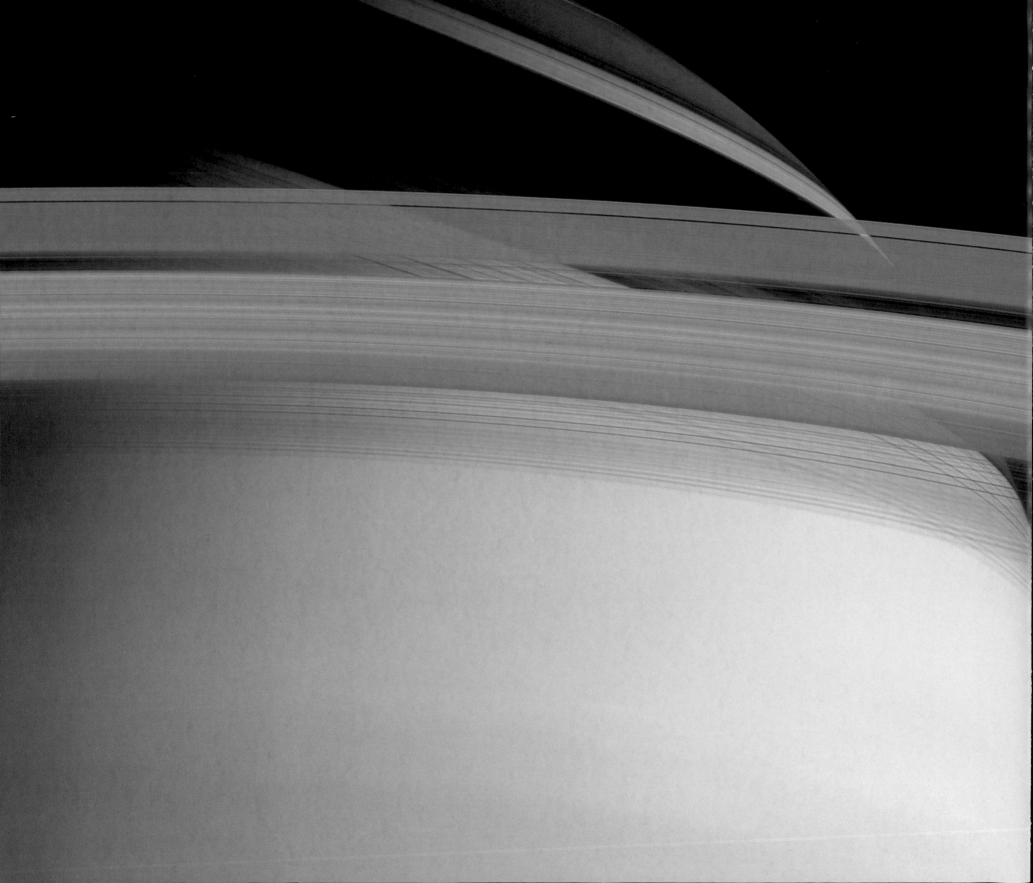

SATURN.

JOAN HORVATH | # SATURN'S CLOSE-UP

Like a starlet revealed in her close-up, Saturn is filling our screen and coming into focus. Imagine a feature film documenting the last thousand years of viewing Saturn using the best technology available. For roughly the first 500 years, the screen would show nothing but a bright yellowish star wandering among the constellations: not all that compelling for those of us watching out there in the dark! About midway through, a fuzzy oval blur would appear. It would emerge and sharpen into the familiar ball and rings as the film's storyline approached our century. Then, right before the credits, there would be a very high-speed zoom in on the rings and moons, with the moon Titan in particular growing larger and larger. Finally, we would flame through Titan's atmosphere, impact, and end with a tight shot of an individual rock on the moon's surface. Improving technology in the movie business has revolutionized what we see, and the same has been true for astronomers. In their case, though, no special effects are required!

The more interesting part of our film begins about four and a half centuries ago. Galileo, widely credited as the first person to use a telescope for astronomy, began to magnify other planets in 1609. His instrument was perhaps twenty power, with optics of very marginal quality. He had to contend with sea-level air and was limited by his eyesight and drawing ability. Photography was hundreds of years

in the future. Despite all that, Galileo made the first observations of Saturn's rings—which he called "handles." Galileo had only a limited time to observe this strange phenomenon, though, before it disappeared. As it happened, right after this discovery Saturn reached a point in its orbit such that the rings were edge-on as seen from Earth, and so apparently disappeared for several years. Galileo did go on to discover Jupiter's moons and realized, heretically, that they circled Jupiter. This was one of the earliest observations supporting the theory that not everything revolved around the Earth.

It took Christiaan Huygens, Dutch mathematician, astronomer, and inventor, with his far-better lenses and longer telescopes (estimated at around fifty power) to characterize the rings as a disk in 1659. Around the same time, Huygens discovered Titan, the first Saturnian moon. Shortly thereafter, Italian astronomer Jean-Dominique Cassini discovered four more satellites: Iapetus in 1671, Rhea in 1672, and Tethys and Dione in 1684. A final sighting in this epoch was Cassini's discovery of the gap in Saturn's rings that now bears his name, the Cassini Division.

Based on this flurry of new insights enabled by the refinement of the telescope, knowledge about the planets continued to accumulate. Communication among observers improved as commerce increased. Some significant observatories were built, mostly to support navigation across the seas, which depended on accurate tables of positions of celestial bodies (calculations, of course, all done by hand). However, it was still unclear what the nature of the disk around Saturn *was*—and it took a few hundred years for the development of mathematics and instruments that could sort it out. In 1789, astronomer and telescope builder William Herschel found more satellites and suggested that Saturn had more than one ring. Nearly 50 years later, Johann Encke may have confirmed some earlier observations of gaps in the rings; one of the larger gaps is today called the Encke Gap.

In the 1890s, James Keeler (first at Allegheny University in Pennsylvania and later at Lick Observatory in California)

confirmed a theory first proposed by James Clerk Maxwell that the rings were not solid, but were made up of particles flying in formation. Using a spectrometer (an instrument that breaks light up into its component colors), he showed that the ring was not rotating all at one rate. This meant the rings could not be a solid object.

Astronomers made all of these discoveries huddled under the domes of observatories, hand-sketching and writing down subjective impressions of what they saw. The use of photography in astronomy became more widespread in the early part of the twentieth century. Photographs—in those days, taken on unwieldy glass plates as much as 35.5 cm (14 in) square—allowed more than one observer to see what a colleague had observed, and to compare observations made on different days and with different telescopes. The discovery of the planet Pluto in 1930 would have been impossible without photography, which made it possible to "blink" between plates taken on different nights to find potential planets moving against the fixed stars. As electronics technology advanced, more sensitive detectors like those in a consumer digital camera replaced photographic plates. This allowed telescopes to gather light more efficiently than was possible with film alone. World War II's advances in technologies like radar allowed observations in wavelengths other than visible light, such as radio waves.

Even with all these advances, astronomy remained more or less a solitary activity. There might be a night assistant to operate the increasingly complex telescope and instrumentation, but a solo observer or small team performed most observations and subsequent analysis of the data. During the careers of currently practicing astronomers, the average number of people in a dome at night has gone down. Some years ago, two night assistants would be there to help an astronomer—one to develop plates, and one to hand the astronomer new ones. As digital detectors replaced photographic plates, neither night assistants nor the astronomer needed to sit in the dome at all. These days, they work from a warm control room that might be far from the telescope.

For example, some telescopes near the summit of 4,200-m (13,800-ft) Mauna Kea in Hawaii are controlled from down in Waimea, at a far more comfortable altitude of 760 m (2,500 ft).

As transportation technology advanced, telescopes were built on taller and taller mountains in more remote locations, and were even flown on airplanes. Telescopes at higher altitudes look through less air. This minimizes atmospheric distortions and allows observers to look at the sky in wavelengths that otherwise are largely absorbed by air or water vapor.

The natural progression of these trends is to make the telescope a fully automated robot with digital detectors and to get it above the atmosphere entirely. The ultimate is to send a robot all the way out to orbit—or even land on—the planet under study. Moving a telescope from the flats to a mountaintop is one thing; launching a telescope is entirely another. Flying a spacecraft for years and having it survive to return data from a virtually unknown environment verges on the miraculous, and therein lies the rest of this story.

⭕ **Early Spacecraft to Saturn.** Until the early 1960s, astronomy was the archetype of the purely observational and theoretical science. There was no option for the observer to do any experiment that involved influencing or sampling the subject. Stars produced light and planets reflected it, and that was all the data available to astronomers. Theoreticians and physicists evolved indirect ways of testing their theories about how the universe is put together. In the end, there was only so much that could be learned about a "new world" without visiting it.

Much of the technology needed for launching spacecraft was developed during World War II, in the form of the German V-1 and V-2 rockets. Germans who worked on the rockets were split up after the war; some went to Russia, some to the United States. The "Russian Germans" got a spacecraft up first—Sputnik, in 1957. Thus galvanized, the United States hurried to launch its own space program. The

A January 26, 1889 page from the notebook of James E. Keeler, one of the most acute Saturn observers prior to the introduction of astronomical photography. Here, he describes his observations using the Lick Observatory 36-inch telescope, one of the largest of its time.

first spacecraft were launched into low orbits around the Earth and taught the American teams some of the basic things they needed to know to operate in space. There were many surprises about the space environment that could not have been predicted based on our Earth knowledge, and many early spacecraft failed. As aerospace engineers learned what was possible with 1960s technology, ambitious "flyby" missions to the other planets were launched. These visits to the Moon, Mars, and Venus (some of which succeeded and some of which did not) gave those early spacecraft engineers

basic knowledge of how to get a robot spacecraft out of Earth orbit in decent working order. Mounting missions to the outer planets—Jupiter, Saturn, Uranus, Neptune, and Pluto—is yet another notch up in difficulty.

Even today, flying a spacecraft to the outer planets is right on the edge of our technological ability. The first robotic mission to Pluto launched in early 2006; the cost and technical difficulty of such a long voyage prevented any earlier attempt. The Pluto mission's launch was almost 33 years after the April 5, 1973 launch of the first robot from Earth to visit Saturn, Pioneer 11.

The biggest concern of Pioneer 11's builders at the NASA Ames Research Center was that the spacecraft was going to fly through the asteroid belt. After surviving that trial by a combination of luck and design, Pioneer 11 flew 43,000 km (27,000 mi) above the top of Jupiter's clouds on December 2, 1974. Nearly five years later, on September 1, 1979, it flew within 22,000 km (14,000 mi) of Saturn. It characterized Saturn's magnetic field and, even though it had a very limited ability to take pictures, was the first to take a picture of the unlit part of Saturn's rings. Pioneer 11 also took the first real pictures of Titan. Pioneer 11's mere survival to return *any* data was an accomplishment, since one of its main goals, as with the first climb of Everest, was to prove it possible to get there at all!

Before Pioneer reached Saturn, the Jet Propulsion Laboratory's Voyager 1 and 2 spacecraft flew by Jupiter in March and July of 1979, respectively. JPL, run for NASA by the California Institute of Technology in Pasadena, California, is the primary NASA center for planetary exploration. The JPL-built twin Voyager spacecraft each carried a spectacular suite of instruments. Voyager 2 was launched first, on August 20, 1977; Voyager 1 left Earth two weeks later, on September 5. At that time, all the outer planets except Pluto were in an arrangement that made visiting all of them possible—an opportunity arising every 175 years. Building two identical spacecraft made it more

likely, barring a hidden design flaw, that at least one of them would survive all the known and unknown hazards to bring back data from this unique opportunity. From the general public's point of view, the most notable instrument was the Voyager camera, recording images with a resolution of 800 lines by 800 pixels per line. This is midway between 2006 American broadcast TV resolution and the high-definition standard, and respectable for 1970s images returned from nearly a billion miles away. The Voyager spacecraft flew by Saturn in November 1980 (Voyager 1) and August 1981 (Voyager 2). They are both still working as of early 2006, returning data about the edges of our solar system to JPL—data that takes 13 hours to reach Earth in the case of the more-distant Voyager 1.

The Voyagers were very closely identified with their Project Scientist, Ed Stone (later promoted to be the head of JPL). Talking to Stone about his spacecraft feels in many ways like talking to Christopher Columbus about the *Santa Maria*. Rather than being able to sail to this new world himself, Stone had to send out a robot explorer to be his eyes and ears. Even though he could not travel on his flagship personally, like any good captain, Stone needed to provision his ship—in this case with the technology to do the job. It's not a short list of provisions! Voyager was the first really "programmable" spacecraft (within the limits of its 4K of onboard memory), allowing it to be reconfigured by controllers on Earth as circumstances demanded. Voyager was the first planetary spacecraft to use X-band communications, which required the spacecraft to be pointed more tightly at Earth than the more-forgiving but less-capable S band used by Pioneer 11. This ability to communicate more data back to Earth was key to the ability to return high-resolution images. As an overarching issue, the spacecraft had to survive far longer than other spacecraft due to the distances to be traveled. This required robust overall system design as well as creativity to work around the inevitable surprises in an unknown environment.

In the 1970s, techniques for navigating between planets were still being refined. For the Voyagers, JPL had to

develop techniques for optical navigation. This process uses the spacecraft's own onboard telescopes to take pictures of the targeted planet against a background of stars. Analysts on Earth then use these images to determine where the spacecraft is more precisely than is possible with older methods involving radio signals. These techniques were crucial for later spacecraft like Galileo and Cassini, which precisely targeted their instruments on the moons of Jupiter and Saturn, respectively.

How do scientists and engineers go about planning for, and then grasping the results of, exploration of the profoundly unknown? Why are people willing to spend decades working with a spacecraft to push knowledge of the solar system just a little farther ahead? Much of the lure is seeing a place for the first time after years of trying to envision these new worlds. Good scientists come up with answers to open questions about how the world works; great ones figure out what the next question to ask might be. Part of the excitement about viewing new worlds for the first time is that it gives a scientist an unparalleled opportunity to come up with those new questions.

For example, what scientific questions about Saturn could not have been asked by the Voyager team before launch? In the words of Voyager's Stone, "At Saturn, we had the advantage of being totally surprised at Jupiter." (Since scientists are in the business of discovering new things, the more surprises the better!) At Jupiter, the Voyager science team was amazed that the moons were all very different from each other, and that moons like Io were geologically active. Upon arrival at Saturn, the team eagerly anticipated more eye-openers—and they were not disappointed. Discovering the sheer dynamism of Saturn's rings, which are changing before our eyes, required a close-up view with cameras as good as those on Voyager. The discovery of nitrogen on Titan (not possible to detect from Earth) hinted that life might exist there, or might once have. Many experiments had waited for generations until a spacecraft could look back at Earth and take measurements *through* other planets' atmospheres and rings, since some measurements have to be taken with absorbed and not reflected light.

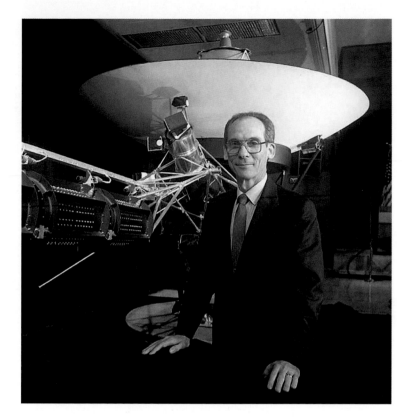

Dr. Ed Stone, Voyager Project Scientist, poses with a full-scale mockup of his ship. This model still resides in JPL's auditorium. Voyager's dish-shaped antenna relays data back to Earth. Its power supply is in the foreground. By comparison, Cassini is three and a half times more massive and five times as tall.

Contrary to the stereotype, science rarely moves ahead in a steady line, with one planned step ahead of the other. In retrospect, there seems to be a clear, straight line leading to the answer—but that's because no one reports the false trails and the speculation that turned out not to be true. Early estimates or extrapolations from Earth experience about the outer planets were often wrong. Stone gives the example of winds on various planets. Scientists had expected that a warmer, bigger planet such as Jupiter would have the fastest winds of all the large outer planets. However, the fastest winds measured in the solar system are on cold Neptune—a fact now attributed to low turbulence due to the cold which allows winds to roar unimpeded. However, we won't really know until we go again . . . and this time stay for a while.

The Voyagers incited a deep affection in the teams that flew them. These spacecraft transcended being machines and became almost the team's offspring, or at least their ambassadors. It is remarkably therapeutic for spacecraft engineers, when frustrated by setbacks technical and bureaucratic, to go to JPL's main auditorium and to visit the detailed, full-scale model of Voyager resident there. Juxtaposed as it is with the auditorium's NASA-blue chairs and scuffed, institutional-grade linoleum, the model brings home that a spacecraft currently beyond Neptune was assembled down the stairs and across the street. The hands of the person buying a cheeseburger in the JPL cafeteria line clicked into place a spacecraft part now so far away that sunlight takes half a day to reach it. It is not surprising that an attempt to move the model elsewhere in the mid-1990s led to a huge outcry by JPL staff and others (including the author of this essay and the following one). Like any child, Voyager meant more to its parents than it could to anyone else.

The Voyagers marked the apex of the second wave of planetary exploration: the best possible observations of planets while flying by at high speed. The third wave of exploration required observation over a longer time and from the closest possible distance—preferably, landing on the surface of the planet in question. This third wave reached Jupiter with the Galileo spacecraft (and the probe it released into Jupiter's atmosphere), and then Saturn with Cassini-Huygens.

○ **Cassini-Huygens.** The Cassini spacecraft is one of the most complex planetary spacecraft ever built, and one of the largest. It's the size of a school bus, even without the booms that project in varying directions, and has a mass of 5,820 kg (12,800 lb). Building the spacecraft, operating it, and analyzing the data it produces takes the expertise of people in 16 European countries and the United States. Cassini is built for long-term investigation, with finely honed instruments designed to answer detailed questions raised by the first Saturn reconnaissance flybys of Pioneer 11 and the Voyagers.

Few large projects, particularly government-funded ones, ever look much like the original proposals when they come to pass, and that seems to go double for spacecraft. The Cassini mission traces back to concepts explored in the mid-to-late 1970s, when engineers at JPL and NASA Ames Research Center started to develop a concept for a Saturn spacecraft and a Titan entry probe. At that time, JPL was finalizing the Galileo mission to Jupiter. Galileo was the first spacecraft to orbit, and therefore study in depth, one of the outer planets. It circled Jupiter from 1995 until 2003 and dropped a probe into that planet's atmosphere. The Saturn mission designs were based on knowledge gained designing Galileo and its probe, combined with experience in the Saturn environment gleaned from the Voyagers. In December 1982, the European Space Agency decided to collaborate with NASA on the Saturn orbiter/probe mission, contributing the Huygens probe to study Titan.

Over the next six or seven years, the spacecraft design and launch date varied as the mission's funding dropped due to other NASA budget demands. Spacecraft go through several phases on their way to circling other planets, during which budgets (inevitably intertwined with politics), engineering practicalities, and scientific goals seesaw back and forth to produce something that will work on the needed launch schedule and within the available budget. Planetary spacecraft, which depend on specific relative positions of the planets to allow for efficient travel from one to another, sometimes have brief "launch windows" that come up only every few years. If the spacecraft isn't ready for its planned window, it might very well never fly, since budget realities might not allow the trained team to hold together for the intervening years until the next opportunity.

Thus, all planetary spacecraft development, from idea to launch, is a race to invent things on a schedule that cannot tolerate delay. The long travel times (seven years in the case of Cassini) also dictate that the spacecraft has to survive for a long time before it takes any of its main scientific observations, making the design process even more difficult. As

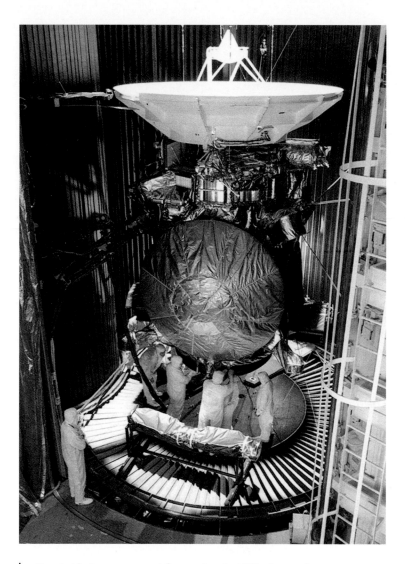

Cassini being prepared for testing in JPL's thermal-vacuum chamber, where the vibrations of launch, the intense heat of the inner solar system, and the cold of the outer solar system can be simulated. Several workers in their "bunny suits" provide scale. The foil-covered Huygens probe is attached to the side facing outward.

budgets swing over the many-years-long development time of large spacecraft, and some technical problems thought to be easy turn out to be difficult, spacecraft design can change drastically.

Even once a spacecraft is launched, the design process may not be over. In the case of Cassini, an error was made in the design of the communications system that links the Huygens probe and the Cassini orbiter. Huygens was not designed to

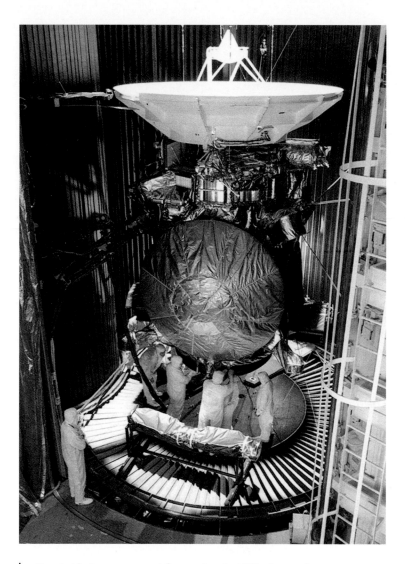

send data all the way back to Earth on its own; it needed Cassini as a relay station. In the original plan for the Titan landing, the two spacecraft (Cassini and Huygens) both were going to be moving at varying speeds relative to each other. As it turned out, the communications system linking Huygens and Cassini could not compensate for the changes in communications frequency resulting from these varying speeds. When this design error was discovered, the hardware was well on its way to Saturn and there was no software solution. The only remaining option was to drastically alter the flight paths of the two spacecraft during the Titan landing to keep their relative speeds within a tight range. Because the problem was discovered four years before arrival at Saturn, there was plenty of time for solutions to be developed, tested, and put in place.

One of the most complex parts of a mission like this is the design of the flight plan, or "trajectory," to get to Saturn. Cassini was launched on October 15, 1997. En route to Saturn, Cassini's trajectory looped around the inner part of the solar system several times, passing Venus twice, then flying past Earth again and finally on to Jupiter and Saturn. This complicated path was designed so each flyby provided a "gravity assist" whereby the energy gained by swinging past a planet accelerated the spacecraft in the right direction at the right speed. Without this technique, the amount of spacecraft fuel required for the mission would be too heavy to launch. For a planetary spacecraft, all the fuel needed to orbit Saturn, for example, has to be carried from the surface of the Earth. Carrying that fuel takes more fuel, and so on. Increasing the fuel needed in orbit around Saturn multiplies the mass of the overall spacecraft by a large amount. It's similar to a mountain-climbing expedition—there is no food to be found on the icy upper slopes, so mountaineers need to carry everything they eat. The longer the expedition, the more food needed and the heavier the load. By comparison, getting into Earth orbit is car camping!

Cassini arrived at Saturn on July 1, 2004, and successfully fired its main engine for about an hour and a half to put it into orbit—a one-shot, critical maneuver that had to work

26

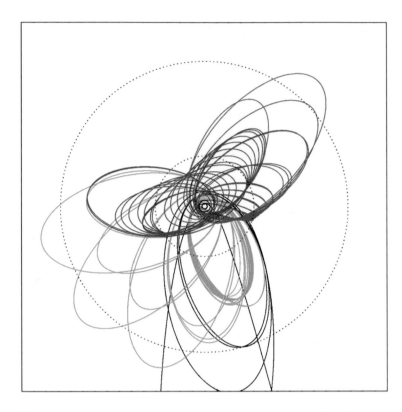

The "petal plot" showing the many orbits Cassini will make around Saturn. The dotted inner circle represents the orbit of Titan; the outer one, of Iapetus. Different colors represent different time periods, each of which have certain science objectives. The tour includes 74 orbits of Saturn, 44 close fly-bys of Titan, and 8 close flybys of other satellites, as well as many more distant flybys.

or the mission essentially would have been over. Cassini is not a smart-enough robot to navigate itself; teams of people on the ground developed a set of orbits long in advance of its Saturn arrival, and they still tweak them from time to time if Cassini drifts slightly from its planned path. The illustration above shows the "petal plot" of Cassini orbits around the Saturn system. Titan is used for further gravity assists to move from "petal to petal" of the trajectory, so the spacecraft needs to keep returning to the vicinity of Titan periodically to send it off in a different direction. This complicated trajectory allows scientists to point their instruments at Saturn, its moons, and its rings from a variety of angles—and to see many satellites up close for the first time. This "system view"

has allowed an unprecedented ability to understand how all the different parts of the Saturn system interact and affect each other. Although they look random, years of work goes into optimizing these orbits to make as many of the desired observations as possible while avoiding running out of fuel or damaging the spacecraft.

On top of all this, the Cassini orbiter needed to drop off the Huygens probe precisely. The strategy for dropping off the probe changed substantially after the communications problem described above was discovered in 2000, three years after launch. In the new arrangement, the probe was released on Christmas Day, 2004, and arrived at Titan on January 14, 2005. The probe had no propulsion of its own, so the orbiter needed to line it up precisely and then release it. (The orbiter later maneuvered so that it would not go into Titan's atmosphere, too!) The Huygens probe descended on a parachute, collecting some spectacular imagery of the surface of Titan, and survived its landing. Scientists didn't know before the fact whether the surface was liquid, solid, or some weird, unknown substance, so it was unclear what would happen when Huygens "landed" (or splashed, depending on your inclinations). As it turned out, Huygens landed on a soft, marshy surface. Images taken from the landing site have an eerie ordinariness to them, looking like a dry streambed on Earth seen through an orange haze. It is difficult to remember that the surface temperature is approximately -178°C (-288°F), which means the nitrogen in the atmosphere is not very far from freezing (which would begin about 32°C/58°F lower). Huygens collected 2 hours, 27 minutes, 13 seconds of descent data and 1 hour, 12 minutes, 9 seconds of surface data, far more surface data than expected. One of the major questions scientists hope the data will answer: are there organic chemicals on Titan? As analysis continues over the months and years to come, more will come to light about ways in which present-day Titan might have chemistry reminiscent of conditions under which life began on Earth.

Many other considerations go into designing a spacecraft to go to Saturn—and even more so if it has to survive an

entry into Titan's atmosphere. First, Saturn is about nine and a half times farther from the Sun than is Earth, so the Sun's light is about 1% as strong as it is at Earth—full Saturn sunlight is about the same as ambient indoor lighting in an average Earth office. Solar panels are not a viable option for a spacecraft around Saturn. In addition, landing on Titan poses engineering challenges because of the extreme cold. More fundamentally, though, the precise conditions encountered by the first probe to visit a new world cannot be very well known ahead of time. After all, the probe is going there to measure the very things its designers would love to know. This means the spacecraft has to be designed to survive a range of possible surface conditions.

The distance also means that signals (data from the spacecraft to Earth and commands from the ground up to the spacecraft) take a long time to travel between Earth and Saturn. Signals from Saturn traveling at the speed of light take about an hour and a half each way, even when Earth and Saturn are closest, and are very weak and spread out when they arrive at their destination. Cassini is about 37,000 times farther away than are our communications and TV satellites, which hang about 35,000 km (22,000 mi) above the Earth's surface. This means that, all else being equal, a signal from a spacecraft at Saturn is vastly weaker than it would be if the spacecraft were orbiting like a communications satellite above the Earth.

To bring in these very weak signals, the Deep Space Network has been developed. Rather than the small antennas on roofs we are used to seeing for satellite TV, antennas of the

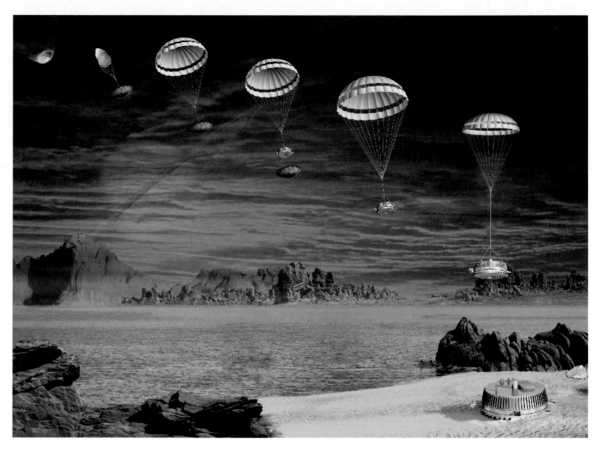

Artist's concept of the Huygens probe descent on January 14, 2005. Deployed by the Cassini orbiter three weeks previously, the probe entered Titan's atmosphere, its heat shield glowing with the heat of its high-speed descent. The shield then fell away and the probe parachuted the rest of the way down, sampling the atmosphere and collecting data as it went.

Deep Space Network (DSN) are as large as 70 m (230 ft) in diameter. These antennas of the DSN are spread around the Earth at three sites—in California, USA; Madrid, Spain; and Canberra, Australia—so that one set of antennas can always "see" a spacecraft anywhere in the sky. Teams at the antenna sites coordinate carefully with the Cassini spacecraft team at JPL to be certain that the antennas are available and pointed when and where they are needed.

○ **Cassini-Huygens Instruments.** The Cassini orbiter carries a dozen advanced instruments, and the Huygens probe hosts six (see page 29). The instruments can be loosely grouped into a few broad types: cameras; imagers; radio science; fields, particles, and waves; in-atmosphere; and on-

surface. Most of the images in this book are from the wide- and narrow-angle cameras of the Imaging Science Subsystem (ISS), which are essentially fancy digital still cameras with big lenses. Cassini's ISS is more than 100 times as sensitive as Voyager's equivalent instruments. The ISS cameras use more than a dozen types of filters, which enhance desired features by letting certain colors of light through and blocking others. For the most part, these cameras return images taken in wavelengths of light visible to human eyes.

In addition to these cameras, there are other instruments we will call "imagers." Some of these imagers in turn are "spectrometers," which capture light or radio waves that human eyes cannot see and split that light up into its component colors for analysis. Some are similar to, but far more sensitive than, instruments previously flown to Saturn or other planets. These gather energy in the ultraviolet, near-infrared, thermal infrared, and radar wavelengths. Much of the data collected by these instruments is energy that could not be gathered by an observer on the surface of the Earth because Earth's atmosphere blocks those wavelengths. Therefore, these are measurements that uniquely can be carried out in space. Making measurements in the infrared, for instance, detects heat emitted by an object. Trying to take infrared readings in the warm air near the surface of the Earth is like trying to see a distant penlight outdoors on a bright, sunny day—all the other infrared washes out what you are trying to observe. In other cases, the presence or absence of some chemicals in the atmosphere of either Saturn or Titan can only be detected when an instrument looks at the Sun through that atmosphere—like checking the color of a piece of glass by holding it up to a light. In that case, the observation needs to be taken by a spacecraft on the far side of Saturn from the Sun, which is not geometrically possible from Earth.

How can we "view" an image taken with light we cannot see? If an instrument measures ultraviolet light, for example, and its image is printed to shine in the ultraviolet, we would see nothing. Scientists work around this by shifting the image to some color we *can* see, which is necessary if we want to see things that otherwise would be invisible. In true color, one wavelength of light registers as "yellow" to our eyes, another one as "green." The shortest wavelengths we can see are violet; ones shorter than that are called "ultraviolet." If an entire image is taken only using wavelengths shorter than the shortest violet we can see, scientists can decide that the very, very short wavelengths in the ultraviolet will be printed as purple. The wavelengths just a little shorter than violet (ones we nearly can see) will be printed as red, with the wavelengths in between shown as green, yellow, and so on. In this way, we can visualize the invisible by shifting these invisible "colors" into ones we can see. This process has the somewhat pejorative term "false color."

Another instrument might be sensitive both to the visible spectrum and the infrared (longer wavelengths than we can see). We might compress all the visible light colors—red, orange, yellow, green, blue, and violet—into, say, blue and violet on our printed picture, and use the red through green colors to represent different types of infrared. A radar map on the television weather report is a false-color image made to show light waves far longer than human eyes can see. A night-vision camera shows us the world mostly in infrared.

On Cassini, instruments like the Composite Infrared Spectrometer (CIRS) produce data that scientists translate into false-color images. For example, CIRS can show how hot or cool (relatively speaking) a given part of the rings is, which in turn tells scientists quite a bit about the ring dynamics. False-color images of these temperature measurements help scientists visualize how heat moves around the Saturn system.

Just as there is "false color," we can think of the output of some instruments as "false sound." Many of the instruments are "fields, particles, and waves" instruments, which directly sample the environment around Cassini. The spacecraft is flying in a silent near-vacuum, but it is continually pounded and pinged by particles (ranging in size from individual atoms and molecules to dust grains) and affected by different types of magnetic and electric fields. As Cassini flies along, it

Instruments on the Cassini Orbiter

Imaging Science Subsystem (ISS) / *Visible light cameras*
Narrow-angle camera takes "close-ups" and is the size of a 20-cm (8-in) diameter telescope. Wide-angle camera is 5 cm (2 in) in diameter. Each has multiple filters.

Composite Infrared Spectrometer(CIRS) / *Infrared spectrometer*
Telescope is 61 cm (24 in) across, and detects thermal infrared or "heat" radiation. Infrared energy is separated into a spectrum where signatures of molecules can be identified.

Ultraviolet Imaging Spectrograph (UVIS) / *Ultraviolet spectrometer*
Has a telescope to collect ultraviolet light, and also operates as a rapid sampling device measuring variations in brightness as a star goes behind the planet and rings.

Visible and Infrared Mapping Spectrometer (VIMS) / *Visible and infrared spectrometer*
Dual telescopes operating in visual and near-infrared reflected sunlight break this light up into spectra to detect signatures of different molecules.

Cassini Radar (RADAR) / *Radio imager*
Synthetic aperture radar makes images of Titan's surface using radar, takes altimetry, and maps radio wavelength thermal emission from other sources.

Magnetospheric Imaging Instrument (MIMI) / *Imager*
Collects data on the characteristics of Saturn's magnetosphere and its dynamic interaction with Saturn, the Sun, and other influences.

Radio Science Instrument (RSS) / *Radio science*
Transmits radio waves from the spacecraft through the rings, atmosphere, and ionosphere of Saturn and Titan to Earth, giving information about density, particle size, and composition.

Cassini Plasma Spectrometer (CAPS) / *Particles, fields, and waves*
Samples Saturn's Van Allen belts of trapped electrons, protons, and charged atoms of different energies. Can measure composition of very sparse ring and satellite "atmospheres."

Cosmic Dust Analyzer (CDA) / *Particles, fields, and waves*
Detects impacts of cosmic dust and faint ring material on the spacecraft, mainly particles of smoke size and smaller. Can measure their composition and trajectory accurately.

Dual Technique Magnetometer (MAG) / *Particles, fields, and waves*
Measures magnetic fields around the spacecraft; by measuring deflections in Saturn's magnetic field near moons, scientists can tell if the moon has a core, an atmosphere, or interior liquid water.

Ion and Neutral Mass Spectrometer (INMS) / *Particles, fields, and waves*
Makes very accurate measurements of the masses of charged and uncharged atoms, primarily taken as the spacecraft flies through the low-density upper atmospheres of Titan, the rings, and moons.

Radio and Plasma Wave Science (RPWS) / *Particles, fields, and waves*
Analyzes electric and magnetic fields around the spacecraft to "hear" aurorae, whistlers, and other waves that move through the system. Can detect dust grains hitting the spacecraft.

Instruments on the Huygens Probe

Descent Imager and Spectral Radiometer (DSIR) / *Visible-light camera*
Takes images on descent and measures upward and downward radiation from the Sun to determine the opacity and composition of the clouds, hazes, and gases in Titan's atmosphere. DISR consists of a camera plus other basic light-measuring devices.

Huygens Atmospheric Structure Instrument (HASI) / *In-atmosphere*
Measures how the temperature, density, and pressure of Titan's atmosphere vary with altitude.

Gas Chromatograph and Mass Spectrometer (GCMS) / *In-atmosphere*
Measures atmospheric composition at several levels in Titan's atmosphere. Capable of detecting "noble" gases like argon and krypton, the rare isotopes of gases, and organic compounds.

Aerosol Collector and Pyrolyser (ACP) / *In-atmosphere*
Collects aerosols suspended in Titan's atmosphere and heats them to determine their composition.

Doppler Wind Experiment (DWE) / *Radio science*
Measures frequency shifts of Huygens probe and attenuation of signal to deduce winds on descent (measured by viewing probe from Earth).

Surface Science Package (SSP) / *On-surface*
Various measurements taken upon impact with Titan's surface and thereafter, to determine if the surface is solid, liquid, or mud, and to measure the composition of the surface.

registers "hits," which can be imagined as hail hitting a tin roof. Cassini's fields-and-particles instruments "hear" each ping of a particle and detect waves of magnetic or electrical energy. The precise ways in which the data is collected and recorded for later playback are complex and different for each of the instruments. Taken together, these instruments develop a complete picture of the magnetic and electric fields shaping the Saturnian system. At the same time, they analyze the composition and distribution of the electrically charged atoms and dust "blown around" by those fields.

The "radio science" instruments exploit two properties of the radio communications transmitted and received by the spacecraft. First, the motion of the spacecraft makes the apparent frequency of the transmitter appear to vary to an observer on Earth (the "Doppler effect"). Second, radio waves are attenuated when they travel through different materials. Therefore, these "radio science" instruments return data about spacecraft movement and about the density (and other properties) of anything sitting in the communication path back to Earth.

The Huygens entry probe contains its own separate set of instruments. Since the probe actually flew through the atmosphere and then landed on the surface, many of these were designed to directly sample and measure the air or the surface upon arrival.

Why so many instruments? Imagine the data from each instrument as evidence in a murder trial, and the scientists as the jury. None of the jury members were actually able to witness the crime under discussion, but all of them have a theory about what might have occurred. They need to work together to evaluate each piece of evidence and fit it into a bigger picture. Looking at a scene in different types of light at more or less the same time is how we gather "evidence." Orbiting the planet for a while and collecting data over time lets us see how rapidly these readings might change—a different type of evidence. Some of these instruments have never been flown near Saturn before, so will provide new

data (notably the radar observations to see Titan's surface through its dense atmosphere). Others are more powerful versions of Voyager instruments.

The previous page lists all the instruments on Cassini and Huygens and gives a brief description of how they contribute their evidence to the scientists' verdicts. Instruments on the orbiter or probe were contributed by the United States, Italy, France, United Kingdom, Germany, Netherlands, Finland, Hungary, Norway, Belgium, Austria, Spain, Sweden, and the Czech Republic. The international scope of the mission is obvious from the number of countries working together to contribute the instruments—and shows how only a truly international effort can help us understand the universe around us.

○ **Who Are The Explorers?** A mission the scale of Cassini requires thousands of people working for decades, with skills including abstruse mathematics, bending metal, and managing people. (No scientists toiling alone under observatory domes here!) Some come through briefly to solve a problem in their particular area of expertise; others might join in mid-career and retire from the project. All have one thing in common: to members of the team that build and fly it, the spacecraft becomes far more than a machine. Relationships similar to that between a mariner, his crew, and his ship develop. The spacecraft becomes a living creature, for which the flight team feels a special responsibility. Ask anyone who has been involved in a planetary spacecraft mission why that is, and their eyes will go slightly misty and out of focus. Most will describe going out at night, looking up, and seeing a planet in which they have a personal stake. Some venture that it's the thrill of being one of the first human beings to see a landscape on another planet—being a virtual Sir Edmund Hillary. For others, it's a cathedral-building feeling: they were part of a first-of-a-kind engineering feat requiring thousands of people to complete. How did these explorers and builders find their calling?

30

It takes a mix of dreamers and practical managers to pull off a mission, and Cassini Program Manager Bob Mitchell is one of the latter. He doesn't see the many spacecraft he's worked on in his nearly 40 years at JPL in epochal terms. A veteran of the Viking Mars landers and orbiters, he doesn't think Cassini is necessarily even the biggest overall planetary spacecraft designers have undertaken. (Viking, in the late 1970s, was more expensive in relative dollar terms, and had four spacecraft on the go to Cassini's two.) Mitchell was a natural choice to lead Cassini, since he had been leading the similar-scale Galileo mission to Jupiter near the end of that spacecraft's life.

Bob started out as a farm kid in Pennsylvania—good training for his later years as an engineer, since on a farm, "you'd have to fix something or it wouldn't get fixed." Moving from a life made up of school, chores, and a bit of hunting to JPL's rarefied air seems to him like a series of happy accidents. These days, he manages a couple hundred engineers at JPL and works with a science team of about 260 people, split between the United States and Europe. Keeping a team that big all moving toward the same goal is a challenge in and of itself; he says it is an unusually cohesive team because the spacecraft is challenging to operate and requires good teamwork to keep things moving along.

In many ways, managing the travels of a spacecraft to Saturn is not all that different from managing any big engineering project: it consists of day-to-day reporting up the chain and crafting strategy for those below. In other ways, the mission is unique. Where else, Mitchell wonders, could a team face the same challenges as in managing the first detailed spacecraft exploration of Saturn's system? He adds that his management job is made easier since the vast majority of his team look forward to coming to work each day, because "it's just plain fun." The sheer time scale of the mission—with seven years cruising to Saturn—created its own challenges, although the seven years passed quickly. As he says, "Time is longer looking forward than looking back."

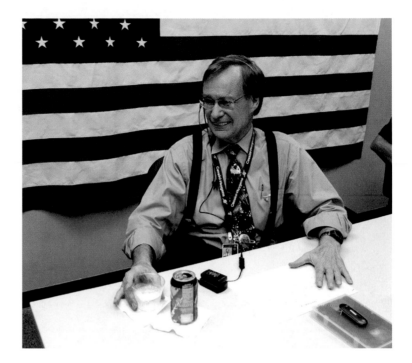

Cassini Program Manager Bob Mitchell celebrates Cassini's successful arrival at Saturn.

Mitchell feels that Cassini's Jupiter flyby enroute to Saturn was a good opportunity to "learn to drive the car." Mitchell's experience operating the Galileo spacecraft at Jupiter meant that he knew how Cassini *should* operate in that environment. Details of how it *did* operate gave some new science insights about Jupiter, but also taught the team some lessons about this new spacecraft.

Cassini's daily "driving" is the purview of Julie Webster, Spacecraft Operations Manager, and her team. Keeping a complicated robot humming hundreds of millions of miles away might seem daunting. However, her description of how to find and diagnose spacecraft problems is simple: "You've got to find your 'goes-intas' and your 'goes-outas' and everything else will fall into place." Webster thrives on the fast pace and pressure of spacecraft operations. She learned decisiveness in her previous job running Cassini preflight tests. "My real claim to fame," she says, "is my ability to think on my feet." Flight operations engineers in general do not like

32

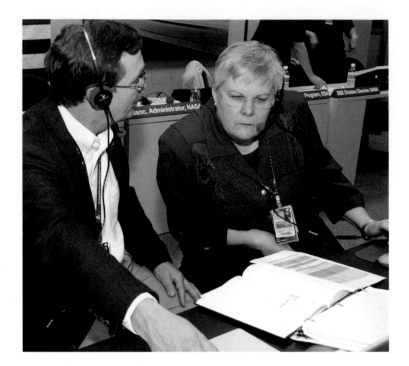

Cassini Operations Manager Julie Webster and Earl Maize (at the time, Cassini Deputy Program Manager) watch data on the night of Cassini's July 2004 arrival at Saturn.

to act too quickly; a JPL truism is, "Send no command before its time." During testing, though, she says you have to have a more aggressive, can-do attitude. "You have to get something accomplished every day or you get behind."

Early in her career, Webster spent time as a chemist at nuclear power plants, geothermal well sites, and a marine research lab. Trained as a scientist, she later gravitated to engineering. "The innovation style is different," she says, for scientists versus engineers. Scientists develop concepts, which she admires but does not consider her strength. "I'm a builder. You tell me what you want and I'll see it in my head and can build it." She grew up watching a father who worked in the oil fields. When he needed a new tool for the rigs he would prototype it with Tinker Toys or whatever was available, then pass it on to a machinist to build. Inheriting this hands-on approach made her love lab work. Of the other engineering staple, math, she modestly says, "I would learn just enough to understand the practical applications."

She became involved in planetary spacecraft while working at what was then Martin-Marietta in Denver. The Magellan spacecraft to Venus was built by Martin for JPL in the late 1980s. During the inevitable long nights getting the spacecraft ready for flight, Julie says, "Venus was at its brightest . . . I would walk out of the building, see Venus, and declare heartily that we *would* get our spacecraft there!" She succeeded both with Magellan and now Cassini, guiding her team through those thousands of goes-intas and goes-outas.

Given that the spacecraft is a robot, who figures out the details of what the spacecraft (and the teams on the ground) are going to do, and when they are going to do it? This is the task of the Sequence Team. "Sequencers" use everything from horse-trading skills to arcane engineering knowledge to get their job done. They need to balance the desire of scientists to push the spacecraft to its limits with the natural inclination of the hardware and software engineers who built "the baby" to protect it at all costs. Bridget Landry of the Cassini Sequence Team brings just the right combination to this table. Born the youngest of seven children in a Navy family in San Diego, she learned negotiation skills as a matter of survival and then added to that a degree in chemistry and stints working on several spacecraft. Another job requirement is the ability to come up with creative ways out of tight corners. An eye for detail and a bit of flair is needed to sell a plan to team members who might prefer another more favorable to their interests. For those skills, Landry draws on her experiences as an accomplished ballet dancer and an award-winning designer of elaborate science fiction and historical costumes. Armed with a rare combination of artistic and mathematical skills, she brags that she's one of the few costume designers who did not throw out their protractor after the high school geometry final.

What are the things she needs to bear in mind when she choreographs Cassini's moves? Most fundamentally, the spacecraft is out of reach of active, "joystick" control. By the time someone on the ground sees evidence of an issue with Cassini and sends even an instantaneous instruction back,

Cassini "Sequencer" Bridget Landry steadies her nerves working on some of her "gridded crafts" while waiting to hear whether the July 1, 2004 Saturn arrival maneuver was successful.

Former Cassini engineer Rene Fradet stands outside Alliance Spacesystems, Inc., the company he founded after leaving JPL.

about two and a half hours will have gone by. This means any errors in commands sent to the spacecraft can have billion-dollar consequences, since by the time any action can be taken, the spacecraft could well be gone. Budget cuts in 1992 meant Cassini's designers had to change the spacecraft's design to one in which all instruments were bolted to the main body of the spacecraft. This makes it tougher to operate than some of its less-constrained predecessors. Like astronauts with narrow visors tightly strapped down in couches, the instruments can only look in the direction that the spacecraft takes them. This means that of the 12 instruments, chances are that most of them will not be pointing where the scientists want to look at any given time. Like kids on a road trip fighting about who gets to sit next to the window, scientists need to share the good views. This is complicated even more because the big, high-gain antenna that transmits data back to Earth also competes with the instruments' needs to be pointed in the right direction, since its position is

fixed, too. On top of this, there are other restrictions against pointing different parts of the spacecraft towards the Sun and exposing delicate parts of the spacecraft to dust and other dangers. Last but not least, the worldwide tracking network on Earth has to be coordinated when data is sent to the ground or commands to the spacecraft.

To plan out Cassini's days and weeks, Landry says she has to bear in mind what has to happen at the same time, what absolutely cannot happen at the same time, and what has to follow something else. It's all a mental juggling act that she also says draws on her experience with quilting and other "gridded crafts." To sell her solutions to the team, she can even draw on a bit of theater if needed.

How is a spacecraft this complex created? Former Cassini Mechanical Systems and Integration Engineer Rene Fradet compares building a spacecraft to being the architect of a house. Everything has to fit inside a limited space; some parts

need to be kept warm and some parts need to be kept cold; the structure can't fall apart; and the construction must use parts that meet codes and standards. Different "rooms" (here, our spacecraft instruments) need different lighting and exposure. Adequate power has to get to all parts of the structure, and piping and valves have to work. Like a house in earthquake country, the spacecraft has to survive the shock and vibration of launch; beyond that, it has to hold together over time—in this case, surviving year upon year of crossing a void that is neither truly empty nor yet truly known.

How did this "architect" come to JPL in the first place? French-Canadian Fradet, formerly an engineering major and hockey player at Rensselaer Polytechnic Institute in New York, says his choice upon graduation was easy. He got job offers from JPL and Proctor and Gamble. "The choice was this," he says, with a faint Quebecois accent still audible, and with Gallic hand gestures showing a two-pan scale weighing his choices, "Spacecraft or Pampers . . . Spacecraft or Pampers . . ." (The father of triplet girls, he has managed to experience both.) People move on from projects like Cassini to many different roles. Fradet left JPL in 1997 to found a startup engineering company, Alliance Spacesystems, Inc. (ASI), in Pasadena. Now with 43 employees following his lead, CEO Fradet often has JPL as a customer. Meetings at "the Lab" resurrect fond memories of his time on Cassini and other projects, since one always stays part of the "family" that worked on a project.

○ **Bringing It All Home.** There is one final, critical aspect of exploring the planets—and that is the role of the general public. More people than ever before have the ability to see state-of-the-art science online, as well as in books like this one. The advance of technology has not only helped us take observations, but also disseminate them widely. For most of the age of sail and beyond, governments supported astronomy because they needed data for navigation across oceans and for timekeeping. There were "gentleman astronomer" hobbyists, to be sure, but most data stayed in the hands of

professional astronomers. One of the first major departures from this model was the founding of Lowell Observatory in 1894 in Flagstaff, Arizona, by astronomy impresario Percival Lowell.

Part scientist, part showman, Lowell popularized astronomy for its own sake and would routinely call newspapers to announce something he or his staff had seen the night before. This caused consternation among his colleagues at more conservative observatories, who preferred to wait for confirmation and multiple observations of a phenomenon before announcing it. Lowell commissioned the 61-cm (24-in) Clark telescope, one of the finest instruments of the time, specifically optimizing it with a long focal length for looking at narrow fields of view such as planets. The lenses and structure of this telescope, manufactured in Massachusetts by A.C. Clark and Sons, were state of the art.

However, Flagstaff was then still something of a western pioneer town, with the best available mechanical designers employed by the local bicycle shop. To this day, bicycle chains are used to drag the telescope dome around on its track as the dome's slit (and telescope under it) follows the movement of the night sky. The frontier-days lens cap also survives—a century-old frying pan with its handle is used to let light into or to close up the telescope. Cookware filling in for precision components notwithstanding, Lowell excited the Wright-brothers-era public about space by using the Clark and other telescopes to study what he thought were canals and vegetation on Mars. Lowell took his sketches to the lecture circuit and newspapers to excite his fans about what might be "out there." Even though much of what Lowell thought he saw was later proved to be wishful thinking (a hazard of pre-photography astronomy), he asked good questions about what might be on other planets and he asked them very publicly. Legend has it that early rocket pioneers—and science fiction writers like Edgar Rice Burroughs (the "Barsoom" series) and H.G. Wells (*The War of the Worlds* and *The First Men in the Moon*)—saw Lowell or read about him. Those writers, and others like them, in turn

inspired many JPL employees. For the last century, there has been a steady flow of ideas back and forth between science fact and fiction. Many ideas about exploring space were first "what-if" exercises in science fiction, and many real discoveries in turn have inspired great stories.

It has taken about a century to go from sketching Saturn under a wooden dome to putting a robot on the surface of Titan. In movie terms, it's like going from Thomas Edison filming silent, black-and-white footage to armies of special-effects people creating a modern feature film. There has been a similar cost to this progress—missions the scale of a Voyager or Cassini take the resources of nations, in addition to the vision of dedicated individuals. A certain spontaneity has been lost, and a scientist with a vision must spend many years raising money and building enthusiasm before being able to cut metal to build a spacecraft. Both in the film and space spheres, however, what can be seen now could barely have been imagined a few decades ago! Now that spacecraft like Cassini have been built and flown, anyone can go online and get a high-quality postcard from "their spacecraft" at Saturn almost as soon as the scientists do. We no longer have to rely on many-times-copied versions of someone else's sketches originally made with half-frostbitten fingers. Finally, all of us can lean back in our seats and marvel at the many faces the Cassini team has revealed to us in Saturn's latest close-up.

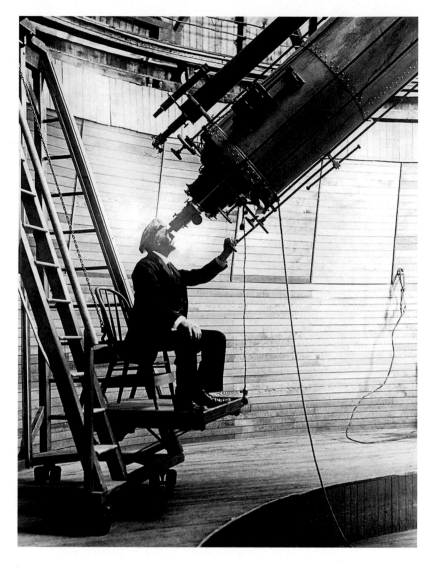

Percival Lowell performs daytime observations of the planet Venus. This photo was taken in the Clark telescope dome between 1900 and 1910.

following spread One of the most remarkable images that Cassini has captured is the sweep of the rings from the unlit side—a view not visible from Earth. The central B ring is dense enough that sunlight doesn't penetrate to the northern regions, making it appear darker than the other rings. Sunlight filters easily through the lower-density rings.

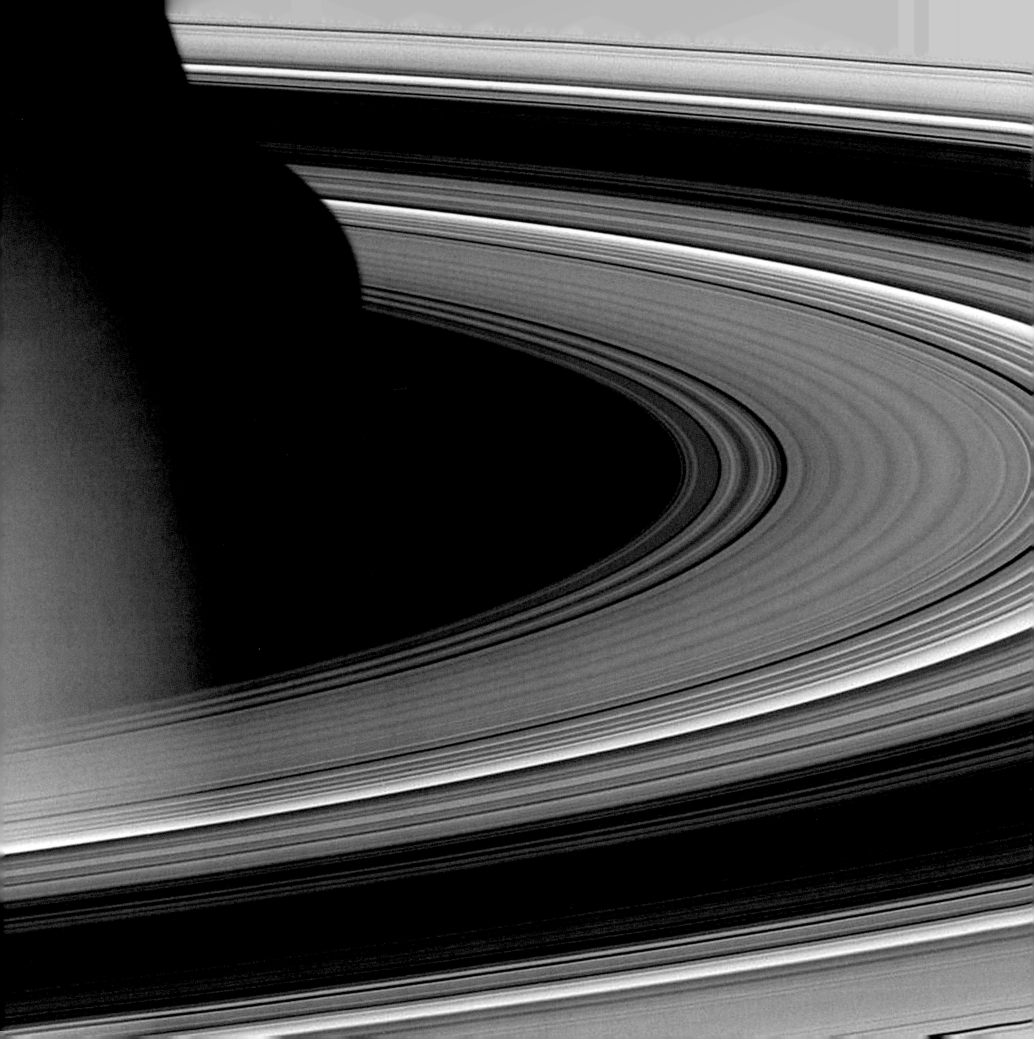

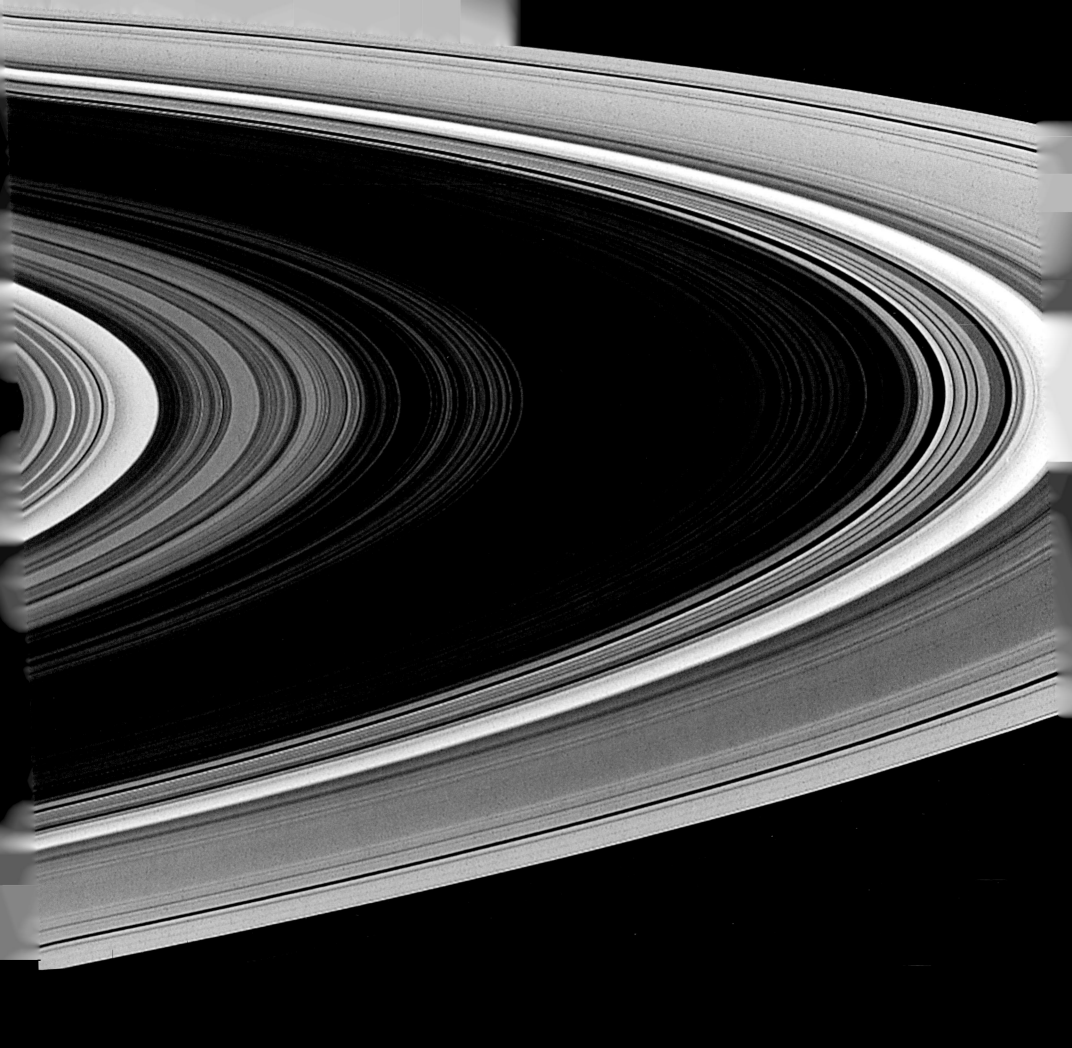

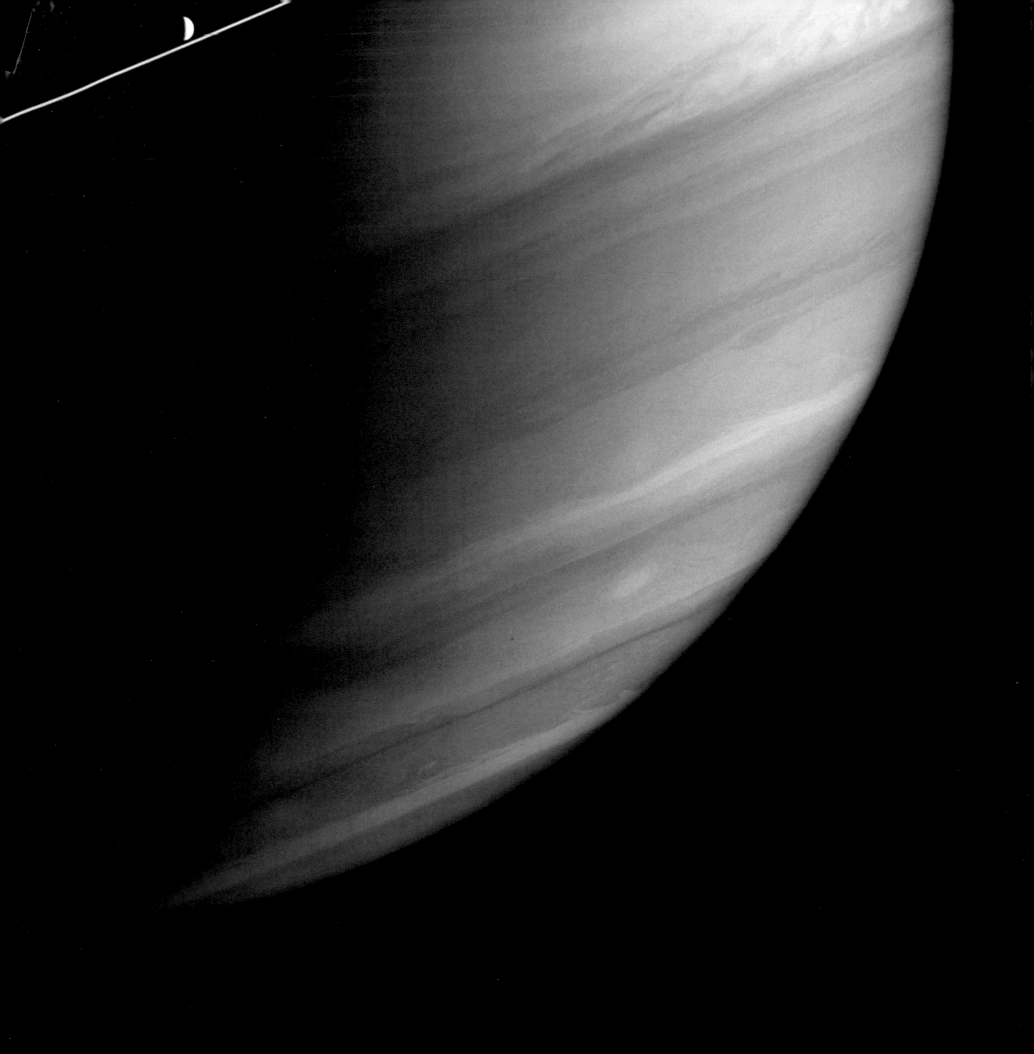

One of Saturn's larger moons, Dione (opposite), and one of its smallest, Pandora (above), both hug the ring plane. Dione is more than 12 times larger than Pandora; both moons are dwarfed by Saturn.

following spread Dione is one of Saturn's regular moons. As Cassini looks back towards the Sun, the moon's impact craters and linear fractures appear in sharp relief. This view is of the region near the moon's south pole.

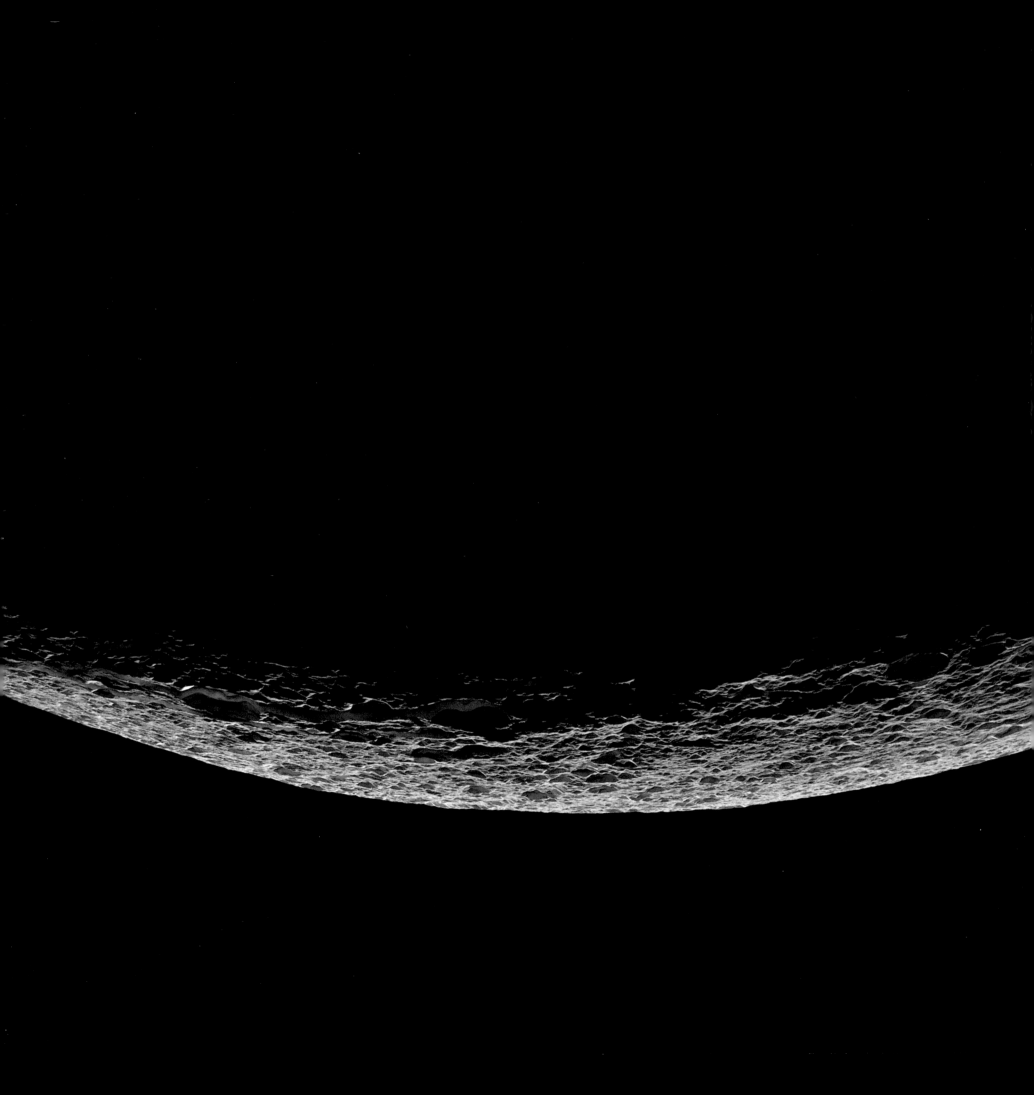

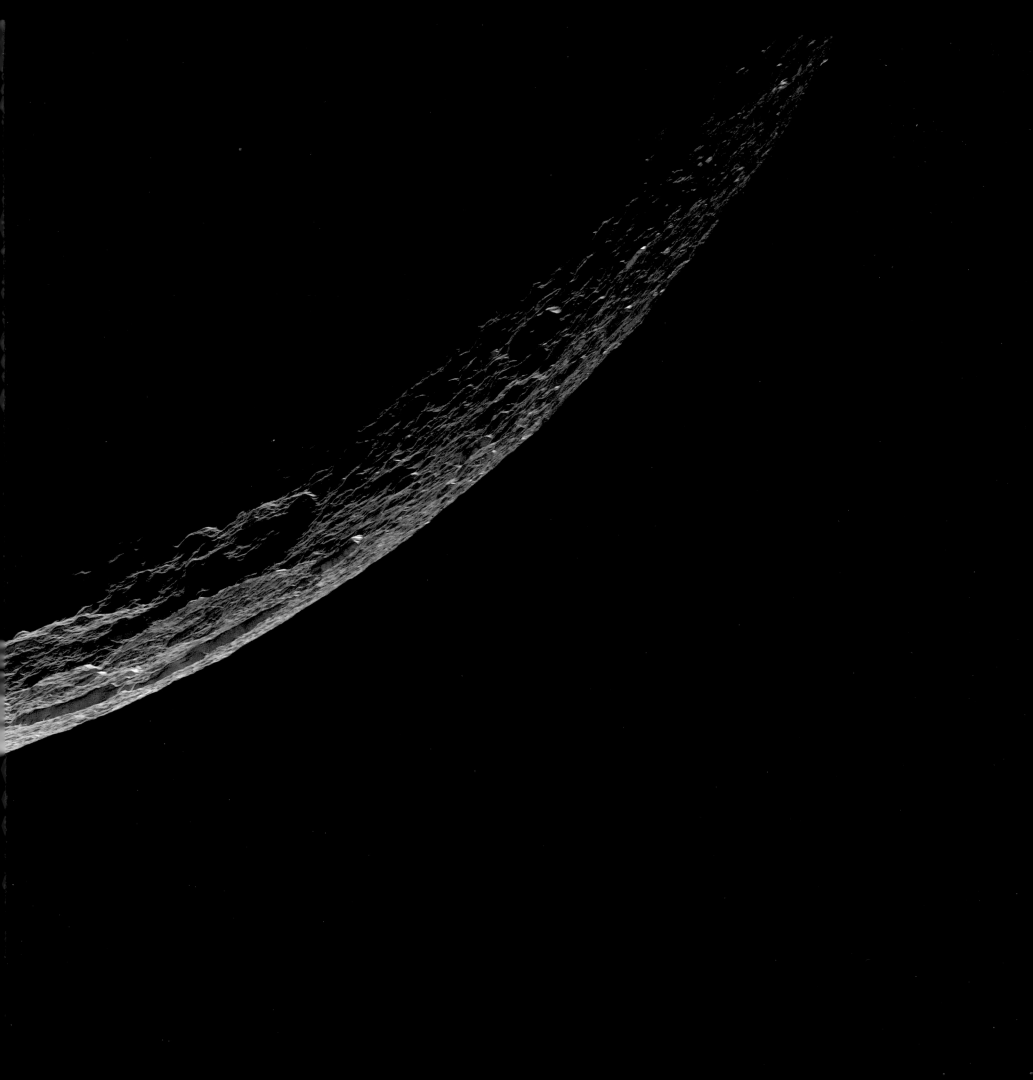

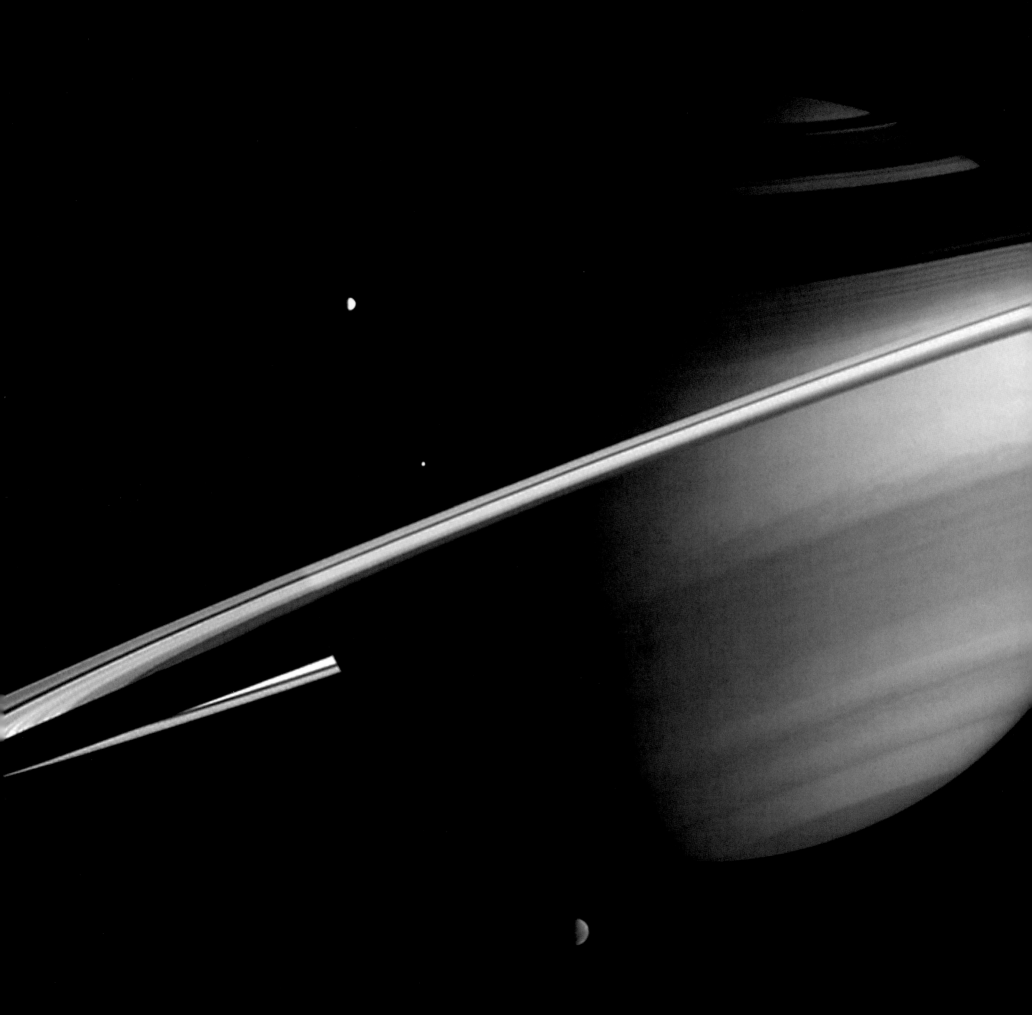

Five of Saturn's 40-plus moons, including Titan (at bottom), were captured by the spacecraft's wide-angle camera. Deep, clear regions of the planet's atmosphere appear darker, while high, cloudy regions are brighter.

These images show illumination of the night side of Dione (below) by "Saturnshine" from the brightly lit face of the planet (off to the left) and of the night side of Saturn's southern hemisphere (opposite) by "ringshine." Except near the equator where they appear edge-on, the rings fill Saturn's night sky, creating an enormous surface that reflects light onto the dark side of the planet.

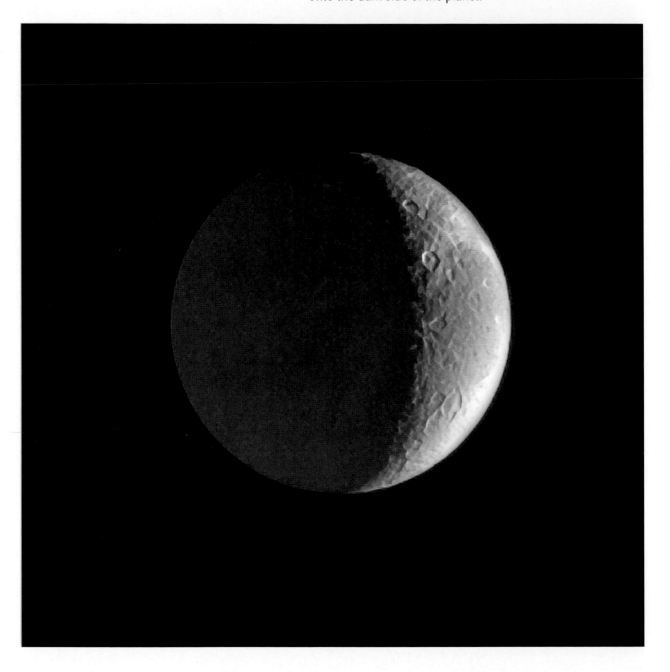

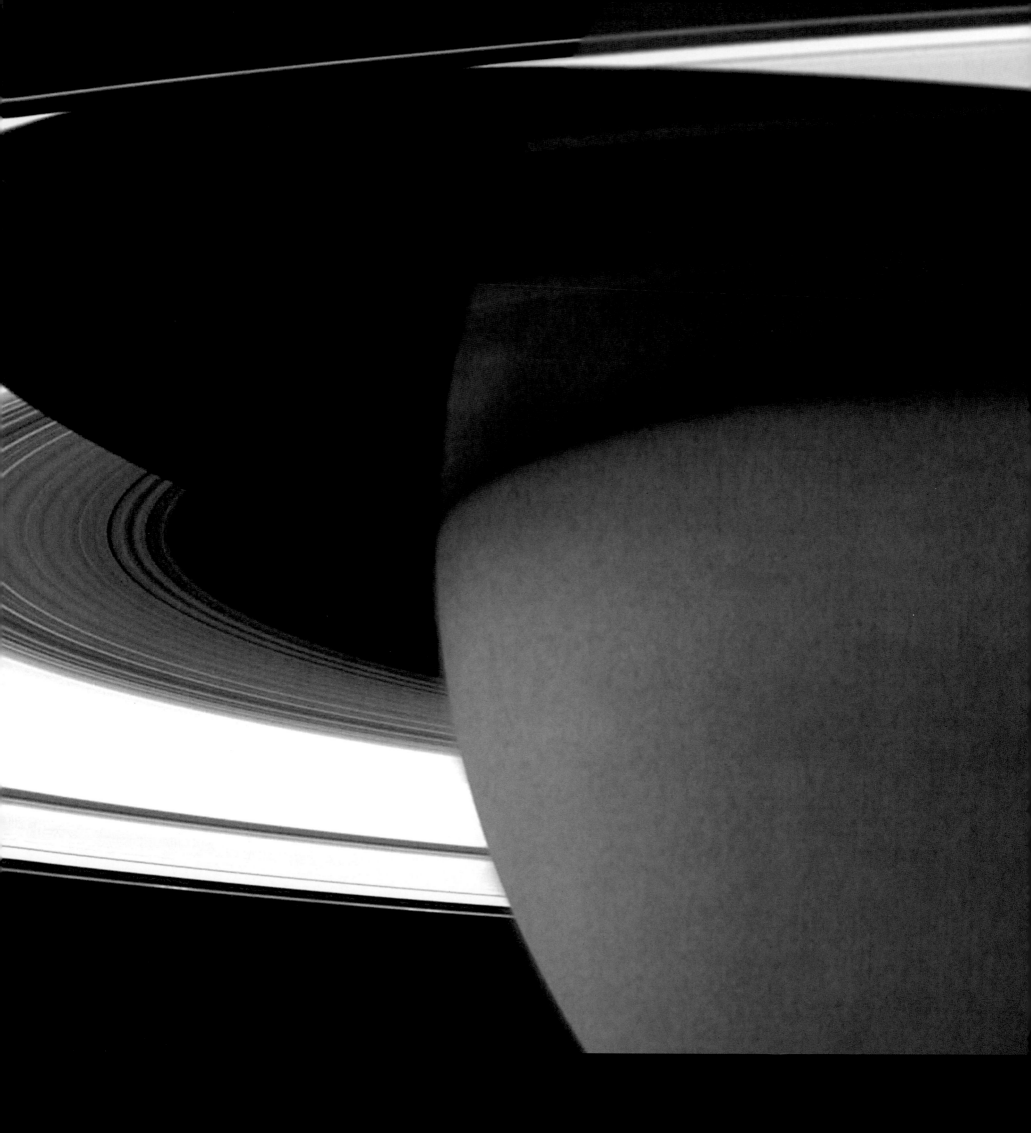

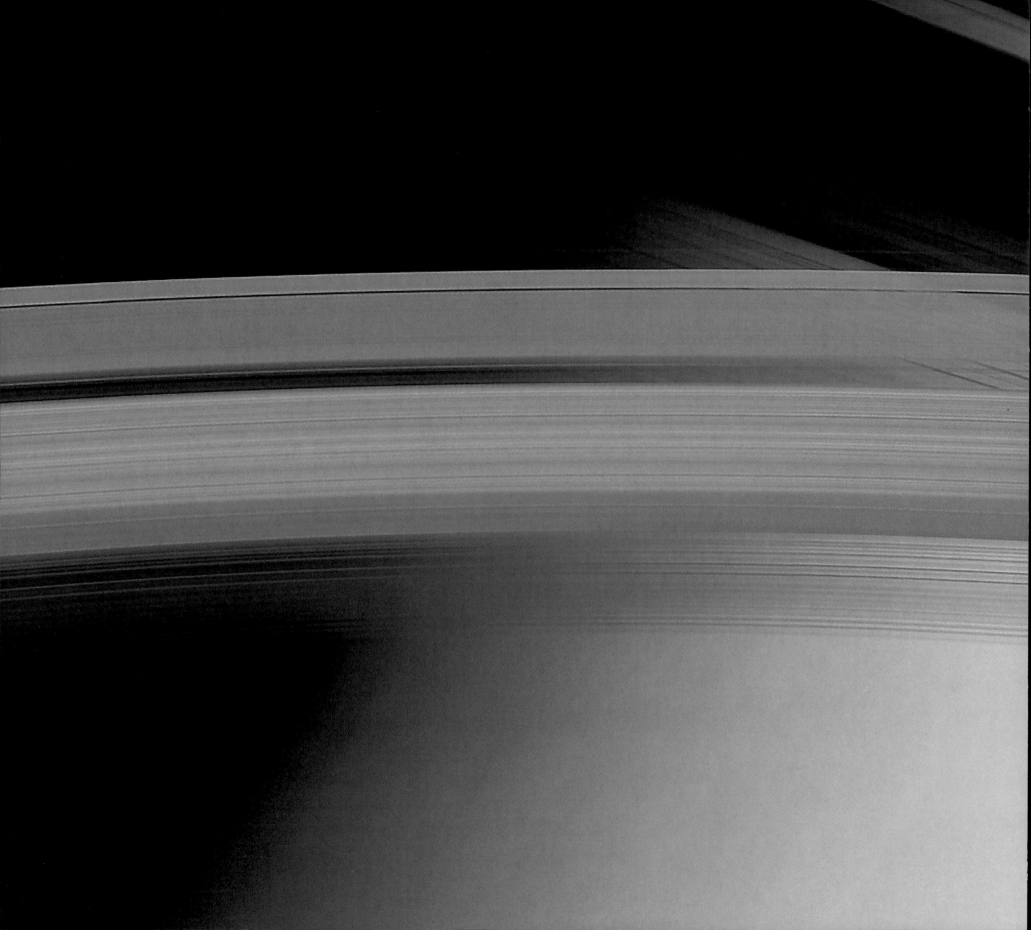

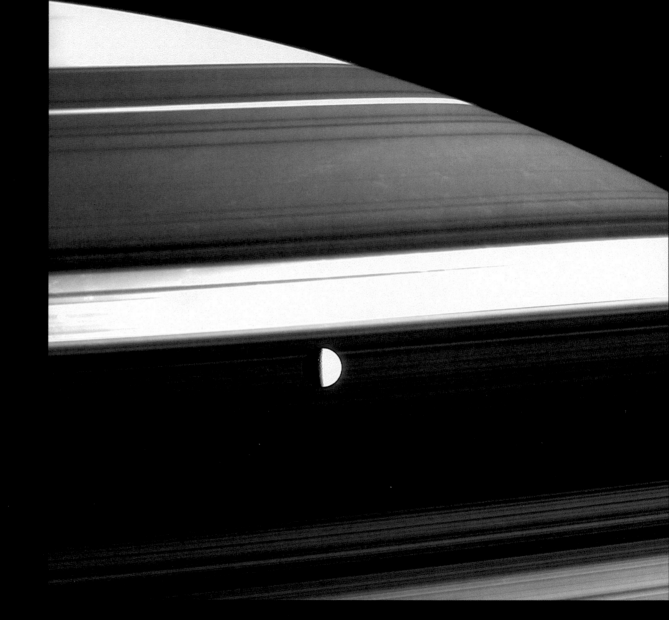

Shadows from the rings stripe the planet. The gray upper
shadows are cast by the translucent A ring; below these, bright
sunlight streams through the Cassini Division. At the bottom,
Dione crosses the deep shadow of the densely packed B ring.

48 Unlike Voyager, Cassini's arrival coincided with winter in Saturn's northern hemisphere. The effect of the prolonged cold of winter on the northern region of the planet, which emerges from long winter nights into the deep shade of the rings, is a cloud-free atmosphere, much like a clear blue sky on Earth. With the Sun below the equator, the rings cast long shadows that appear as arcs encircling the planet.

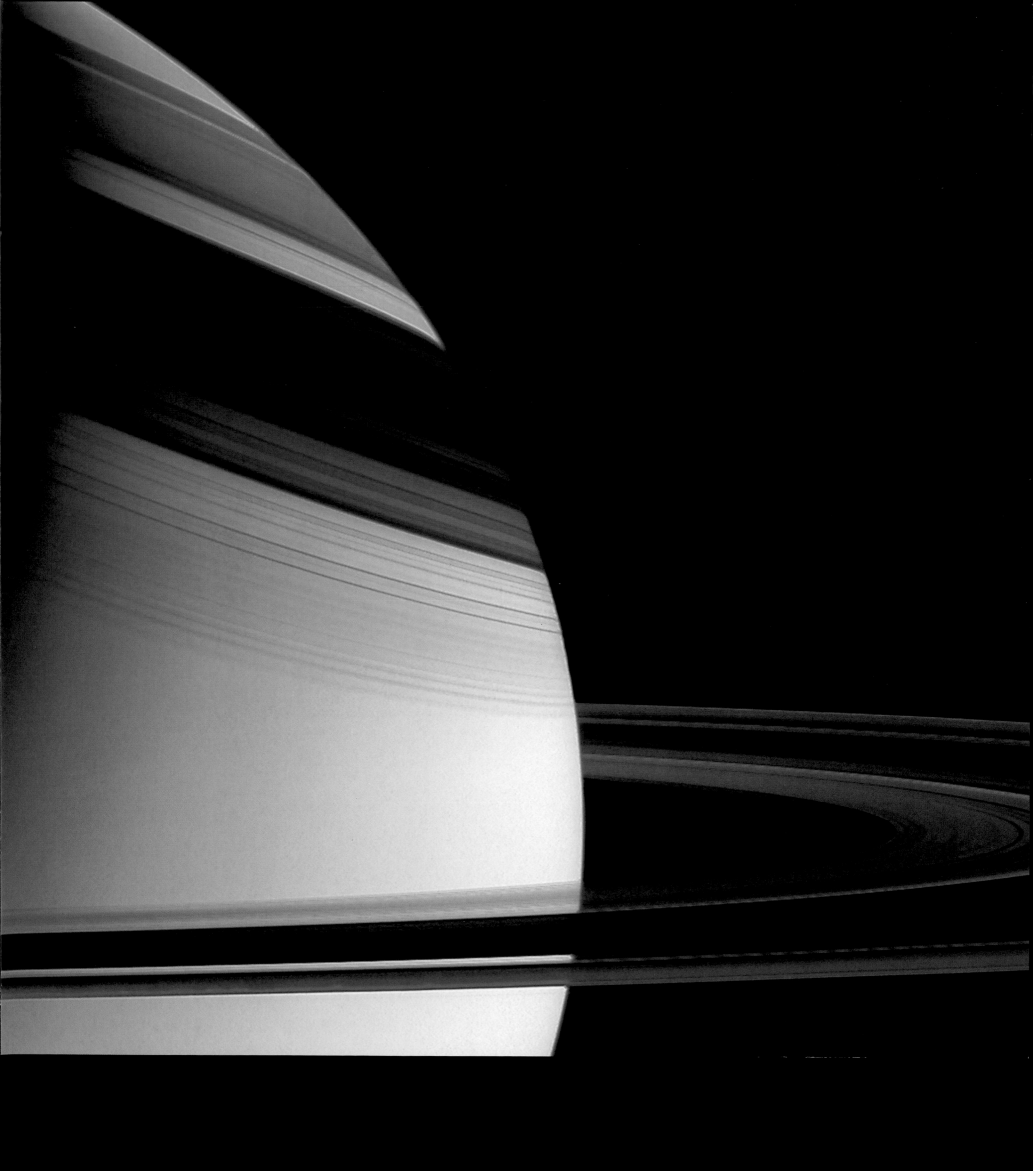

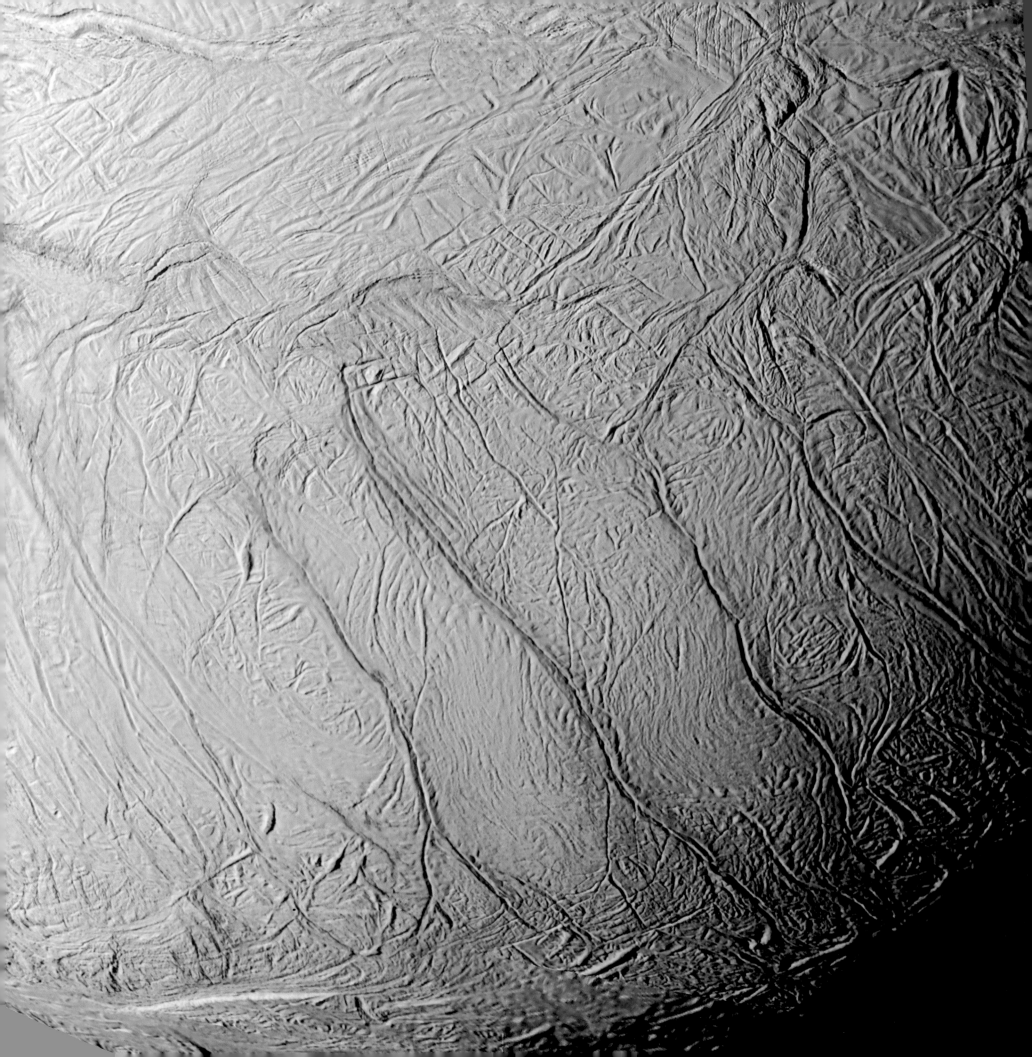

opposite Some of the most exciting findings of the mission have come from Saturn's moon Enceladus. The long, blue (false-color) features called "tiger stripes" revealed in this close-up are warmer than the rest of the moon and may contain fresh water ice. If liquid water exists, there is the potential for life to evolve.

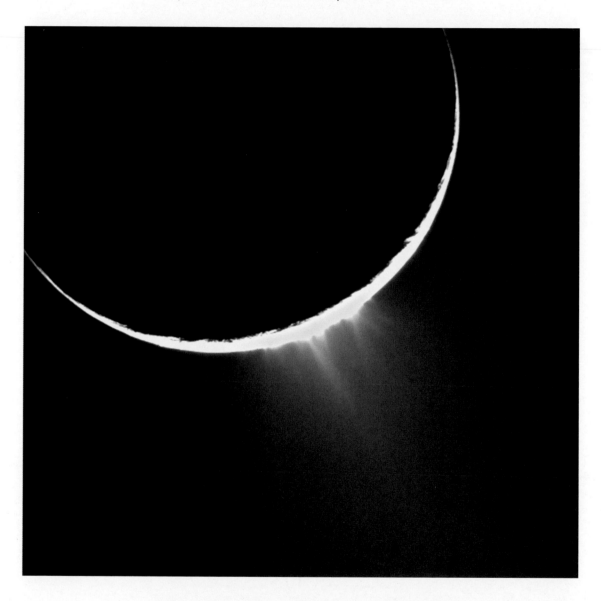

Enceladus, backlit by the Sun, vents fountain-like jets of fine material from the south polar region containing the "tiger stripes." The ejected material feeds Saturn's faint E ring and helps explain why it varies with time.

Wispy features on the trailing hemisphere of Saturn's icy moon Dione were first seen by Voyager. Cassini has now revealed the features to be steep, abrupt cliffs of ice fractures that stand a few hundred meters (¹/₄ mi) high.

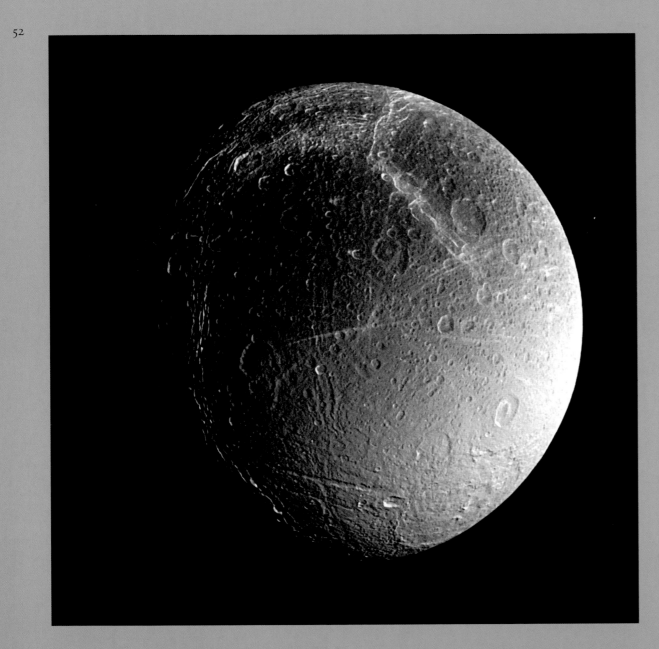

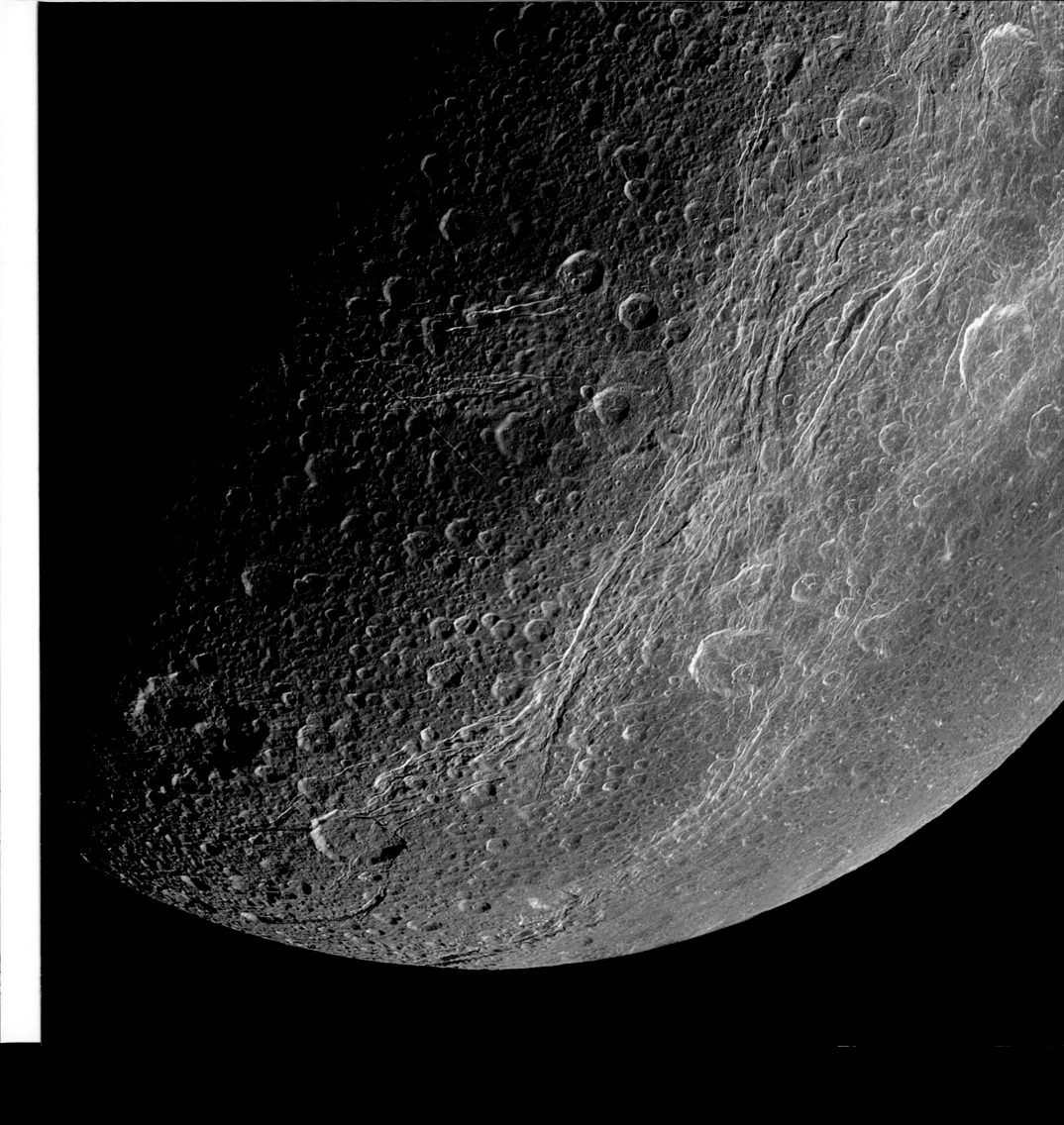

opposite Saturn and its rings appear prominently in this natural-color image, along with three of Saturn's smallest moons: Prometheus, Pandora, and Janus (from left to right). Prometheus and Pandora straddle the narrow F ring. All of these are considered ringmoons—small icy bodies that orbit in and around the main body of the rings.

following spread The planet's shadow on the rings lengthens as the season creeps from its seven-and-a-half-year-long summer into an equally leisurely autumn. The planet's night side is faintly illuminated with "ringshine," light reflected from the rings. Saturn's moon Janus keeps watch at lower left.

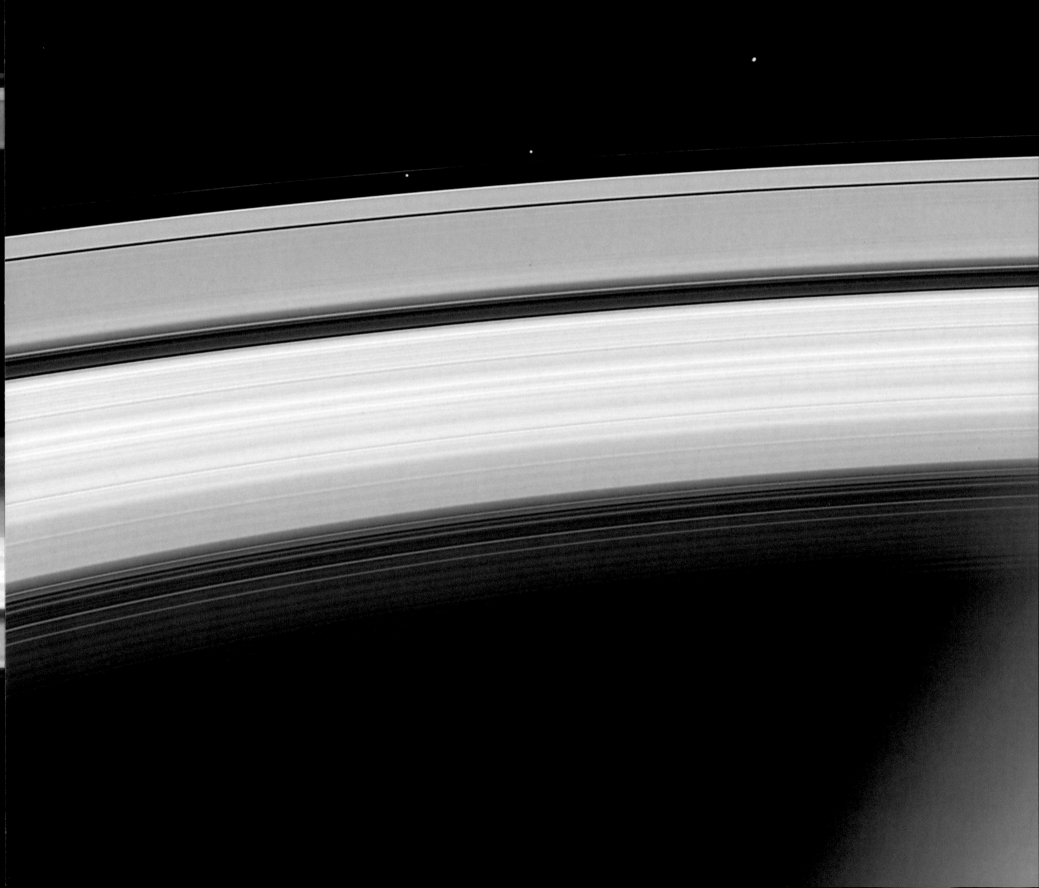

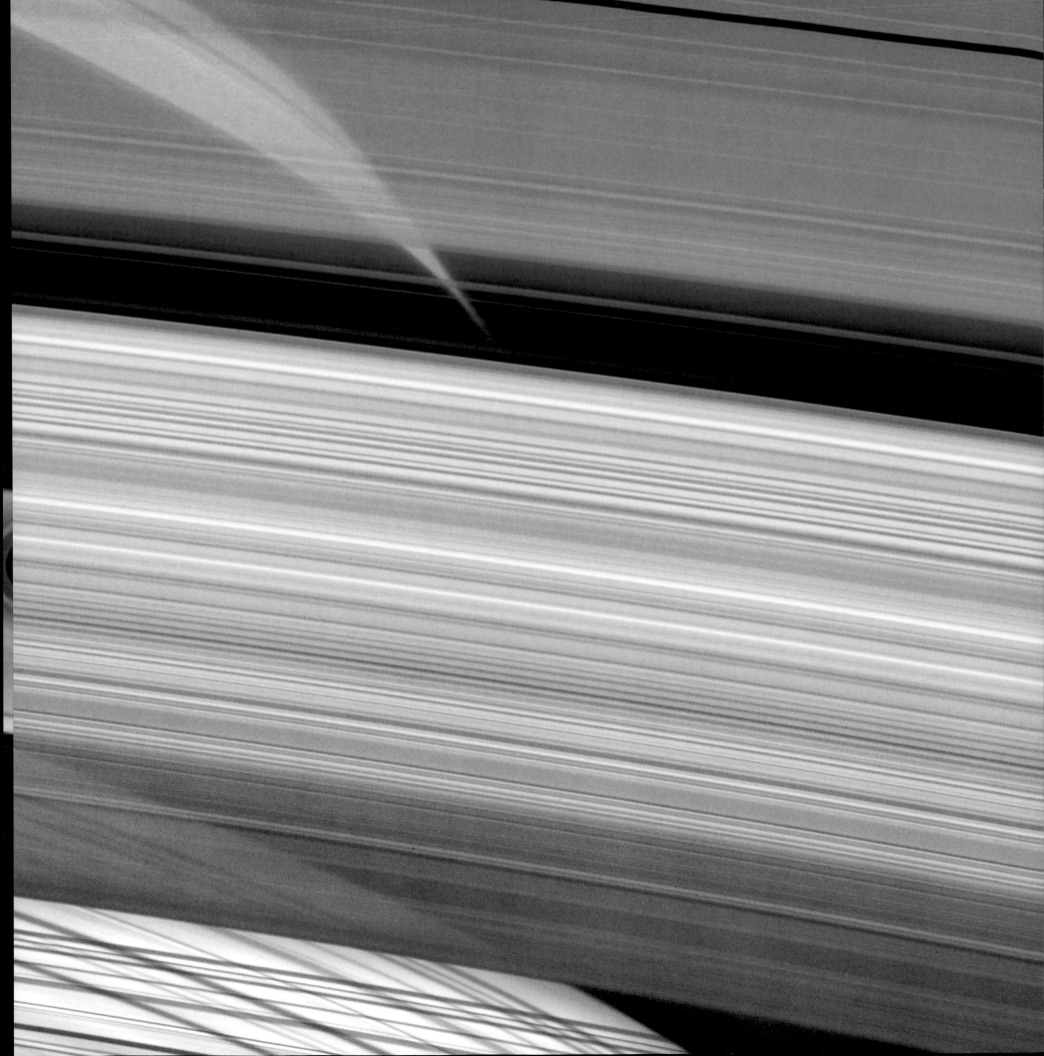

opposite Cassini's cameras have captured close-ups of Saturn's rings on a scale never seen before, enabling scientists to study their composition and structure in detail. The transparency of several of the rings is evident here and on the following spread. In this image we can peer directly through the A ring (towards the top) and the C ring (at bottom) and see some of the shadows they cast on the planet's atmosphere. The bright diagonal band near the top is light streaming through the Cassini Division between the A and B rings.

following spread Cassini uses its unique point of view to photograph the unlit north face of the rings. Saturn's night side, lit by ringshine, is dimly visible through the C ring closest to the planet. At top left, the planet's shadow blots out a wedge of the rings. Most of the dark areas are dense regions in the B ring, but some are gaps seen against the dark background of space. This image is about 40,000 km (25,000 mi) across—more than three times the Earth's diameter.

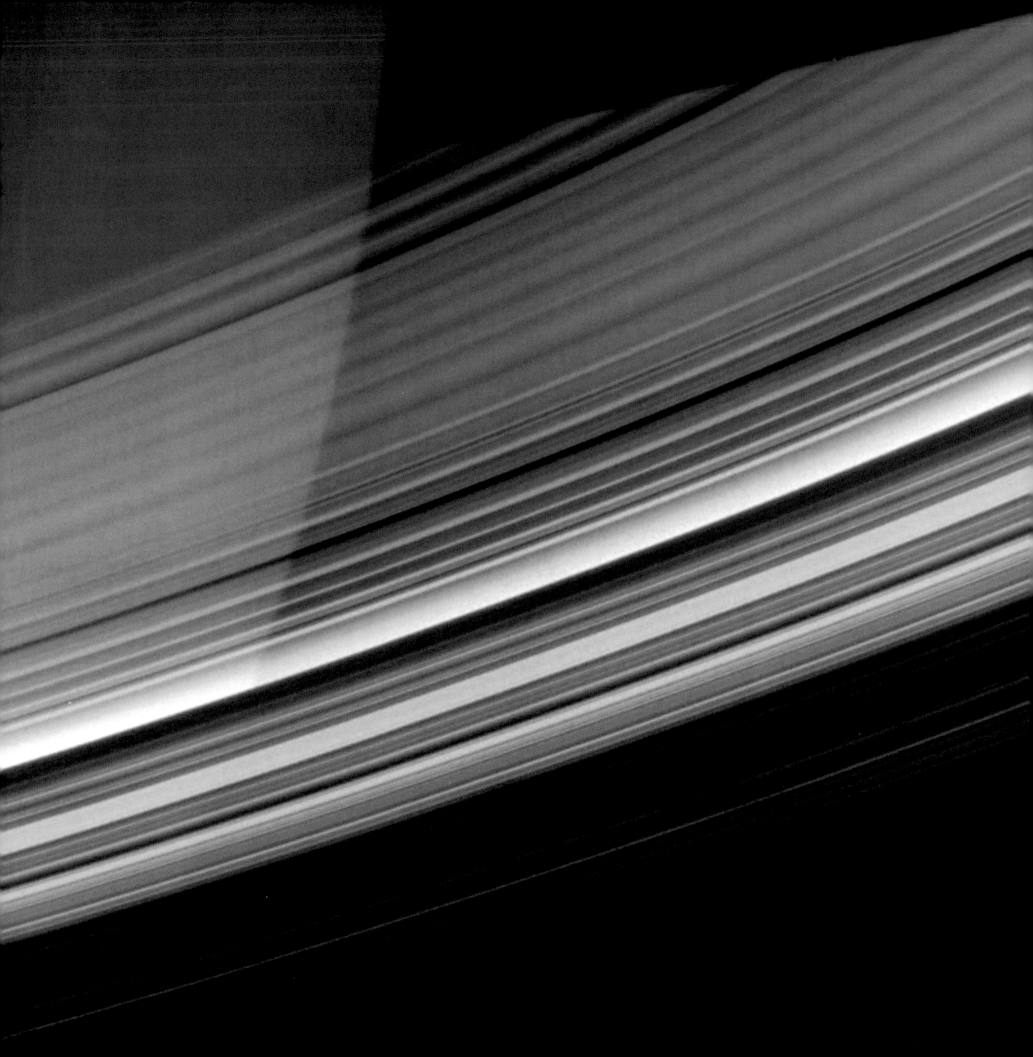

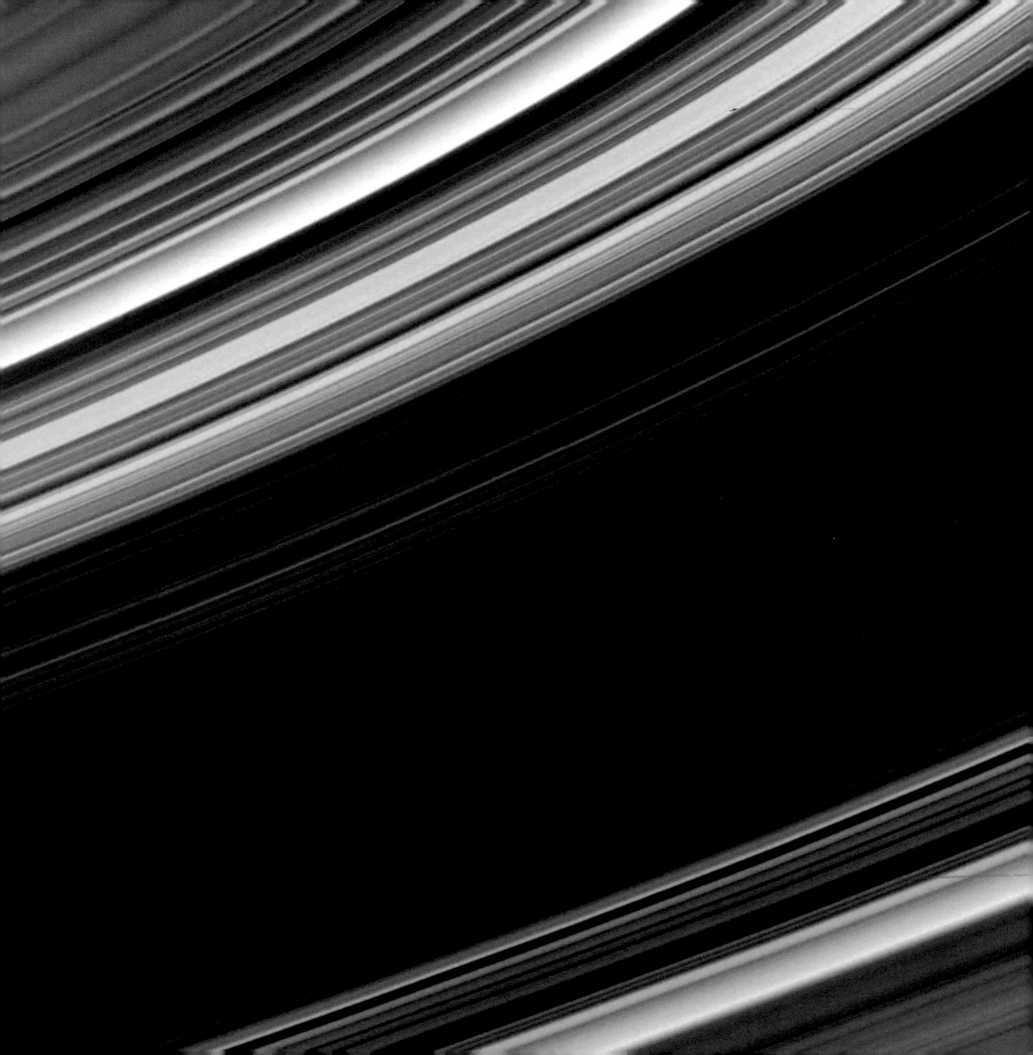

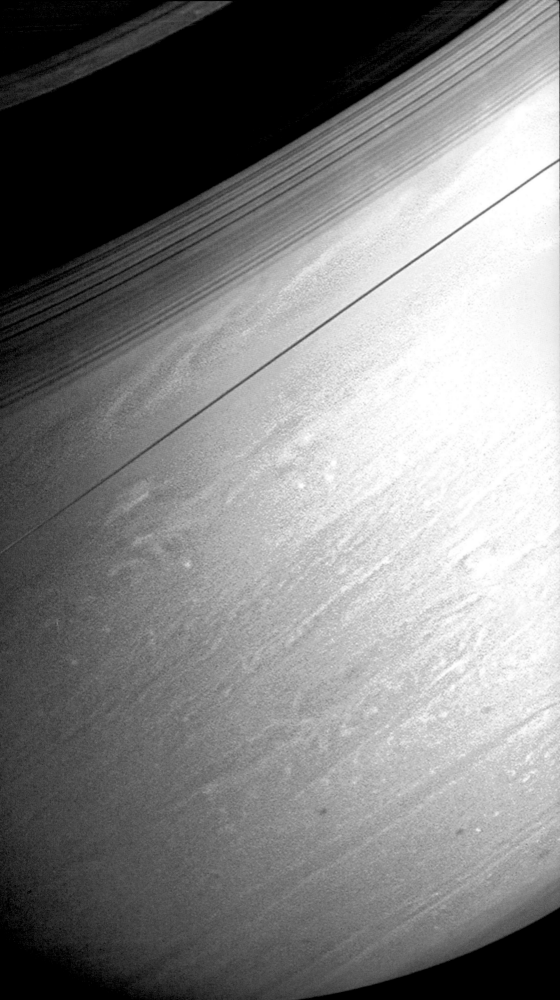

Saturn's magnificent rings are made of countless particles of water ice, orbiting the planet at 15 times the speed of a rifle bullet. In diameter, the rings would reach nearly the distance from the Earth to the Moon but they are no more than tens of meters (yards) thick. Viewed edge-on, as here, they virtually disappear but their bold shadows are still visible on the planet's northern regions.

Scientists study color variations in false-color images, such
as this one of the outer A ring, to determine the composi-
tion of the ring material.

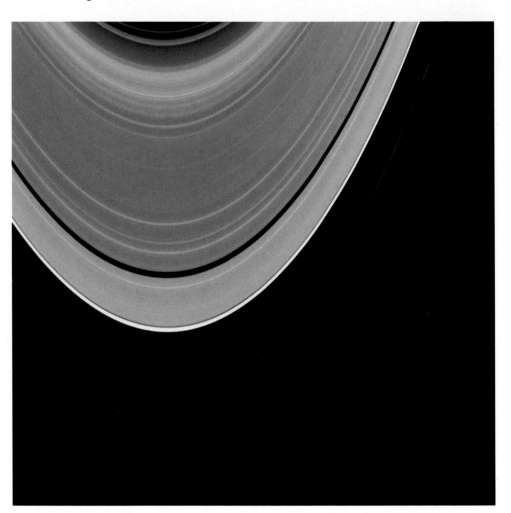

opposite　Saturn's shadow drapes the rings. This early in the mission,
the Sun was still high above the equator so the planet's
shadow didn't reach the outer edge of the rings. The narrow
F ring displays several transient clumps of particles.
Epimetheus appears at left, and Prometheus is seen inside
the F ring near top center.

following spread　The planet that was seen by Voyager to be yellow ochre
displays its true, multi-hued coloration in what is easily the
finest photograph of Saturn obtained to date. This glorious
portrait was tiled together from 42 overlapping exposures.

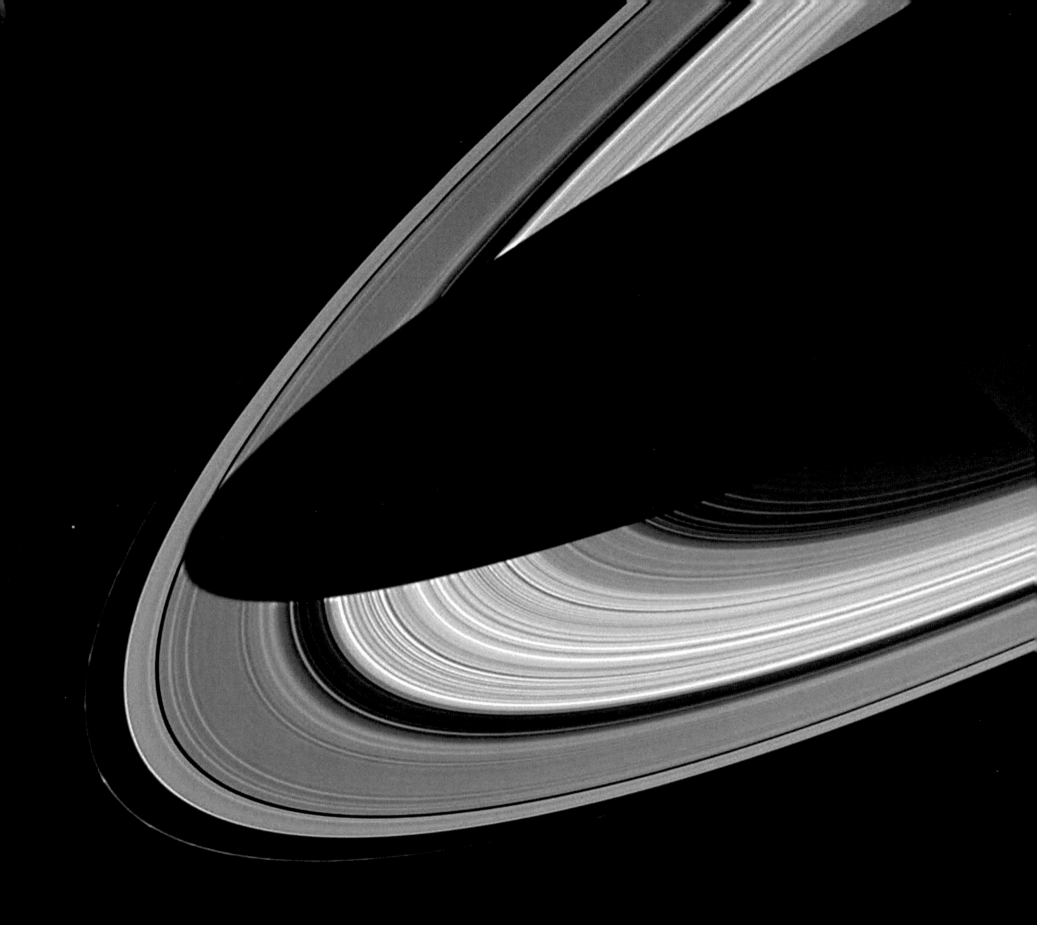

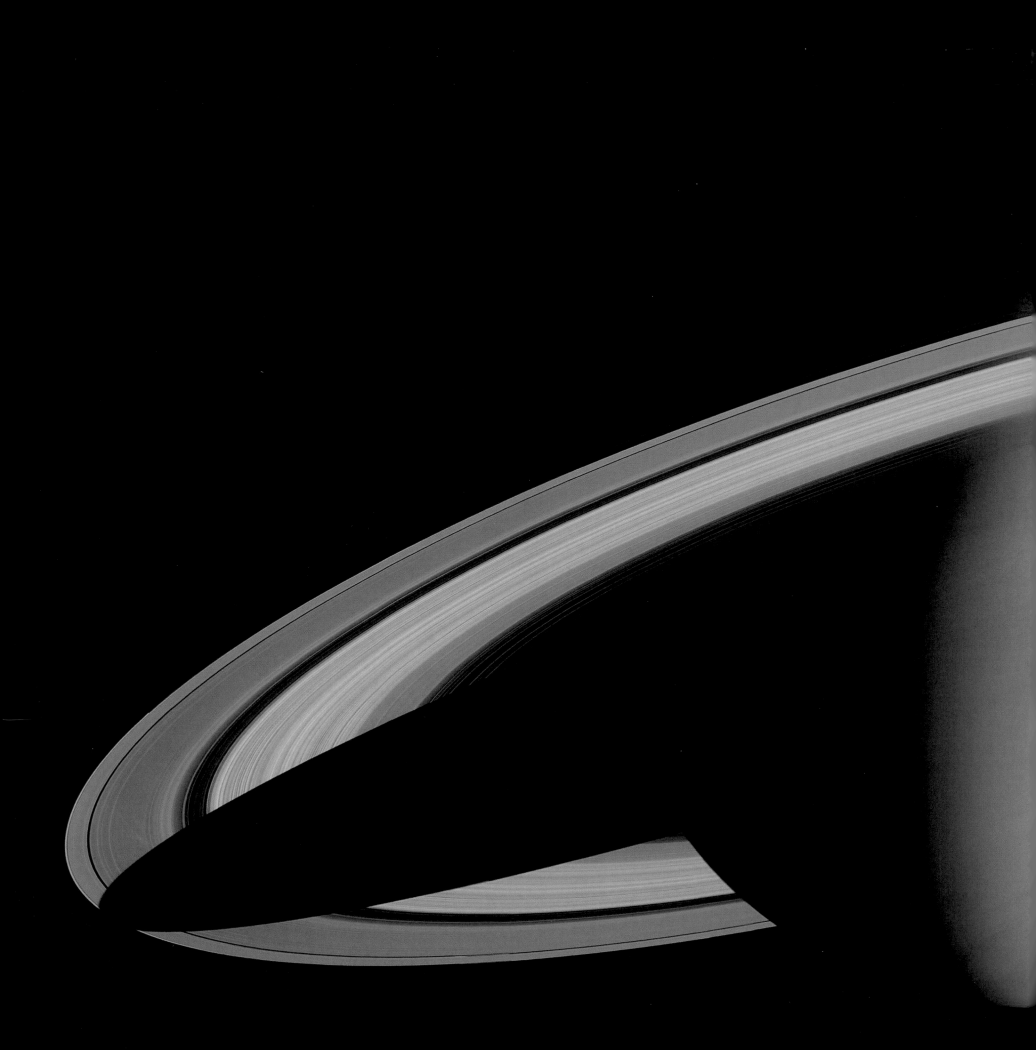

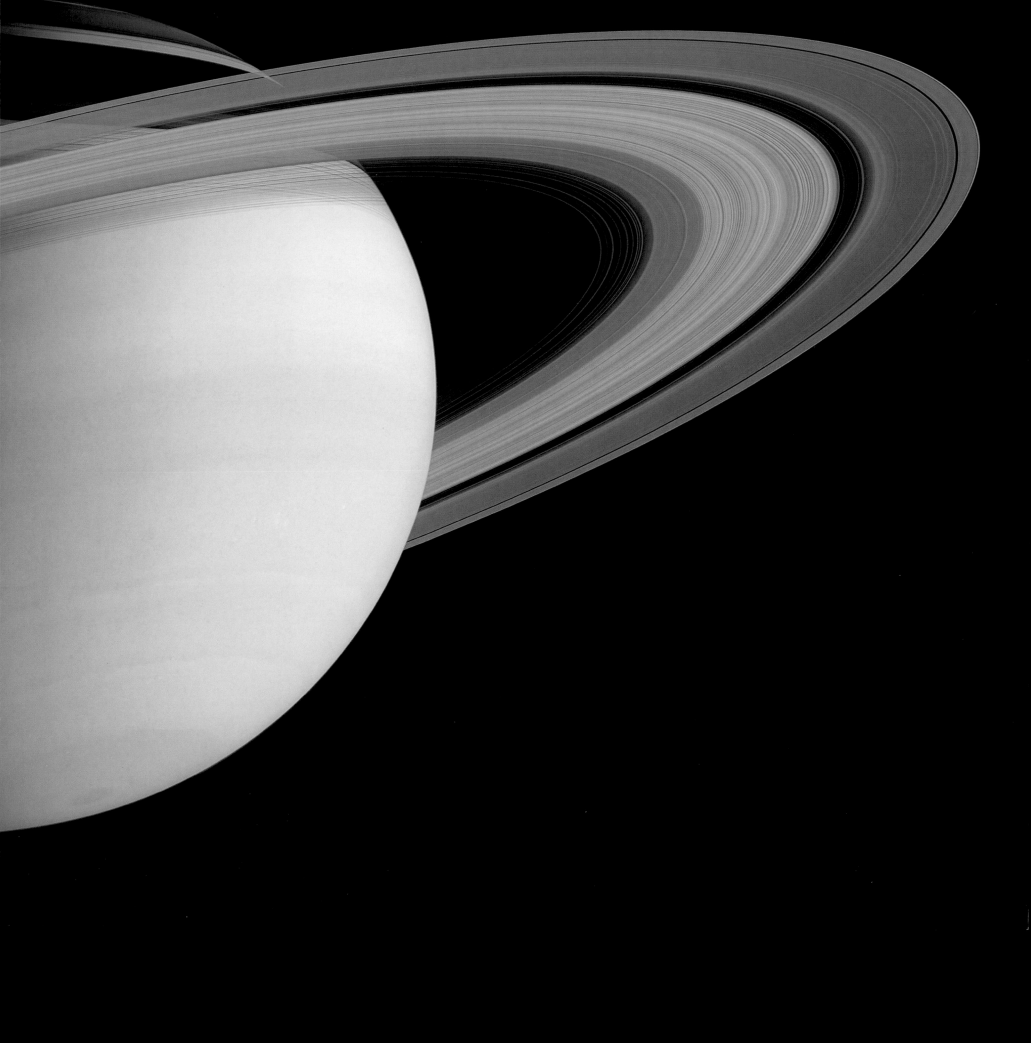

above As Cassini flew past Titan, its camera captured this unusual view of Saturn through the moon's murky upper atmosphere. Titan's deeper atmosphere is thick enough to obscure the rest of Saturn entirely.

right Mimas drifts by Saturn's northern hemisphere, now in winter. The startling blue of the planet's northern region, believed to be seasonal in nature, has been one of the big surprises of the mission.

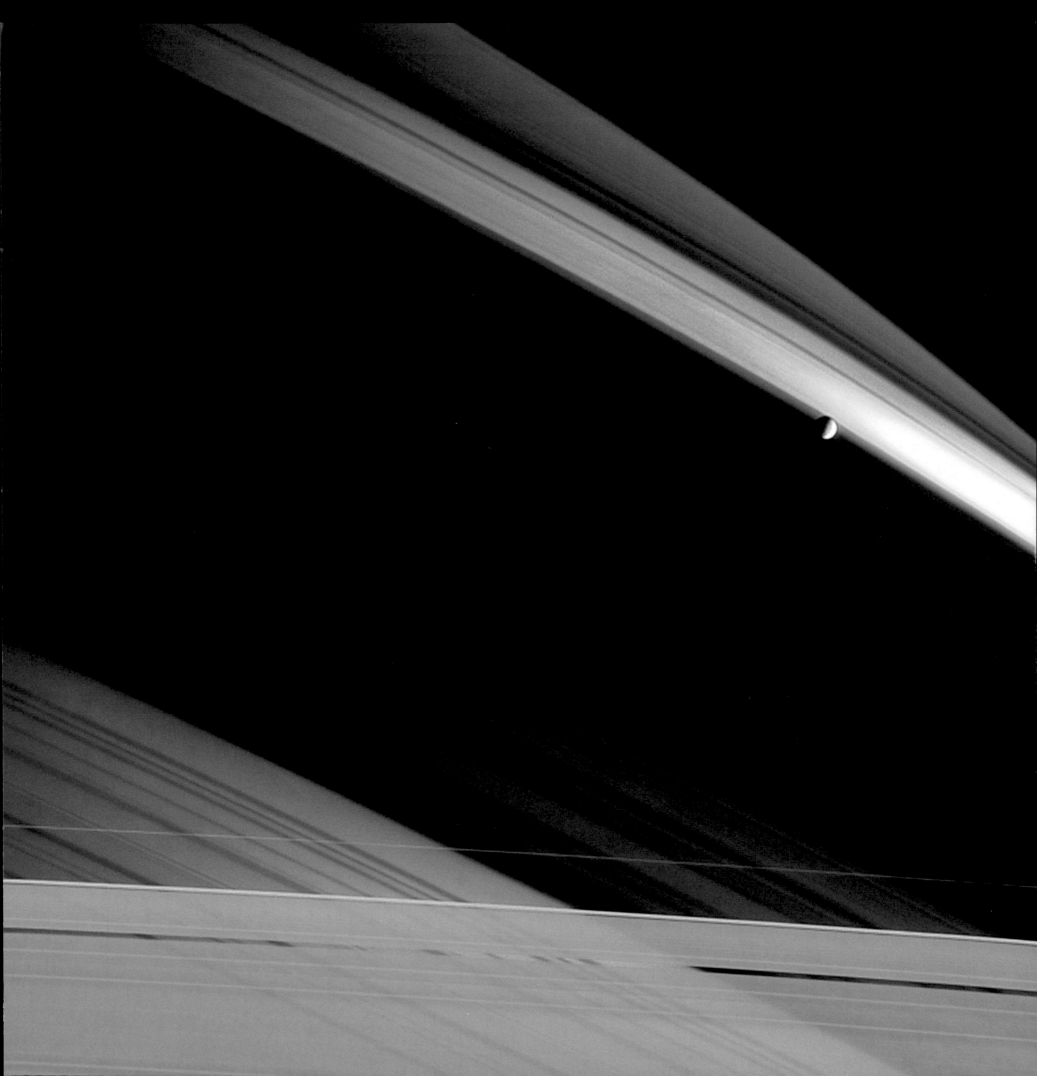

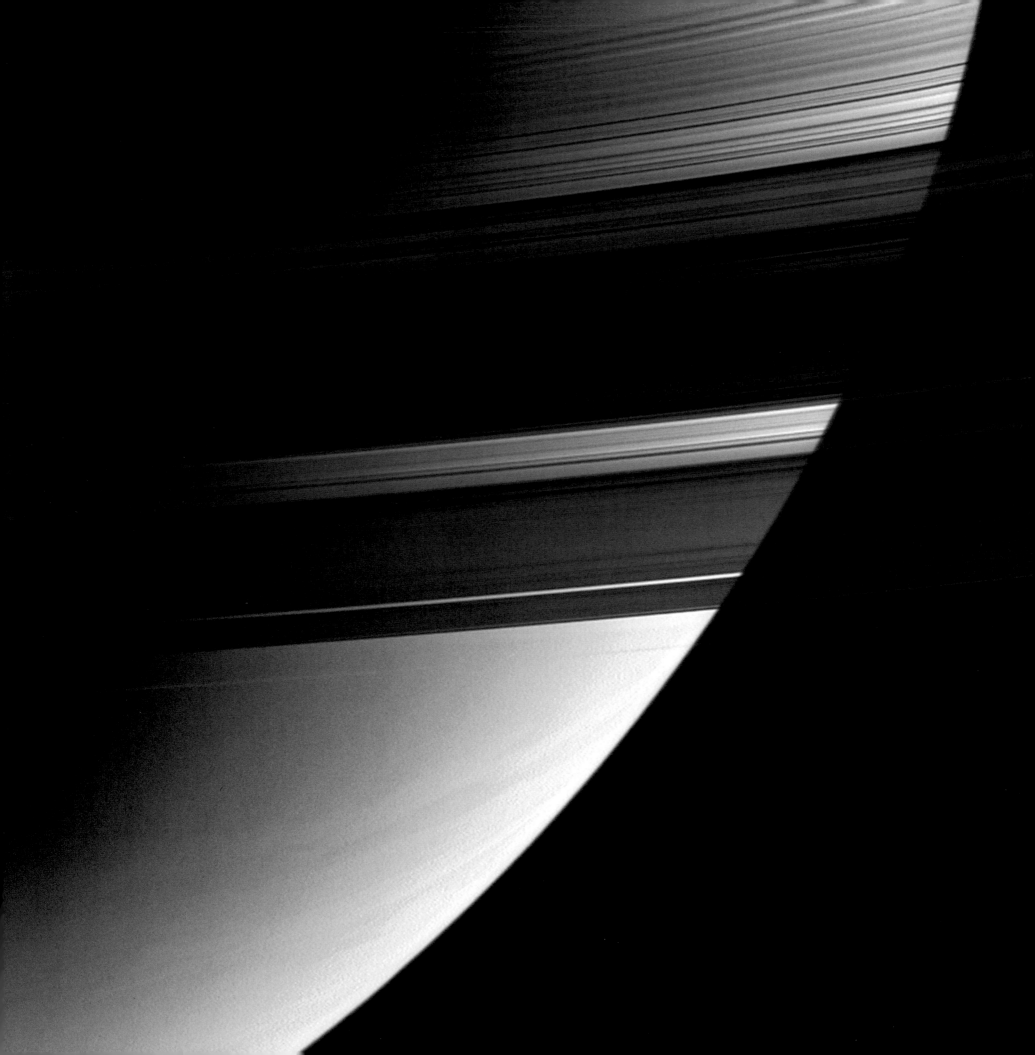

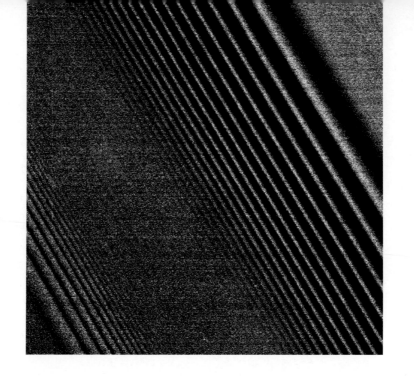

opposite The rings' unlit face is a study in light and shadow.

right One of the highest-resolution images taken by Cassini shows details of two spiral waves in the rings, wound up as tightly as watchsprings.

Jeff Cuzzi | # A Ringed World

Saturn is aptly called the jewel of the solar system. The planet still glows with heat from its creation, and its deep atmosphere churns out hurricanes the size of Earth. Its moon Titan, larger than several planets, is blanketed by an atmosphere denser than our own; rivers of liquid natural gas carve through Titan's iceberg mountains and flow down to plains of organic mud. Saturn has more moons than we can accurately count, and the count is constantly changing. And, of course, it has a uniquely spectacular ring system.

Fascinating enough as a celestial display, the Saturn system also provides us with some key insights into the origins of our own planet and of the life on it. Saturn and its rings are like a miniature model of the forming solar system, where processes caused a disk of gas and particles to coalesce into planets. Saturn's disk of particles shares many of the same processes, allowing us to study planet formation close at hand. The atmosphere of Titan provides us with another model—a planetary-scale organic chemistry lab where we can observe those first halting steps whereby simple matter evolved into complex matter, and complex matter to simple life forms—a process that may be universal. While Titan is too cold to support life as we know it, Saturn's much smaller moon Enceladus may have a great, warm lake of liquid water beneath its icy surface. At the bottom of this lake, internal

heat may boil a stew of rich chemical nutrients much like at mid-ocean ridges on Earth—an environment where many scientists think life on our planet began. On a grander scale, more than 150 planets that have been discovered orbiting other stars in our galaxy are gas giants like Saturn and Jupiter. Better understanding of the gas giants that live in our own backyard will help us understand these more remote cousins—some of which may have habitable moons of their own.

The stuff from which Saturn, and we ourselves, are made has a very long history. Hydrogen and helium were the first elements formed when our universe flashed into being 13 or 14 billion years ago. They condensed out of pure energy and from them the very first stars and galaxies were formed. Over the billions of years since then, stars much like our own Sun have created all the other elements—oxygen, carbon, iron, and so on—in fusion reactions in their cores, producing the light by which they shine. Small stars carry their elemental creations to their graves, but the death of large stars spews gases and solids made from these elements—"stardust"— widely across the surrounding interstellar medium. Millions, or even billions, of years later, chance events lead an especially dense cloud of gas and stardust (a mix of solids including ice, rock, metal, tar, and so on) to fall inwards under its own gravity and settle into a flattened, rotating disk of gas and dust. At the center, a new star forms, surrounded by its family of planets. Disks of gas and stardust like these, called protoplanetary nebulae, are commonly seen in regions of our galaxy where new stars are being born.

○ **The Planet.** Giant gas planets like Saturn and Jupiter probably grow from the inside out. Comet-like objects, already formed from the original stardust in the nebula, come together to form a solid core for each new planet. These cores, which astronomers casually refer to as "ice and rock," contain a complex mix of various kinds of "ices"—not only water ice but various other frozen compounds of carbon (methane, carbon dioxide, etc.) and of other elements like sulfur and nitrogen—and "rocks," which are mainly compounds of iron, aluminum, and magnesium with oxygen and silicon. Along with the ice and rock came a roughly equal amount of carbon-rich, tarry organic molecules that formed over millennia by sunlight acting on icy grains as they floated between the stars. This gummy mix is still to be found in the nuclei of comets that escaped becoming a part of some giant planet's core to career wildly through the solar system.

Once Saturn's core of solids reached a critical mass (more than 10 times the mass of the Earth), it had enough gravity to grab a huge portion of the surrounding hydrogen and helium gas—nearly 10 times its own mass! It is this envelope that makes Saturn almost 100 times more massive than Earth. Over a time of perhaps centuries, an entire band of gas and dust ringing the nebula near Saturn's orbit collapsed onto its solid core. This must have been an impressive event. The huge amount of energy released in this collapse heated the newly formed gas giant, and it glowed red-hot for tens of thousands of years. In its early days, Saturn was too warm for small, icy moons or rings to form as close as we see them now, so their formation must have been delayed for some time. Its atmosphere has cooled slowly, over its five-billion-year lifetime, to the current frigid condition we observe today.

Although Saturn is 100 times more massive than Earth, it has such a low density that it would float on water; this is because the light gases hydrogen and helium make up about 80% of its mass. Underneath all this hydrogen and helium gas, Saturn's deep interior and core, while made from "rock and ice," is nothing like the surface of the Earth. With 80 Earth masses of matter pressing down on it, it has a pressure of 9 million kg/cm^2 (128 million lb/in^2) and a temperature of 14,000°C (25,000°F)—much hotter than the surface of the Sun. As you descend into Saturn's atmosphere, the gas gets denser and hotter, but it's still gas—evaporated ice and rock, compressed under huge pressure. There's no distinct solid or liquid surface anywhere to stand (or float) on.

When we look at Saturn, we see only gas and clouds. On Earth, all clouds are formed of water, either liquid or ice, but on Saturn, several different materials form clouds—each at a

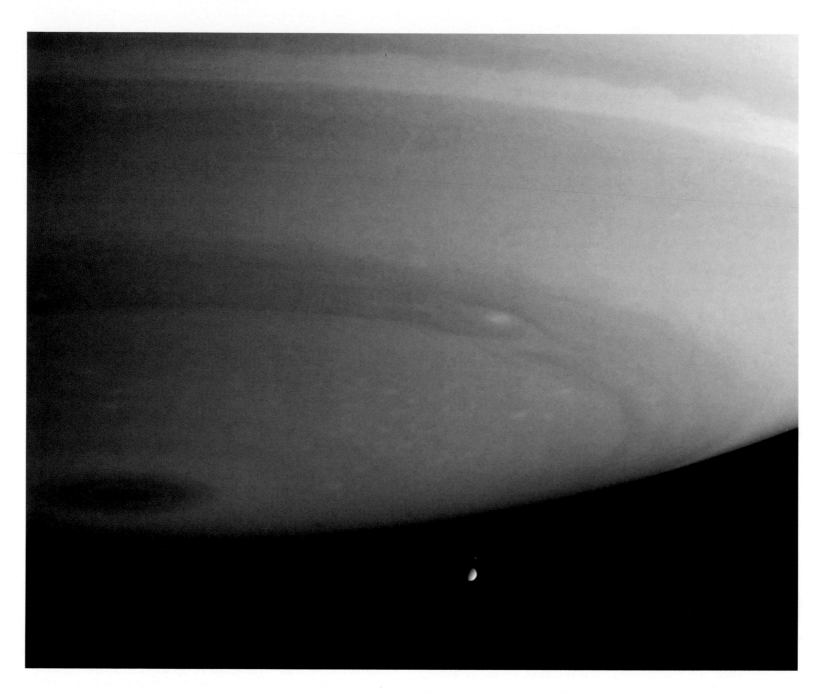

Looming over Enceladus, Saturn's southern hemisphere shows latitudinal cloud bands and a giant, eye-shaped storm in one of its jet streams.

different temperature, and thus at a different height in the atmosphere. Trace amounts of gases other than hydrogen and helium, which account for only a tiny fraction of the planet's mass, provide all of its cloud particles and coloration. Saturn's abundant hydrogen has combined with the carbon, nitrogen, and oxygen inherited from interstellar gas and dust to form methane, ammonia, and water at about 1% of the mass of hydrogen. Gases of sulfur and phosphorous are present in lower amounts. We expect to find at least three cloud layers—an upper one of ammonia, a middle layer of an ammonia-sulfur compound, and the lowest cloud layer, where the atmosphere is warmest, made of water. Until we send a probe into Saturn some day, we have to deduce the cloud properties from telescopic observations. Cassini's images are being

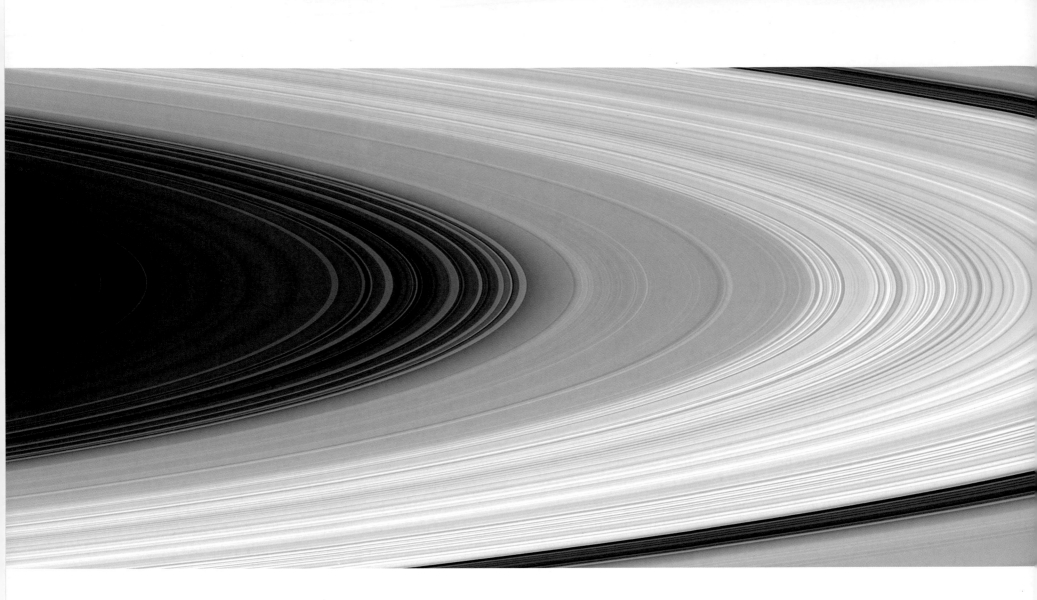

physics of the arms of spiral galaxies, are most abundant in the A ring because it lies closest to Saturn's various ring-moons—Prometheus, Pandora, Janus, and Epimetheus—and Saturn's smallest, innermost regular moon, Mimas. The waves form at orbital resonances, which are places where the ring particles orbit the planet in an exact simple fraction ($\frac{1}{2}$, $\frac{3}{5}$, $\frac{36}{37}$) of the time it takes a particular moon to do so. At these resonances, even the tiny gravitational impulses from these remote moons—about the same as that exerted by a truck driving by you on the street—can reinforce each other and cause small, synchronized motions in the ring particle orbits. These motions get amplified further by the even tinier self-gravity of the ring particles themselves, creating graceful spirals that slowly turn, like pinwheels, each at a different rate, in time with the moon that causes them.

Spiral waves are useful probes of ring properties because their structure tells us the mass both of the moon and of the ring material they travel through. Even more significantly, they transfer momentum between the rings and the moons, causing the rings to fall inwards and the moons to recede outwards. If the current rate of transfer has been going on since Saturn formed, the five closest ring moons should have spun away from the planet long ago, and the A ring should have fallen into the B ring. One perhaps startling idea that can reconcile the theory and observations is that Saturn's rings and ringmoons are younger than the planet.

The dense B ring is permeated by irregular, "record groove" structure without much of a pattern. This structure is created partly by fluctuations in the amount of matter and partly by variations in the brightness and/or packing density of

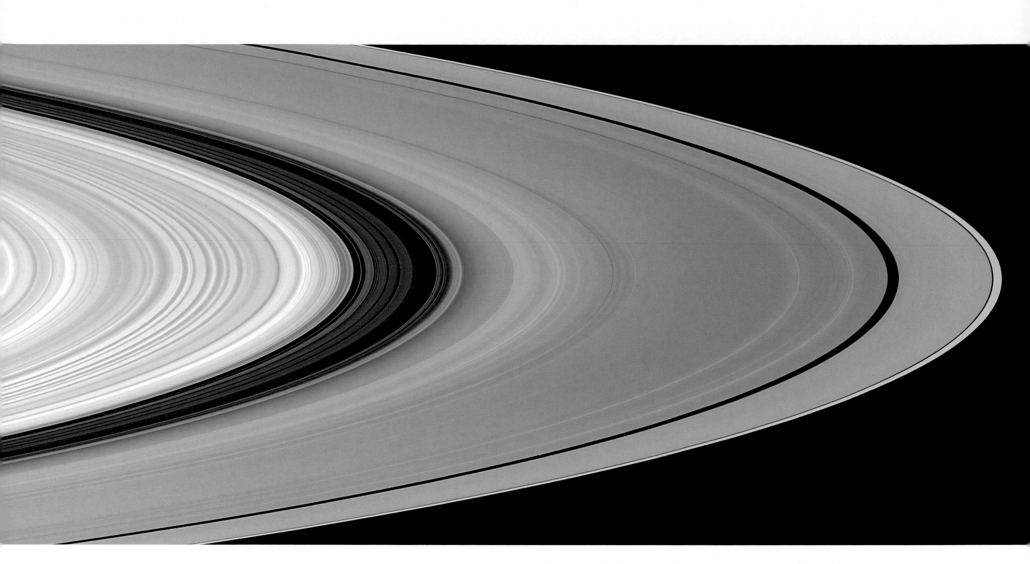

the ring particles, as described above. In contrast to our good understanding of the well-separated spiral waves in the A ring, almost none of this pervasive B ring structure is understood.

The diffuse E and G rings lack dramatic structure, but are far from boring. Variations in brightness have been seen in both, over periods of months. Something is going on in those faint bands! The E ring is probably maintained by geysers of icy dust vented from the molten subsurface of the small moon Enceladus, which orbits in the middle of it. The G ring has no obvious parent moon, so its variations with time suggest collisions between small members of a yet-to-be-detected tribe of moonlets. Time variations have also been seen in some of Saturn's other low-opacity rings; the D ring, which lies even closer to the planet than the C ring, is nothing more than a faint collection of G-ring-like features—but several of

This natural-color view of Saturn's ring system shows, from left: the dusky, neutral-colored C ring; the much denser and redder B ring, which is full of brilliant features across its outer two thirds; the less dense Cassini Division (right center) where the particles are dark grey; and the tan A ring which is bisected by the Encke Gap (and narrower Keeler Gap) towards its outer edge. The narrow strands of the F ring are visible in the blackness at far right.

them seem to have changed position since Voyager 1 and 2 first observed them.

The stranded and kinky F ring is a fireworks display of activity. When the F ring was first discovered, we thought that the ring's straddling "shepherd moons," Pandora and Prometheus, somehow confined it and kept it from straying. However, these "shepherds" have shown a tendency for unpredictable

("chaotic") orbital behavior of their own, and we now suspect instead that the entire region between them is so full of their overlapping resonances that no truly stable orbits exist there at all! Moreover, Cassini has discovered, lost, and (maybe) rediscovered orbiting objects that change appearance in weeks and cross over the orbit of the F ring. It's likely that the entire region between Pandora and Prometheus is sprinkled with still-undetected moonlets of different sizes, orbiting chaotically and colliding unpredictably, like a little asteroid belt.

While the F ring may not be shepherded, the same physics of moons pushing ring material away does explain two prominent empty gaps in Saturn's A ring. The effect arises from the way the moons' gravity acts upon waves they excite in nearby ring material. The 325-km (200-mi)-wide Encke Gap in the A ring contains at least one moonlet, Pan, and a number of kinky ringlets that seem to be continually changing their appearance. Cassini has discovered another moonlet orbiting within an even smaller gap—the 30-km (19-mi)-wide Keeler Gap—suggesting that most or all of the other gaps in the rings are caused by small, embedded moonlets, for which searches are underway.

In all four gas giant planet systems there is a transition from large moons far from the planet, through more numerous but smaller moons closer to the planet, to rings very close in. The transition from moons to rings is called the Roche limit. Planets exert tremendous gravitational forces on their orbiting moons and particles. Much like our Moon's gravity raises tides in our own oceans, the planet's gravity raises tides in the body of a nearby moon that can tear it apart if it is held together only by its own weak gravity. These forces can also prevent small particles from growing into larger ones. The closer the orbiting particles are to a planet, the greater these forces are and the smaller the particles tend to be.

The small moons embedded within gaps in the rings probably represent fragments of the larger moon or moons that were somehow destroyed to form the rings; they must be held together by their solid material strength—actual chemical bonds—rather than their weak gravity. Finding where these moonlets came from will be the key to understanding the origin of Saturn's rings.

The composition of the material making up the rings and moons tells us even more about the parentage, formation, and convoluted history of the rings. We've known for decades that the "stuff" of the rings is mainly water ice, which is widespread and abundant in the universe. Pure water ice looks white, but the rings have a somewhat tan or taupe color, which scientists casually refer to as "reddish." The A and B rings are redder—even to the eye—than any of Saturn's moons. This means that some other, reddish-colored (blue-absorbing) material must be mixed in with the ice. This material may be a mix of organic molecules involving carbon, nitrogen, and hydrogen, but there is no definite identification yet. On the other hand, the particles in the less opaque C ring and Cassini Division are darker, perhaps the brightness of a tar-and-gravel road, and appear more of a neutral grey. Cassini's near-infrared spectrometer and ultraviolet spectrometer have both mapped the subtle diagnostic spectral "fingerprints" of the embedded materials. The material that darkens the C ring and Cassini Division contains iron, probably in silicates, and probably also carbon-rich organic material.

We are only starting to put these fragments of data together into a story of ring evolution. On Earth, small forces of erosion, acting inexorably over long time spans, can have large effects. At Saturn, the constant bombardment of the rings by interplanetary grains (40 metric tons or 44 tons a day fall on the Earth alone) plays a similar role. Because the surface area of the rings is so huge (hundreds of times the area of Earth) for their relatively small mass (a millionth that of Earth), they would have swept up the equivalent of their own mass of interplanetary debris over the 4.5-billion-year age of the solar system. This interplanetary debris is pretty dark stuff—about one-third rock and one-third carbon-rich organic tars—so mixing it with an equal amount of ice would pollute and darken the ice dramatically. While ring particles of all three other giant outer planets are quite dark—for reasons probably related to this process—Saturn's A and B ring particles, at

least, remain quite bright. Computer models of this process reproduce the broad features of ring composition—the A and B rings (having the most mass) remain the closest in brightness and color to the original reddish icy material, and the low-mass Cassini Division and C ring have been polluted the most. Moreover, even though at boundaries between these different rings the amount of material changes abruptly, its color and composition seem to change only gradually, in agreement with the models. Unless our estimates of the infall rate of interplanetary pollution are seriously in error, Saturn's still-bright rings are much younger than the solar system.

These bright-ring results, and the rapid spiral-wave evolution discussed earlier, independently imply that the rings may be no more than a few hundred million years old—about a tenth the age of Saturn itself, dating perhaps from the Devonian "age of fishes" on Earth. The surprising possibility that Saturn's spectacular rings may be a fairly recent ornament to their host planet leads us to wonder how this happened.

Perhaps one of Saturn's pre-existing moons was destroyed in place by a marauding comet. The mass of the rings is close to that of Mimas, which has a crater recording an impact almost large enough to shatter it. As far as we can tell, there are no traces in Saturn's rings of the probably silicate-rich core of such a parent moon, but close-up studies of the two moonlets known to lie in gaps in the rings will be important. The bizarre moon Hyperion certainly looks like a fragment of a larger object; if it had been smashed by a comet, some pieces of its icy shell might have fallen far inwards into the ring region, while other pieces would have splattered across the faces of the surviving moons, causing the many small craters we see there.

Another way for the rings to have formed would be if a large, wayward member of the outer solar system's tribe of Kuiper Belt objects—at least one of which is now known to be larger than Pluto—had wandered too close, within Saturn's Roche limit, and had been stripped of its icy shell by tidal forces while its rocky core kept flying by. In this case, we might not be surprised if the icy ring material were somehow different in composition from the ices more common on Saturn's moons. Further observation by Cassini, and a lot more analysis, will be needed to resolve this issue.

In either case, one can imagine a pretty hazardous environment for a while as fragments flew through the system on highly disturbed orbits, colliding with Saturn, the moons, and each other at high speed, further breaking each other up into smaller pieces. As the pieces got smaller, the collisions would have become more frequent and the relative speeds dampened out, allowing the particles to settle slowly from a thick swarm towards a thin layer in Saturn's equatorial plane.

For either of these two origin scenarios to have occurred as recently as a few hundred million years ago is improbable—and still controversial—based on our current understanding of the outer solar system. But, improbable or not, a recent origin for the rings would resolve several current problems at once. Cassini observations, including the current infall rate of interplanetary debris and the composition of the material making up both the rings and their intermingled moonlets, will remove many key uncertainties, help us understand how and when the rings formed, and predict how they will evolve in the future.

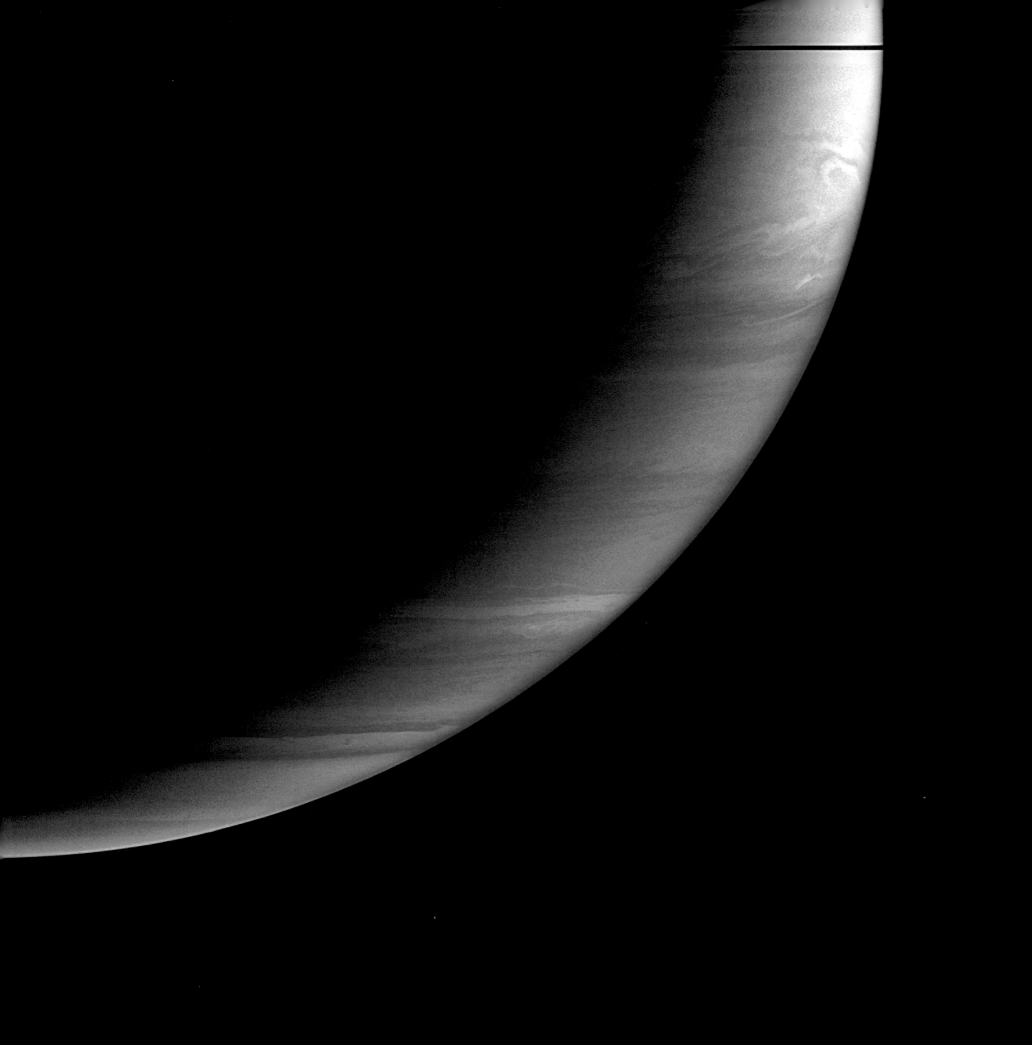

opposite Use of an infrared filter enhances the differences between Saturn's many bands of alternating jet streams. Planetary scientists are still debating how they are formed, but probably convection and temperature differences deep underneath the cloud tops and the very fast rotation of the planet both play a role.

following spread The next six spreads show an imaginary flyover of the rings from the sunlit south face across the ring plane to the unlit north face. As Saturn's seasons change, the Sun hits the rings at different angles. The rings, now lit on the south face, will be edge-on towards the Sun in 2009, then tilt so the north face is lit—a change which, if all goes well, Cassini will be there to observe.

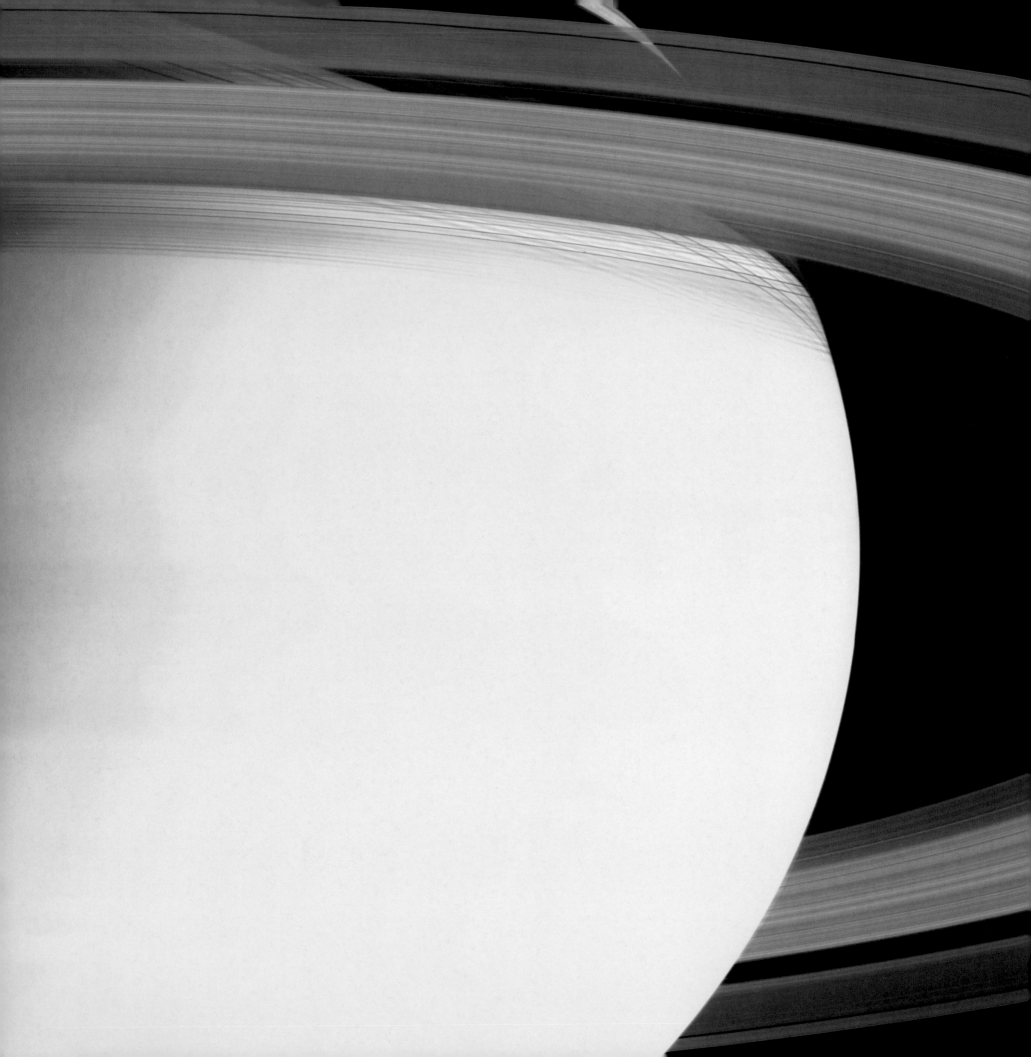

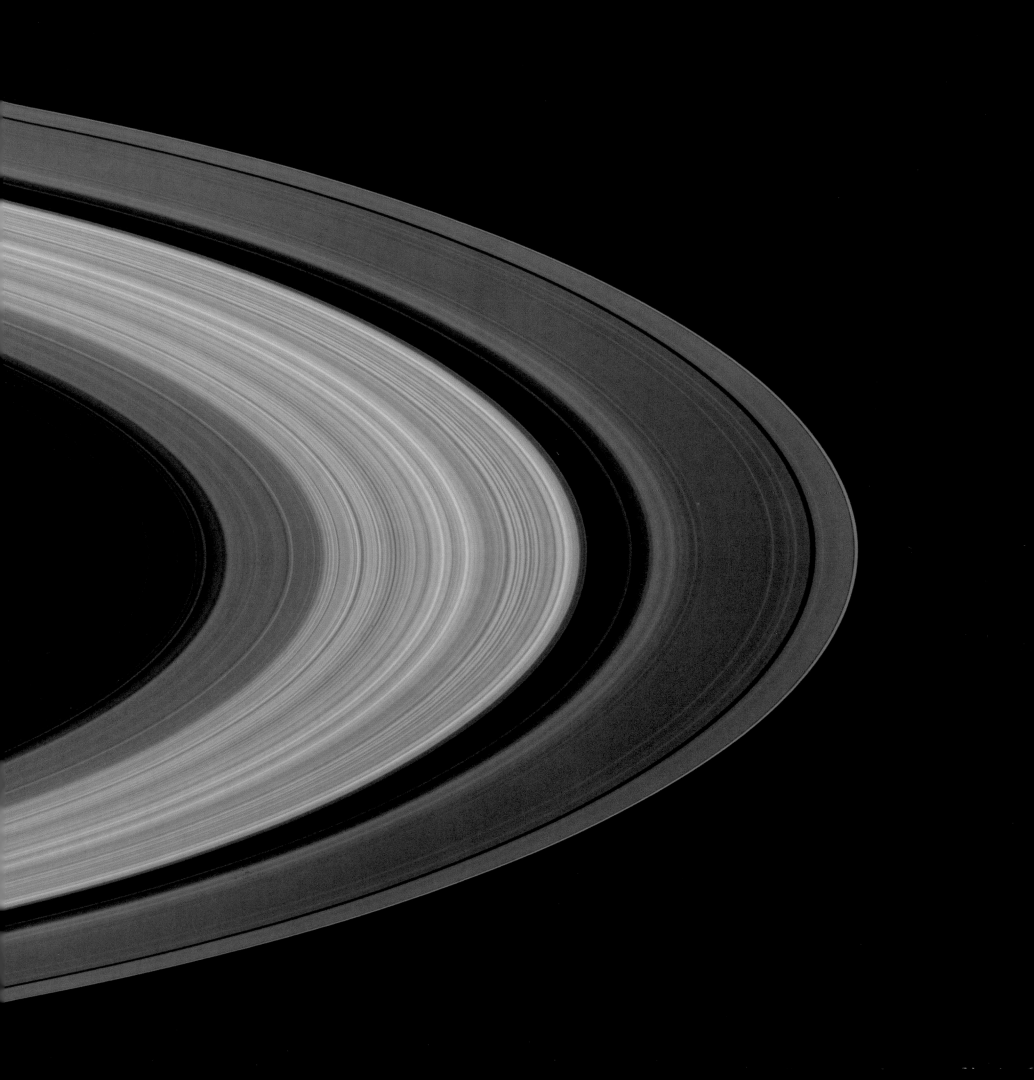

86 When the spacecraft is almost level with the rings, their enormous width diminishes to a narrow ribbon—but their shadows on the planet's northern hemisphere still loom large. The rings dwarf Saturn's moon Tethys.

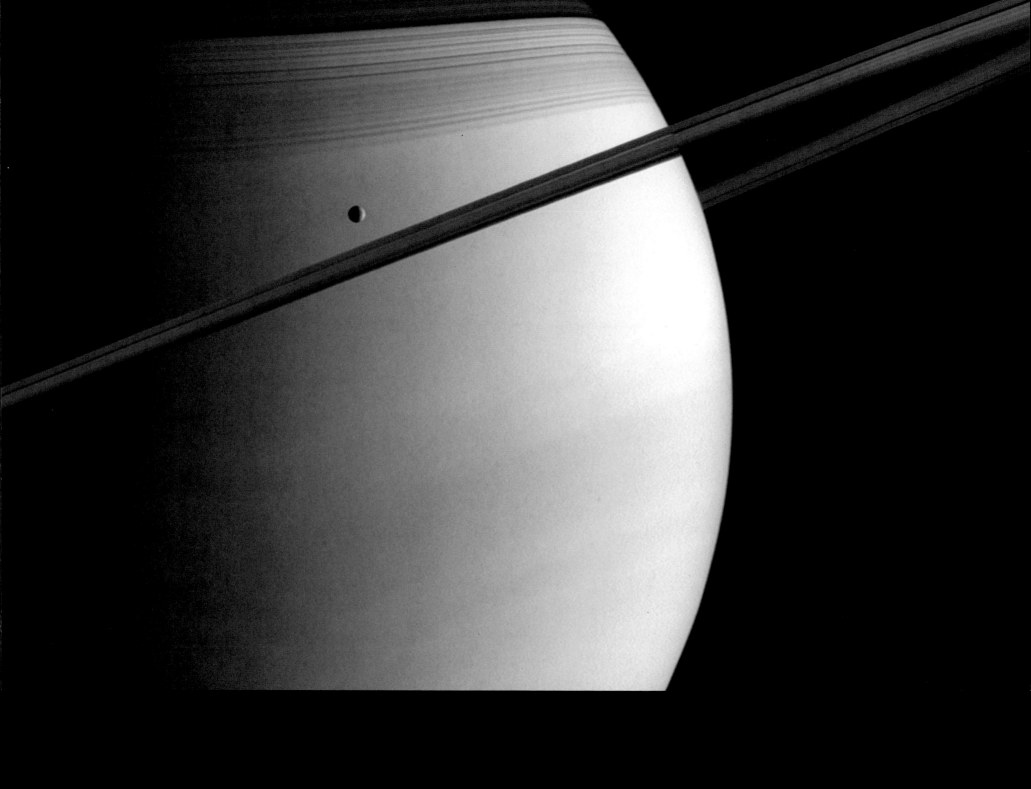

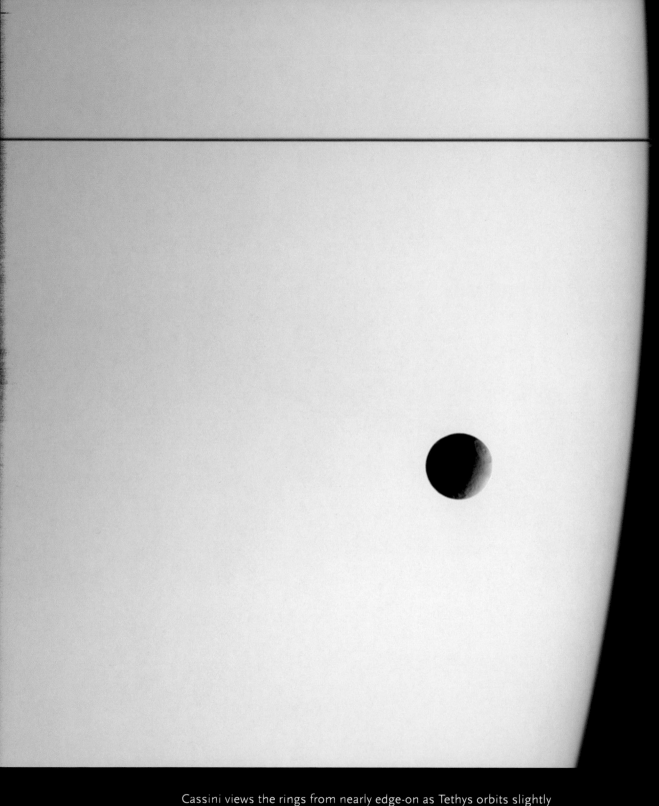

Cassini views the rings from nearly edge-on as Tethys orbits slightly

A close-up view, with Dione passing between Cassini and the rings. In reality,
the rings are even thinner than they appear here—less than 30 m (100 ft).

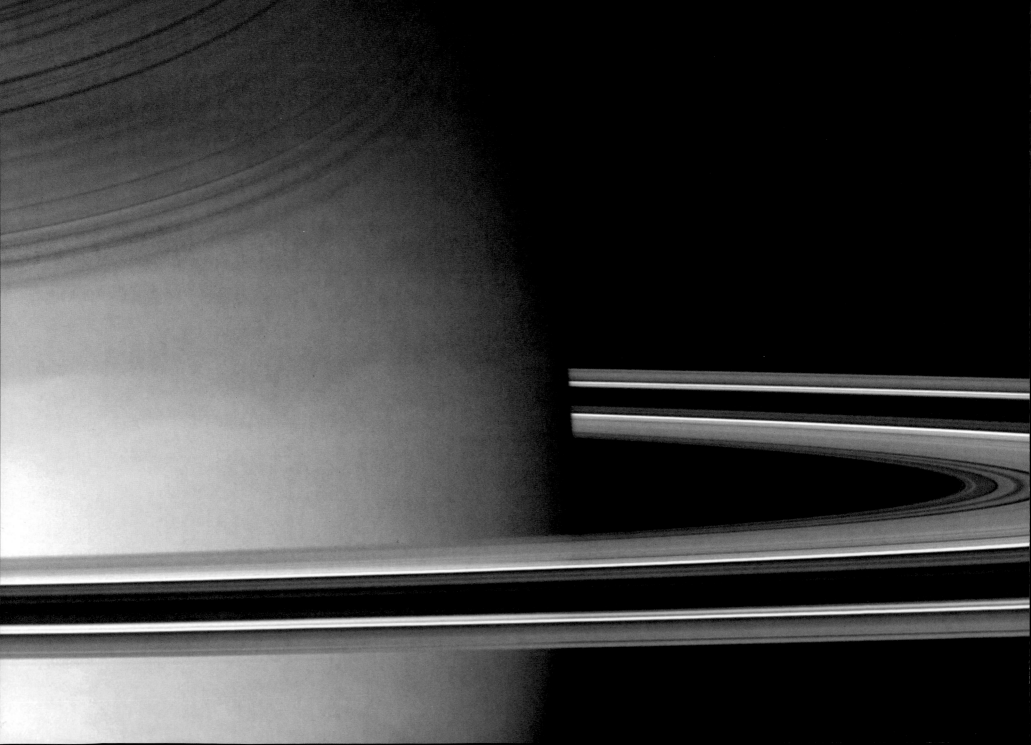

opposite Moving northward, Cassini looks down on the rings' unlit face.
On the unlit side, the dense B ring appears much darker than
the more translucent A and C rings.

following spread Like the lead dividing the panes in a stained-glass window,
dense regions in the B ring block sunlight, while less-dense
regions allow much of the light to shine through. The moon
Mimas is obvious above the rings, and the much smaller ring-
moons Prometheus and Janus are visible to its right. The span
between the inner edge of the C ring and the outer edge of the
A ring is about 62,300 km (38,700 mi), about five times the
size of the Earth.

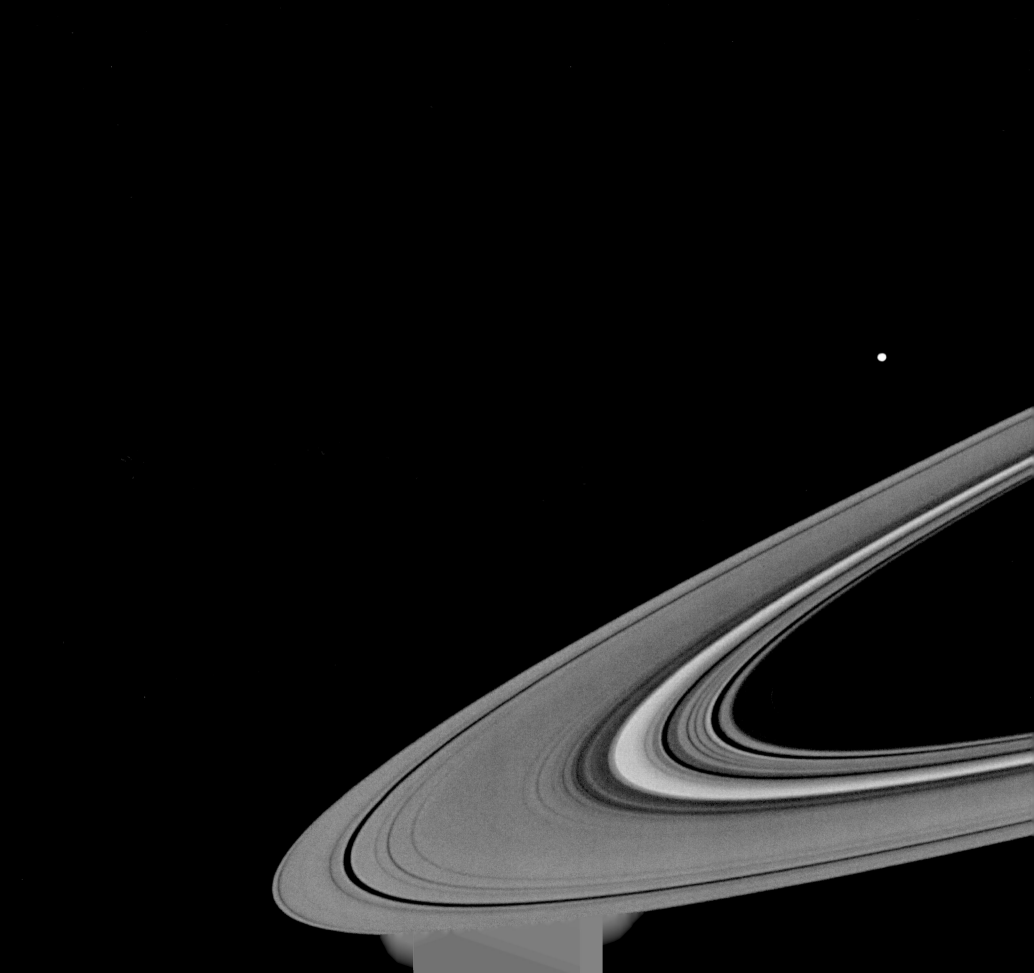

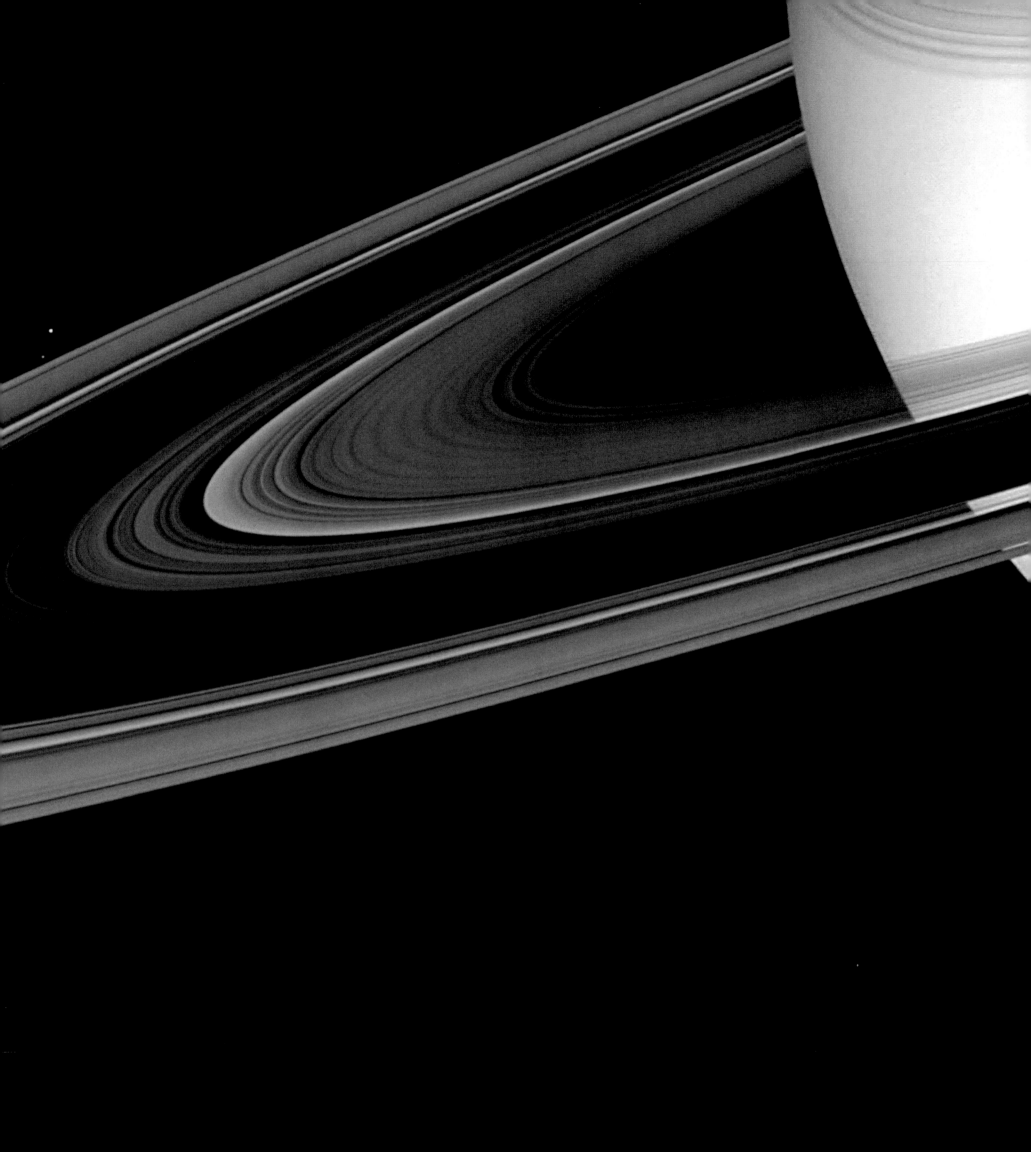

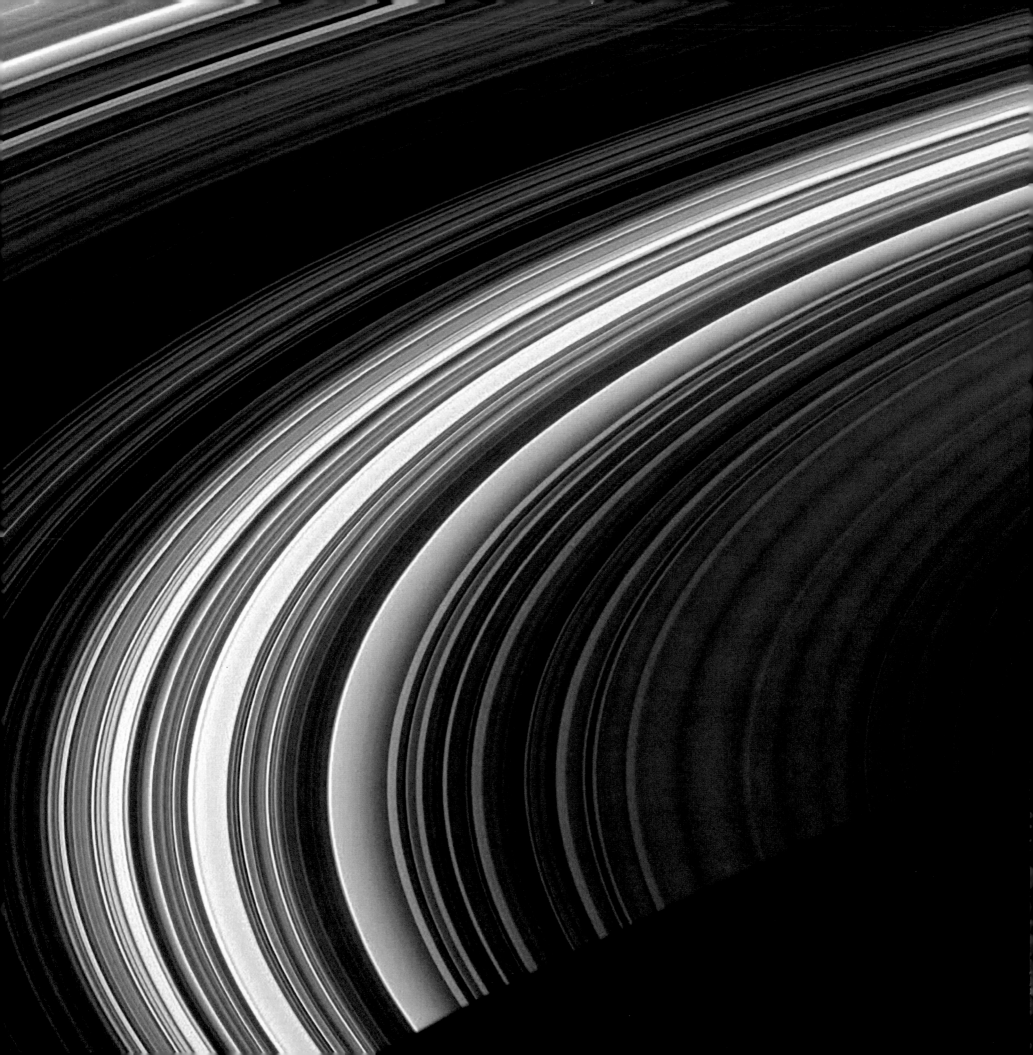

opposite From a vantage point directly above the ring plane, Cassini captured exquisite detail of the unlit side, visible via scattered and transmitted light. With the rings lit from below, gaps and areas of high particle density appear dark (the darkest band is the dense core of the B ring) while regions of lesser particle density appear bright, such as the inner B and outer C rings curving through the center.

following spread The incredible thinness of the rings, given their extent, is striking here, as is Saturn's oval shape caused by its rapid rotation. Scientists have struggled for a century to detect the edge-on rings from Earth, without success.

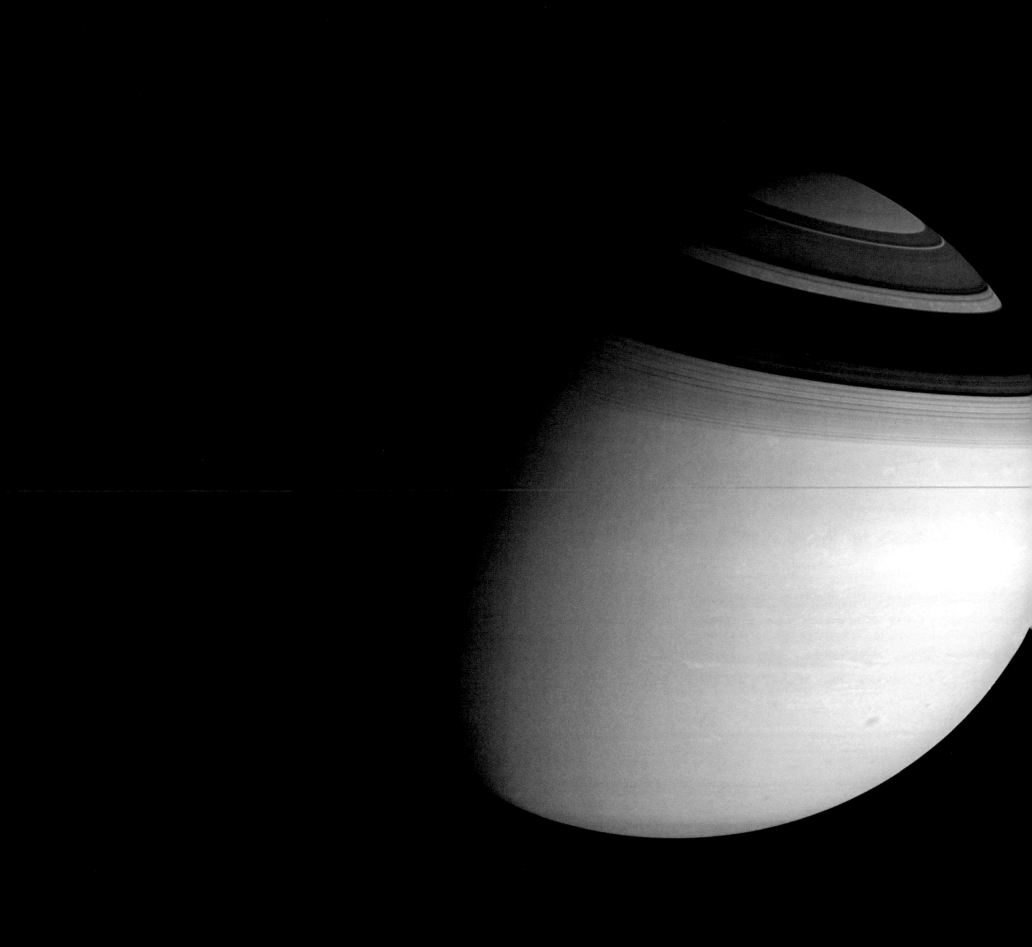

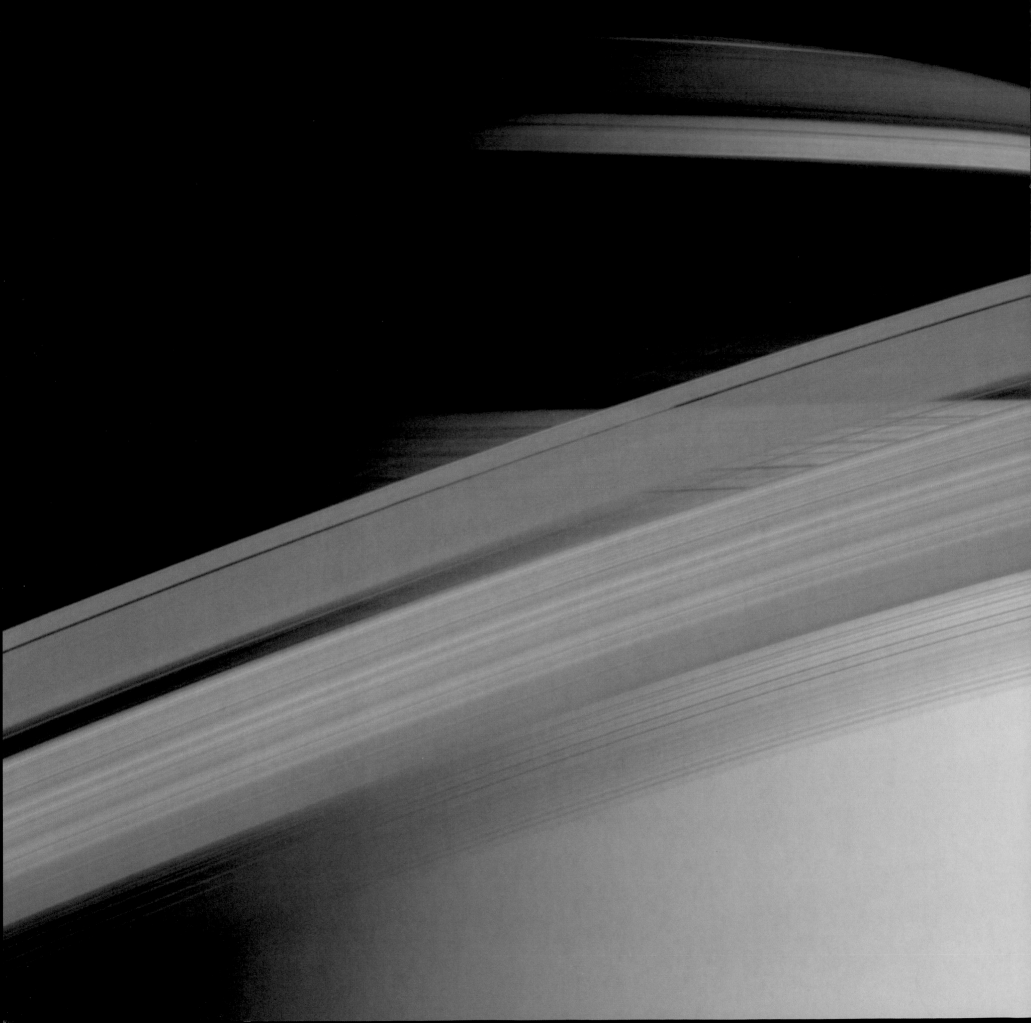

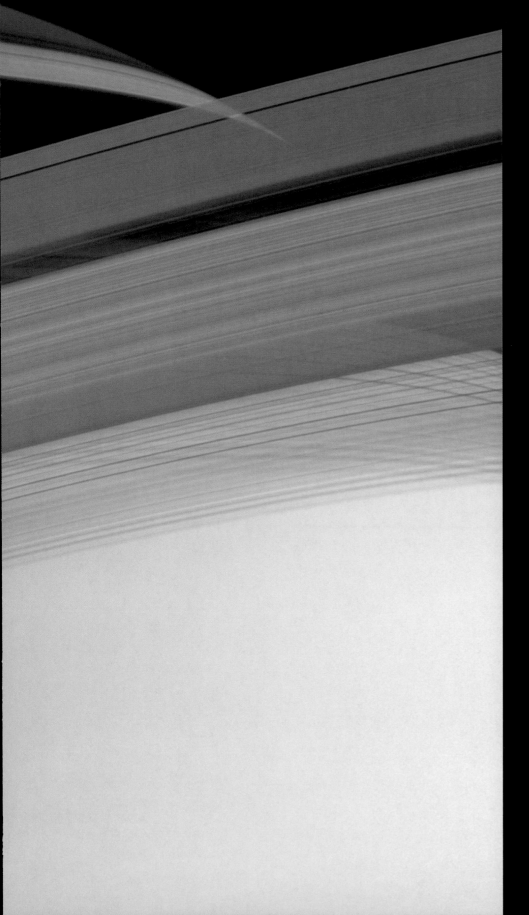

Saturn's axis of rotation is tilted 27 degrees, leaving the planet's north pole in constant darkness during the long years that winter chills the northern hemisphere, just as on Earth. If Cassini is still orbiting Saturn in 2009 when the rings align edge-on to the Sun once more, the spacecraft will be able to photograph a lit north pole.

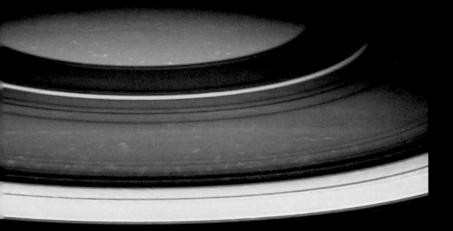

Compared to the planet's warm-toned southern latitudes (right), the north polar region glows a surprising blue (above). This contrasts sharply with Voyager's images of a yellowish planet. Scientists believe that the rings' shadows are cooling the northern latitudes, causing its pale, peach-colored clouds to dissipate and leaving clear blue skies. If the Cassini mission lasts until the Sun again warms the northern hemisphere in 2009, scientists will have a rare chance to watch it change back from cool blue to its familiar peach color.

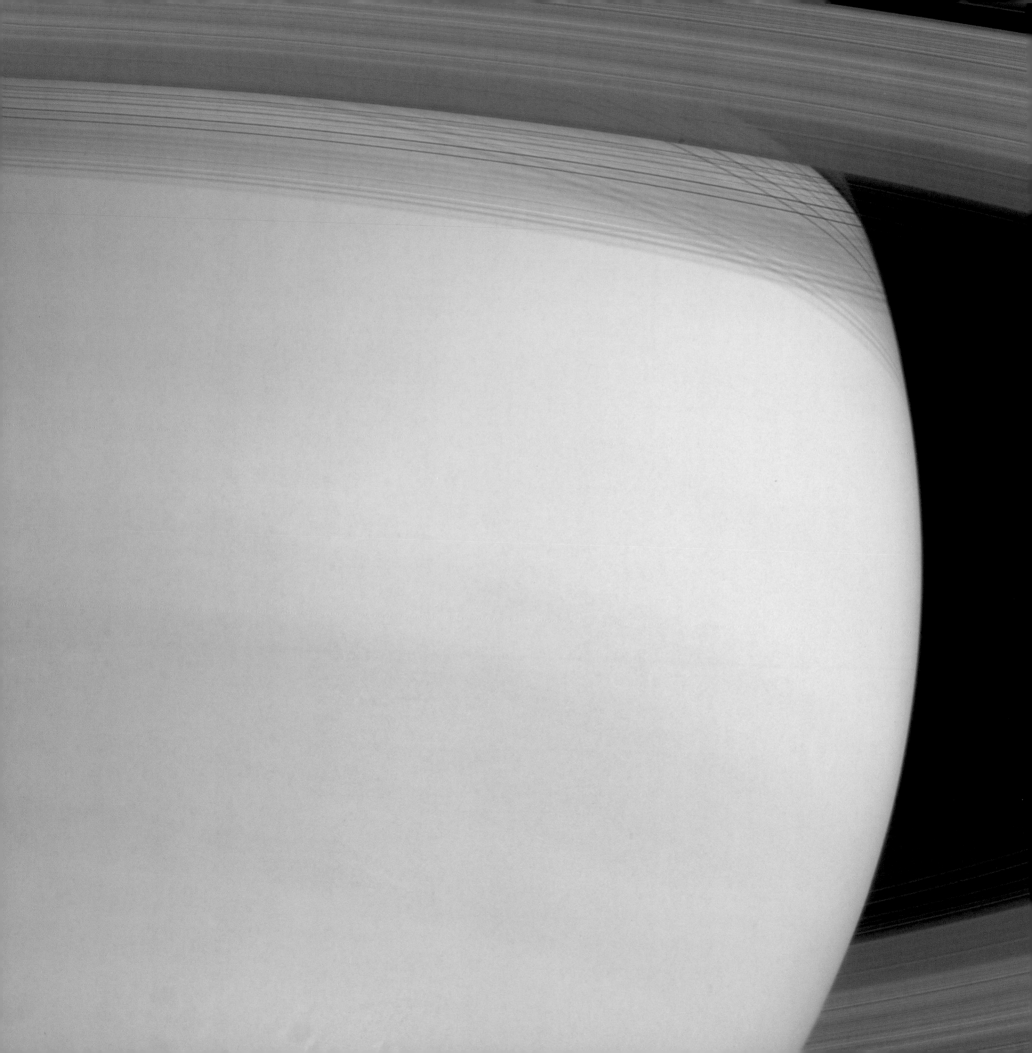

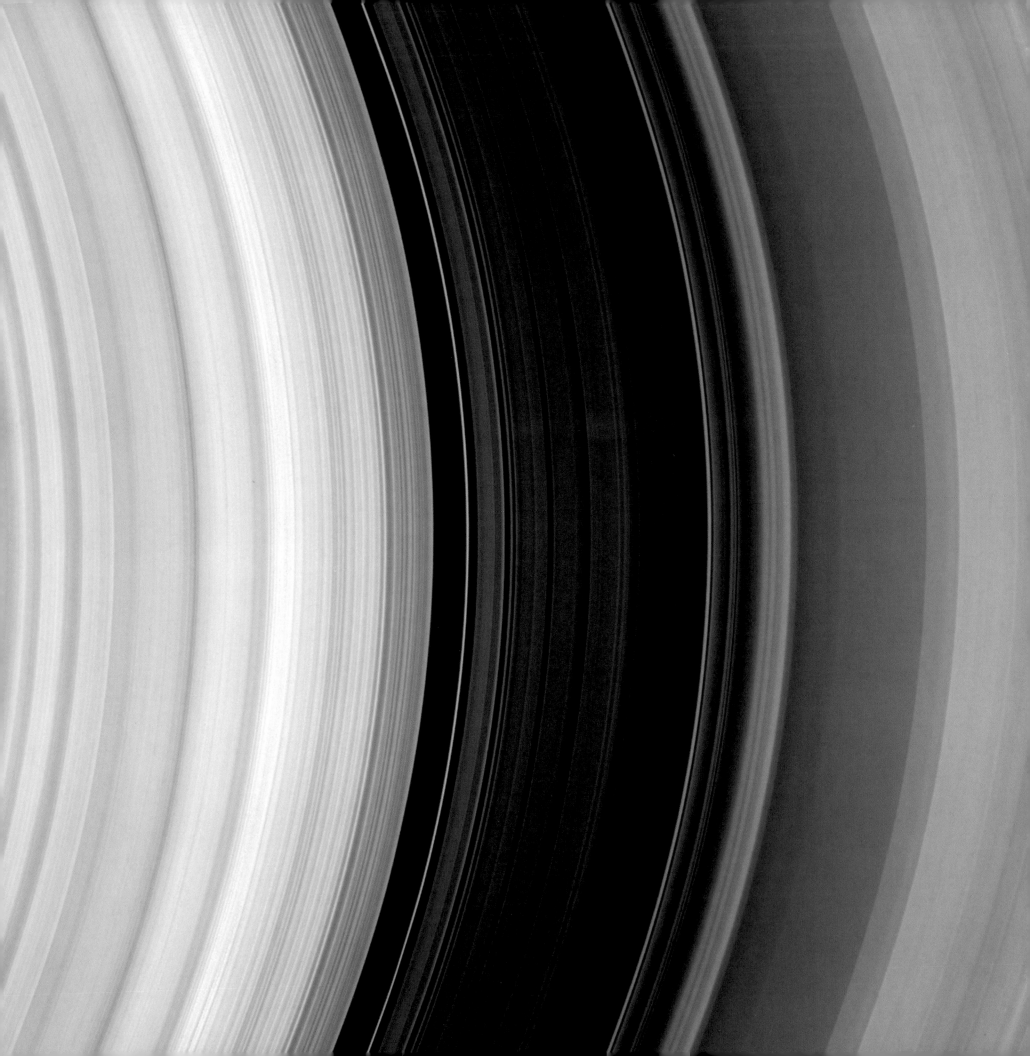

opposite The 3500-km (2100-mi)-wide Cassini Division separates the bright B ring (at left) from the A ring (at right). Once thought to be empty, the division actually contains five bands of dark material in its inner part and a smooth ramp in its outer part. Its particles are darker and less red than particles in the B and A rings on either side.

right The color difference between the icy moon Enceladus and the icy A and B rings is clearly discernible in this natural-color image.

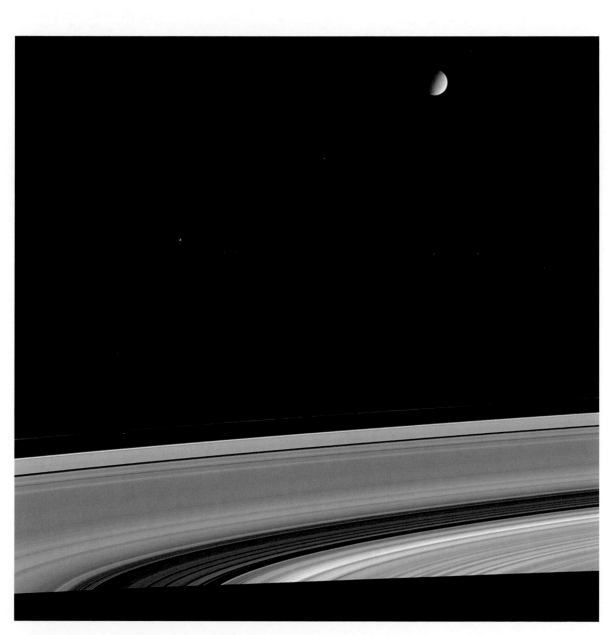

following spread Crisply defined jet streams circle the planet, made visible here by using a methane filter. Areas with the least methane, such as high cloud layers and the rings, appear brighter, while latitudes with deeper clouds are darker. Winds in the equatorial jet streams can reach velocities of 500 meters per second (1120 mph), five times as fast as the fastest winds on Earth.

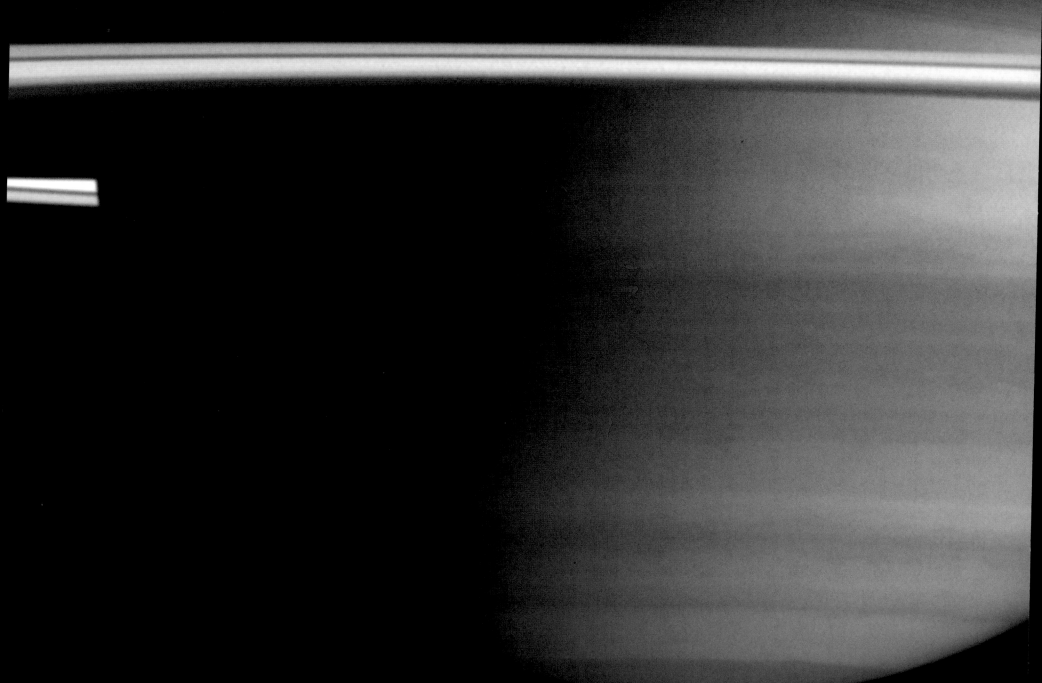

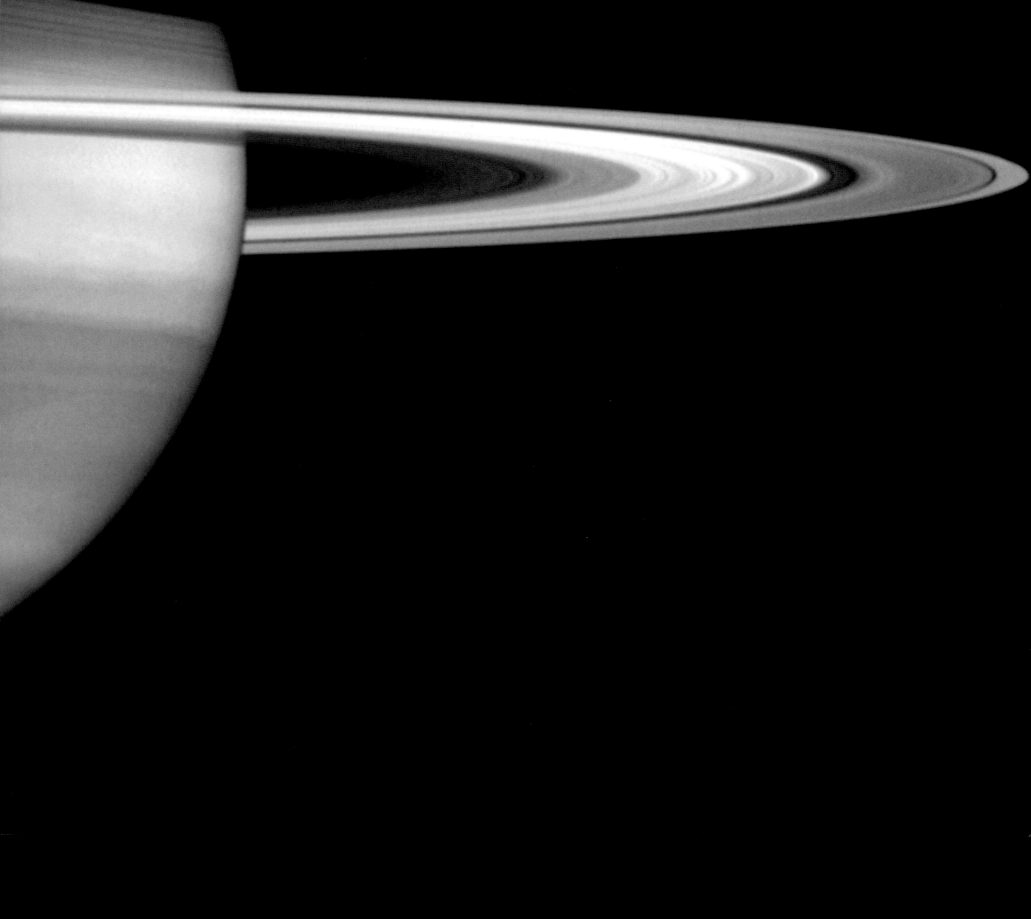

106 *opposite* Subtle colors, hinting at complex chemistry, play across the rings in this natural-color image. Water ice should be white, but varying degrees of reddish color (particularly in the A and B rings) indicate the presence of other materials which may have been there since the rings' formation or been deposited at a later time.

following spread Cassini's camera captured striking detail in this close-up of the outer portion of the A ring with the multi-stranded F ring on the right. The A ring's Encke Gap contains several clumpy, dusty ringlets, and at least one embedded moonlet—Pan— here seen as the bright dot in the gap toward the upper left. Cassini has shown that another moonlet orbits in the narrow Keeler Gap near the A ring's outer edge. The F ring's companion moon, Prometheus, can be seen just inside the ring, at the lower right.

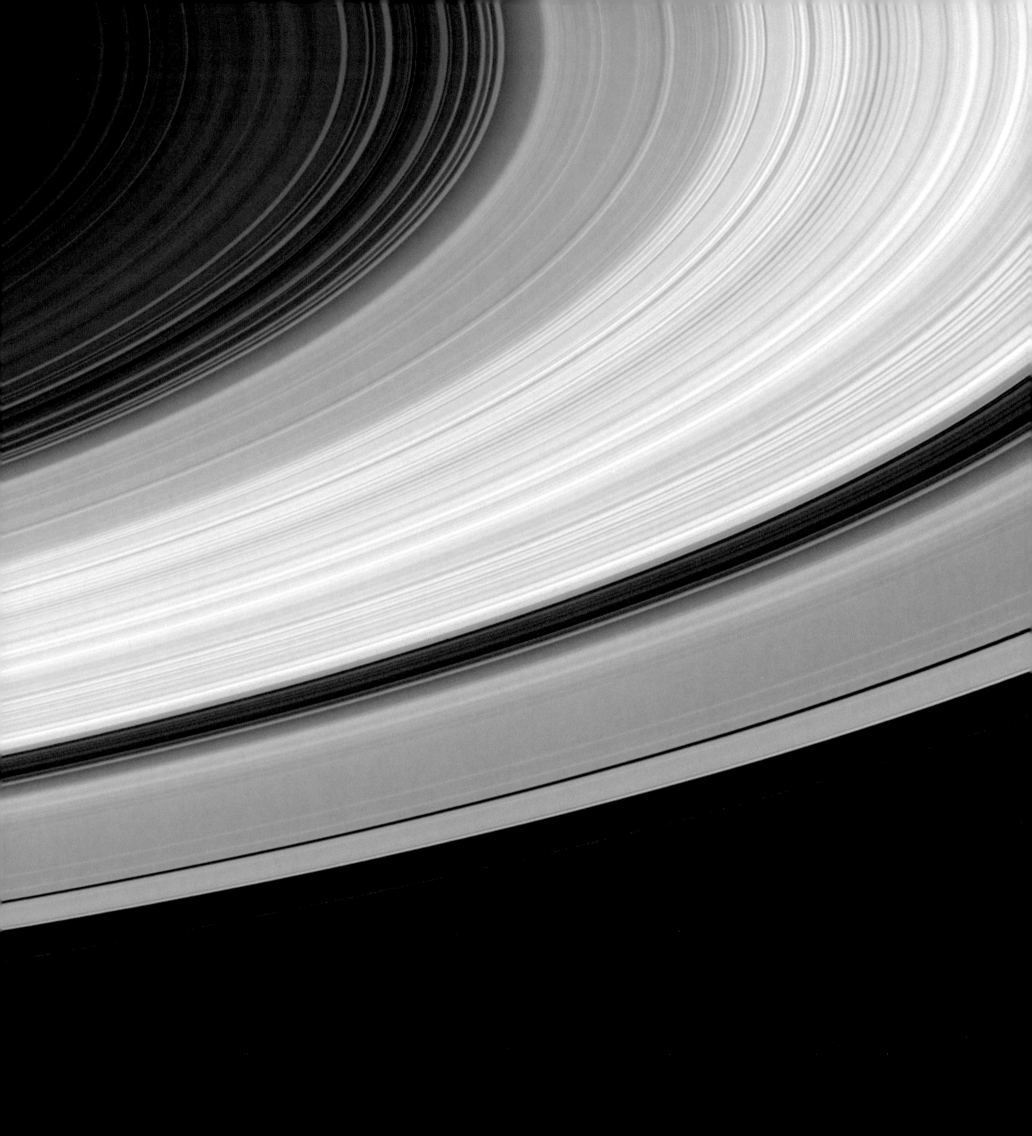

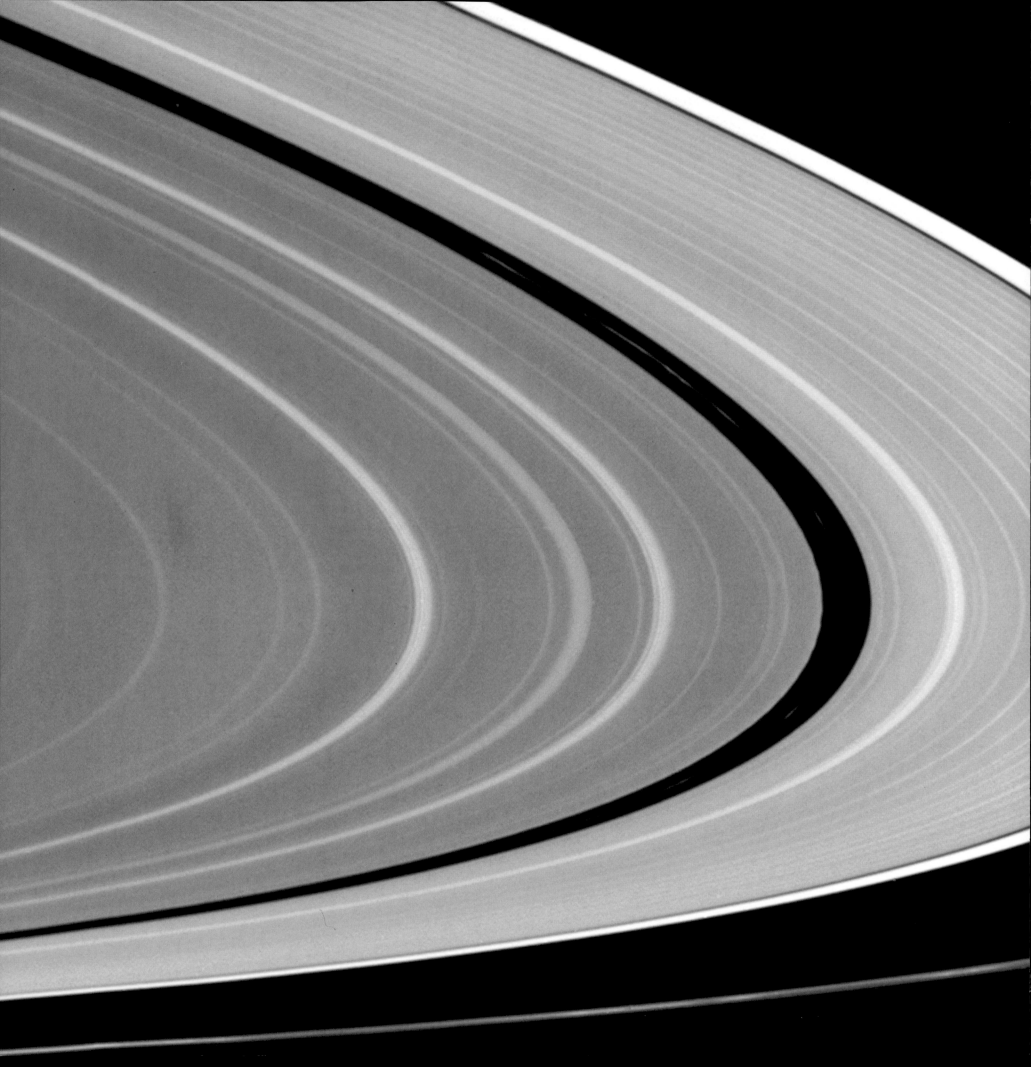

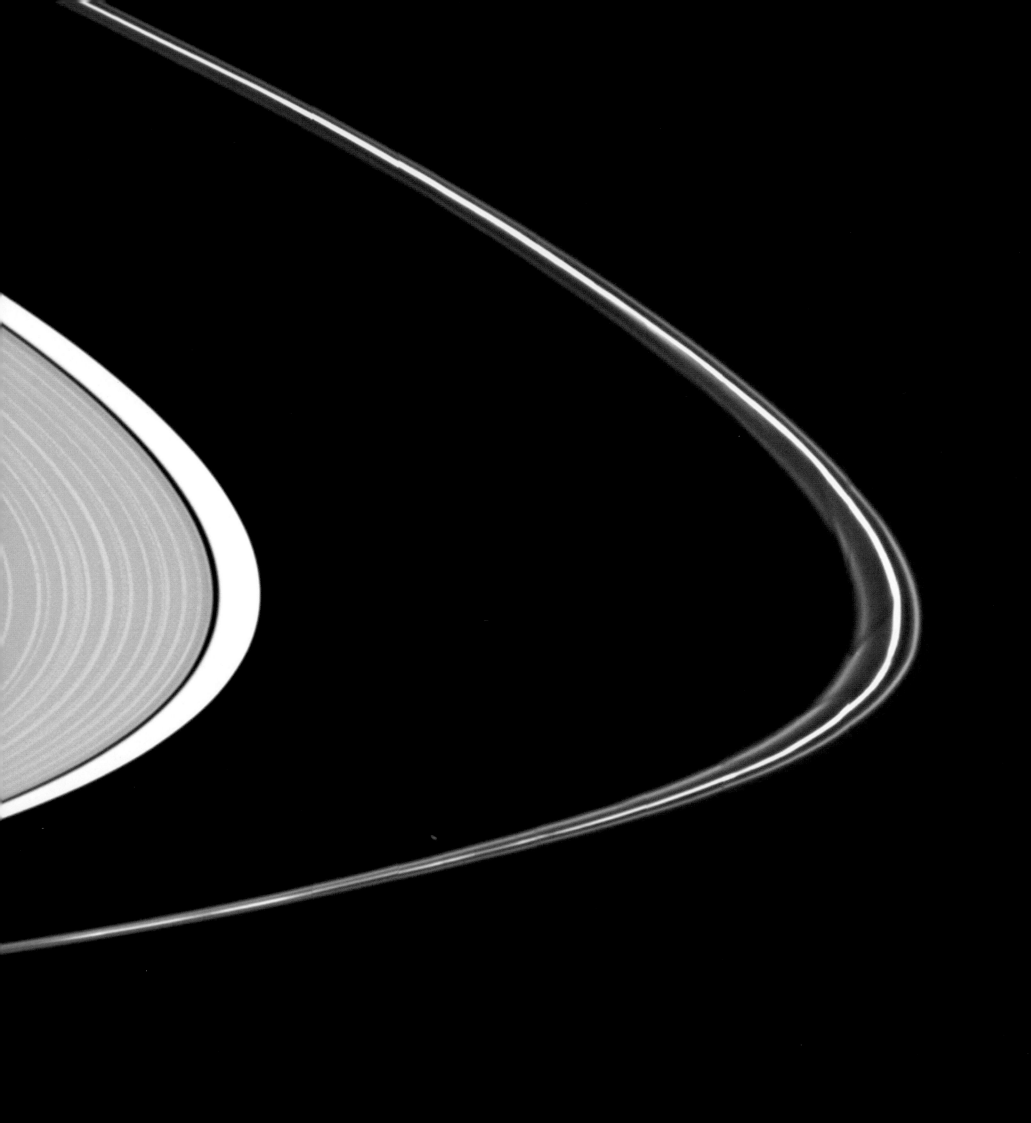

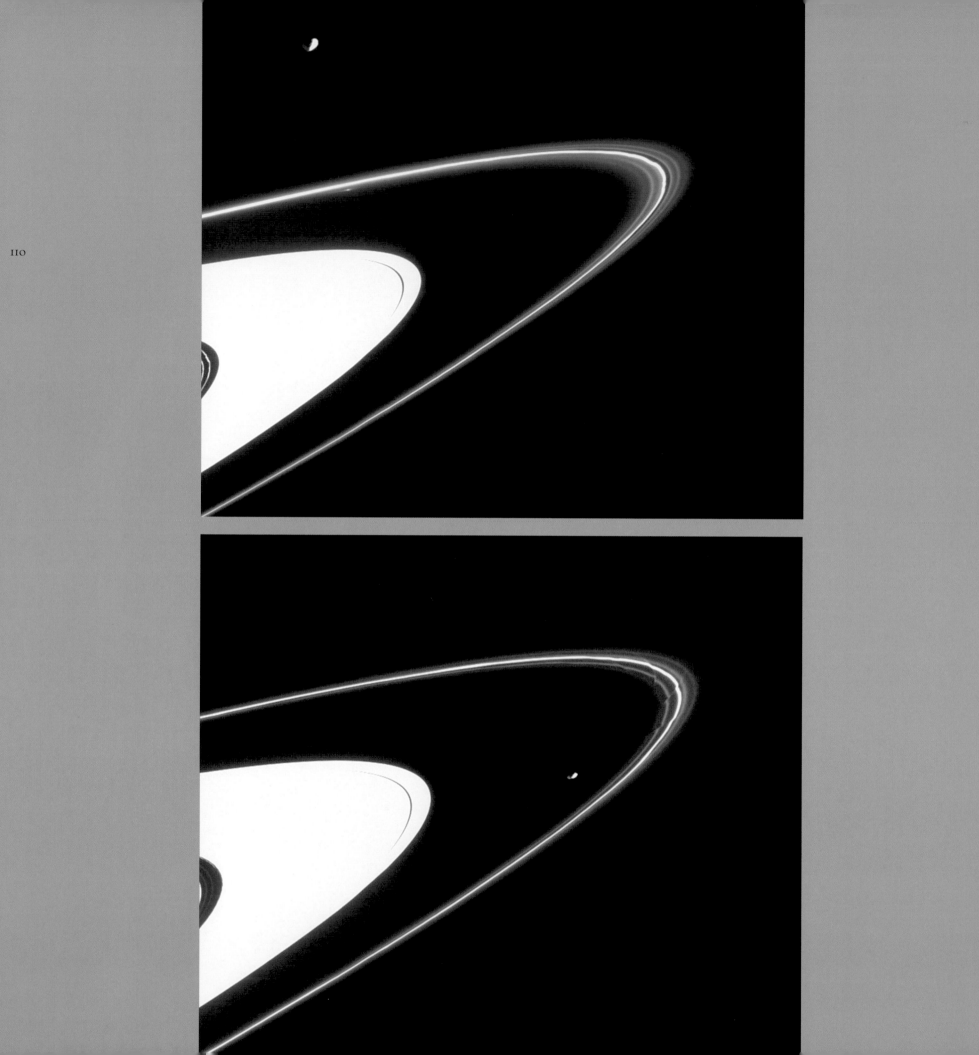

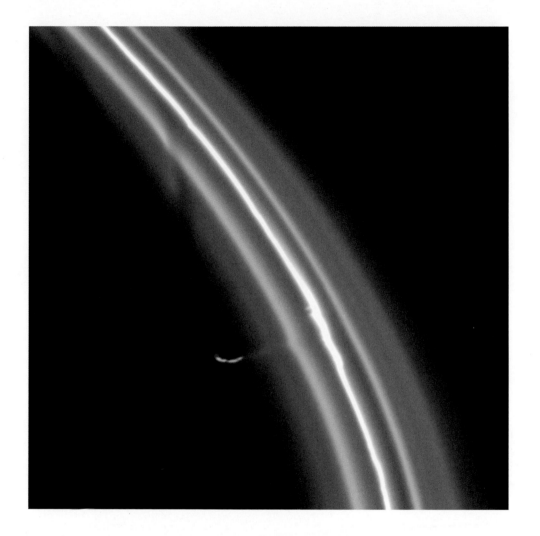

opposite In the upper panel, the multi-stranded F ring flows smoothly (although a short-lived clump of material has just formed in its inner regions at the left). Just hours later (lower panel), Prometheus, orbiting clockwise, creates "drapes" in the ring by disturbing the orbits of its particles. Prometheus and the F ring approach and recede from each other as they orbit Saturn, and these drape structures open and close in tandem.

above When Prometheus (seen here as a thin crescent) moves closer to the F ring, the drapes take a new form—"emptied channels" (top of image). In addition, the moon has apparently torn a strand of material from the ring.

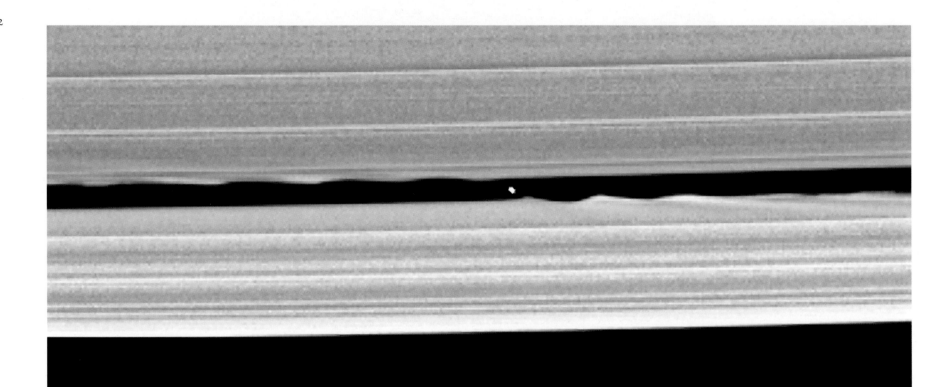

above Suspecting that it might contain an embedded moon, scientists trained Cassini's camera on the 30-km (20-mi)-wide Keeler Gap in the outer A ring to reveal the moonlet Daphnis. This tiny moon keeps the gap open while stirring up waves in neighboring ring particles. From the size of the waves in the Encke Gap, imaging scientists were able to estimate the mass of Pan, a technique they hope to use with this new moon.

opposite The 325-km (200-mi)-wide Encke Gap (the dark diagonal band) has scalloped edges similar to those of the Keeler Gap. The waves, seen by Voyager, led to the discovery of an embedded moonlet, Pan, visible at the center of this image. The Keeler Gap is very close to the outer edge of the A ring.

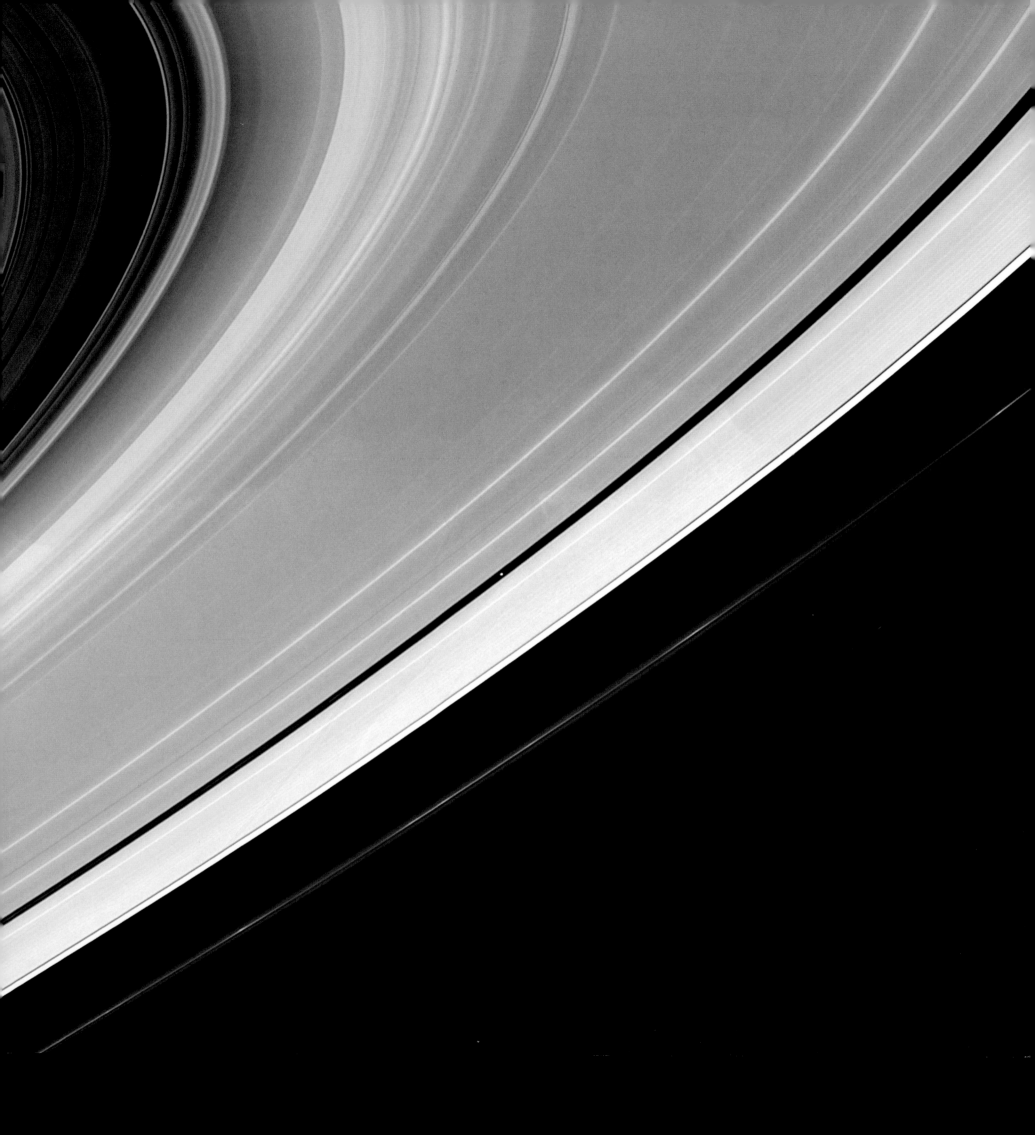

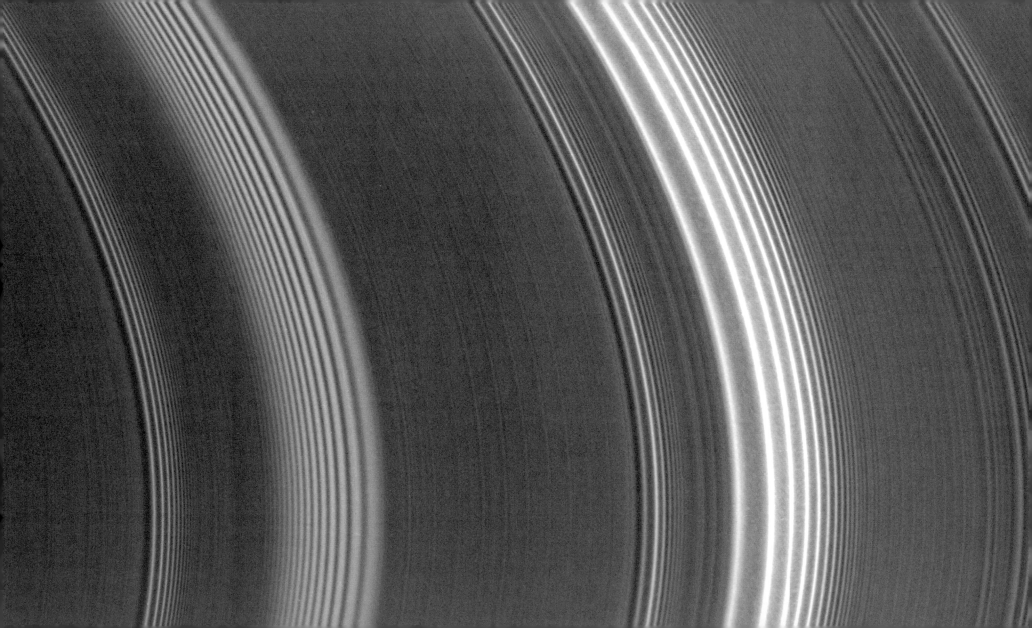

An extraordinary close-up of the A ring, taken right after Cassini arrived at Saturn, shows a series of spiral density waves (with spacing decreasing outwards) and one spiral bending or vertical flapping wave (with spacing decreasing inwards). It also shows the wavy edges and "wake" which precede the moonlet Pan on its rounds of the Encke Gap.

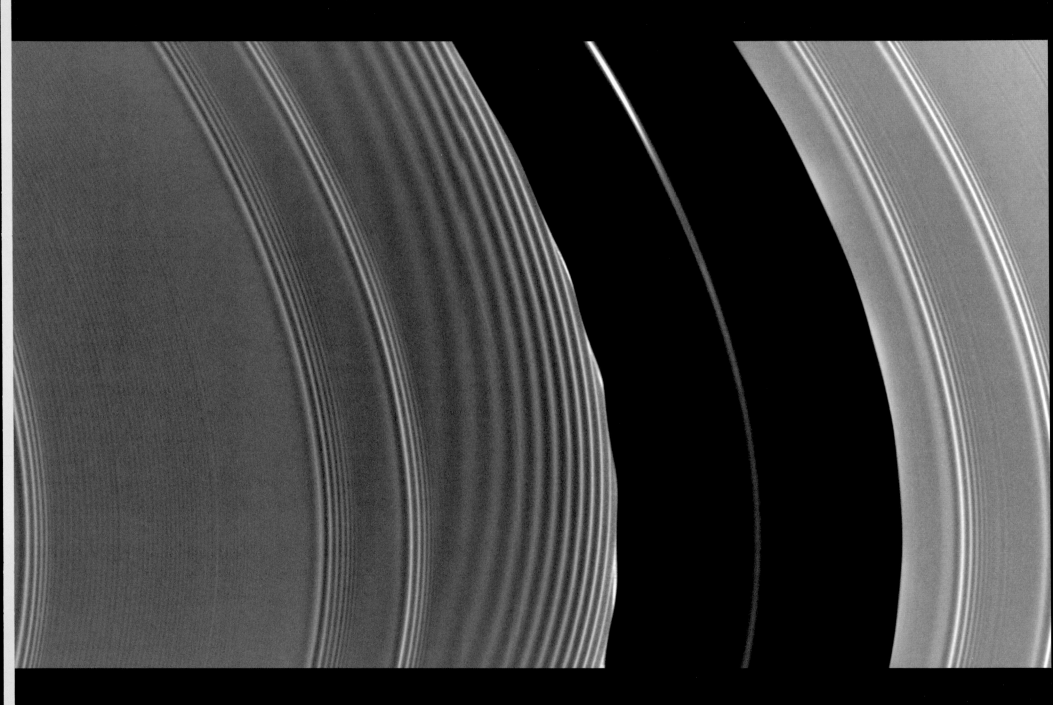

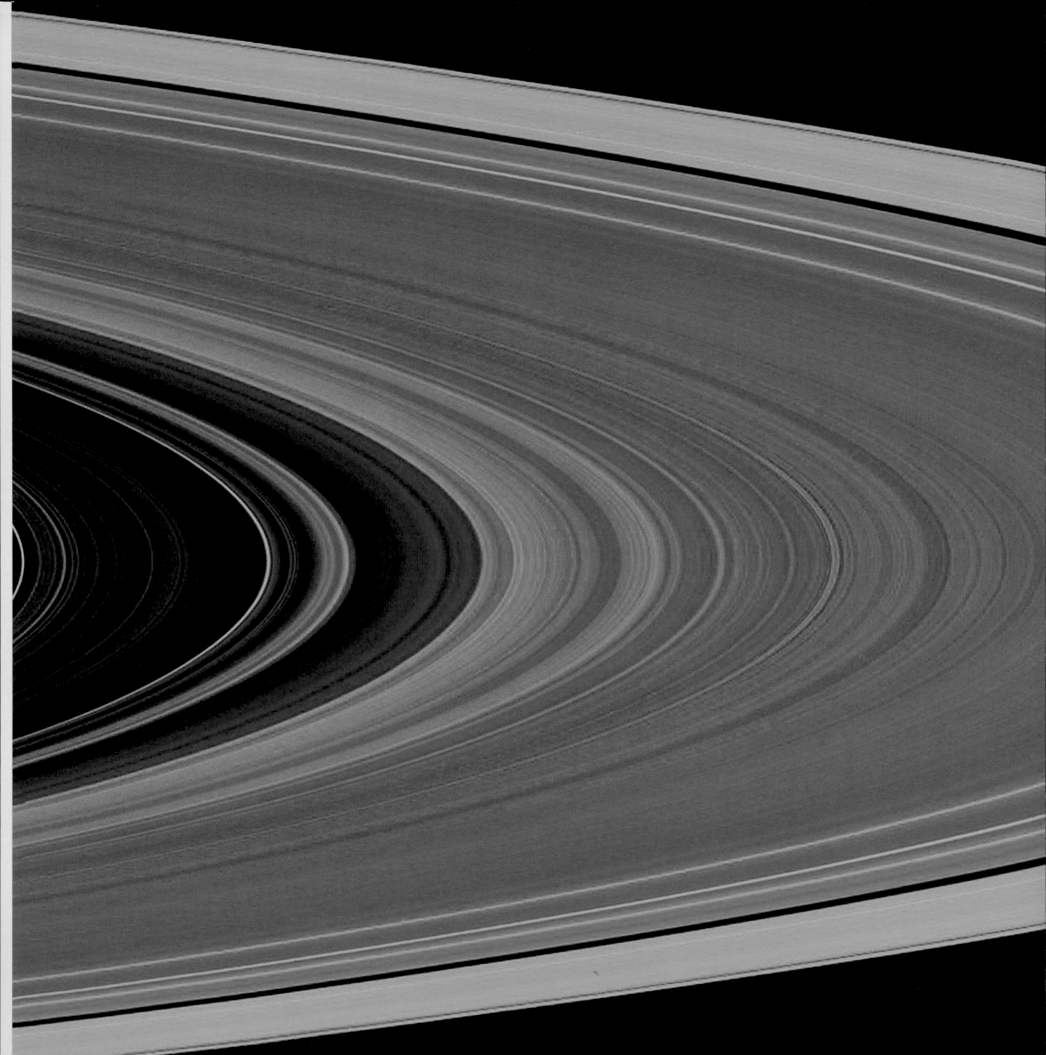

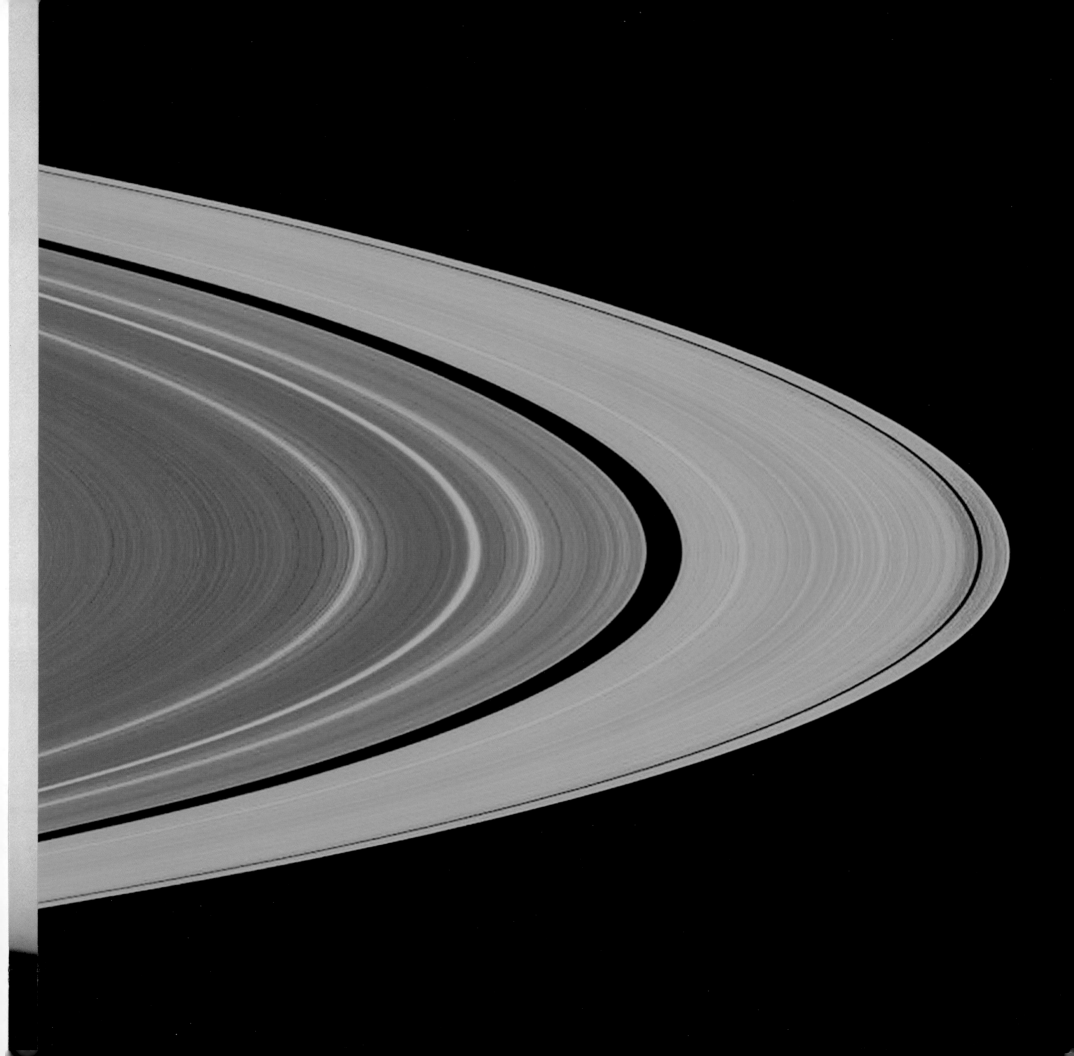

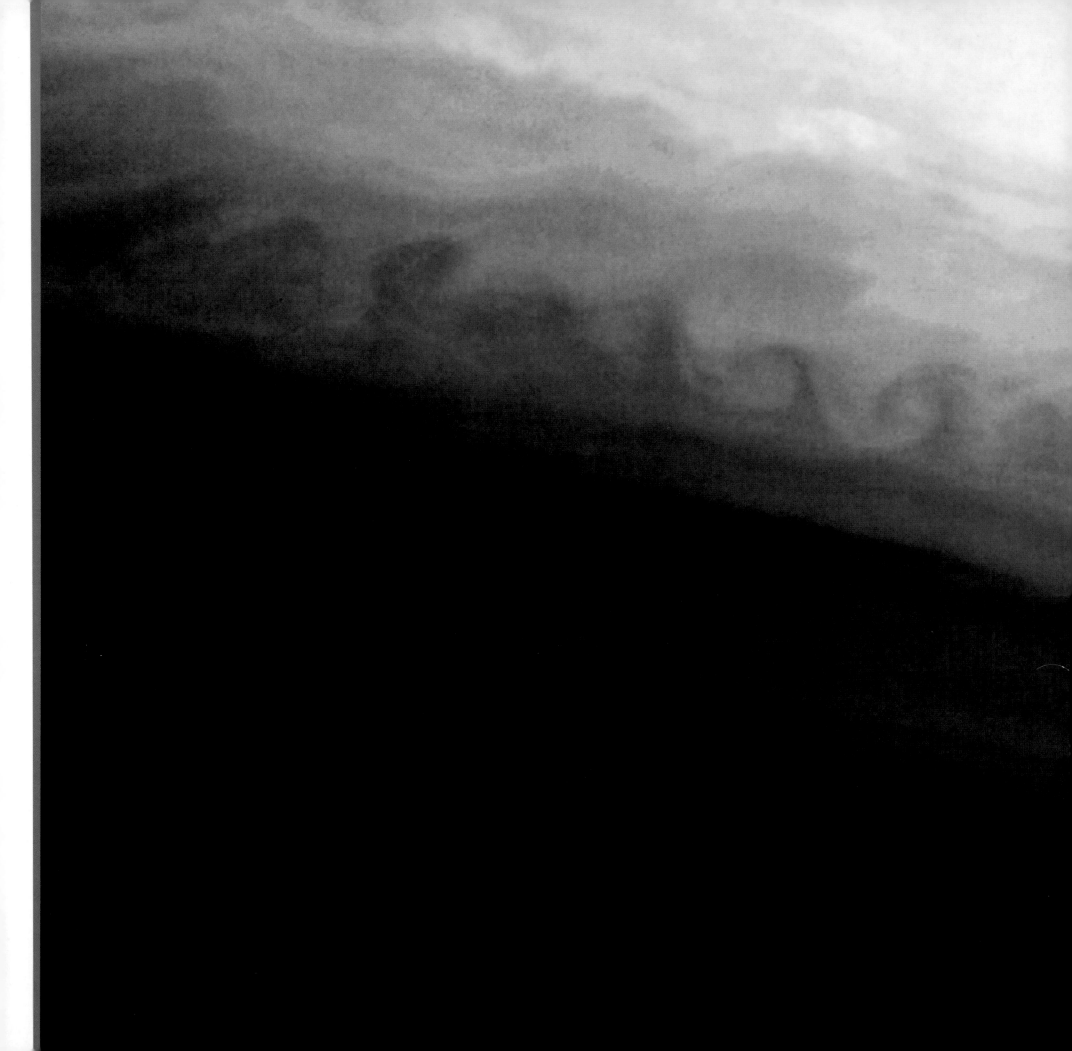

Much like waves stirred by wind blowing across the ocean's surface, huge waves 4,000 km (2,500 mi) across curl and break along bands moving at different speeds in Saturn's atmosphere. Wind shear between bands also generates the oval storms that come and go on Saturn.

These natural-color views show how Saturn's largest moon, Titan, would look to the human eye: a hazy globe shrouded in a thick, orange, hydrocarbon haze. Voyager couldn't see through this haze to the moon's surface. A closer view (right) reveals multiple layers of very fine particles high above Titan's main atmosphere.

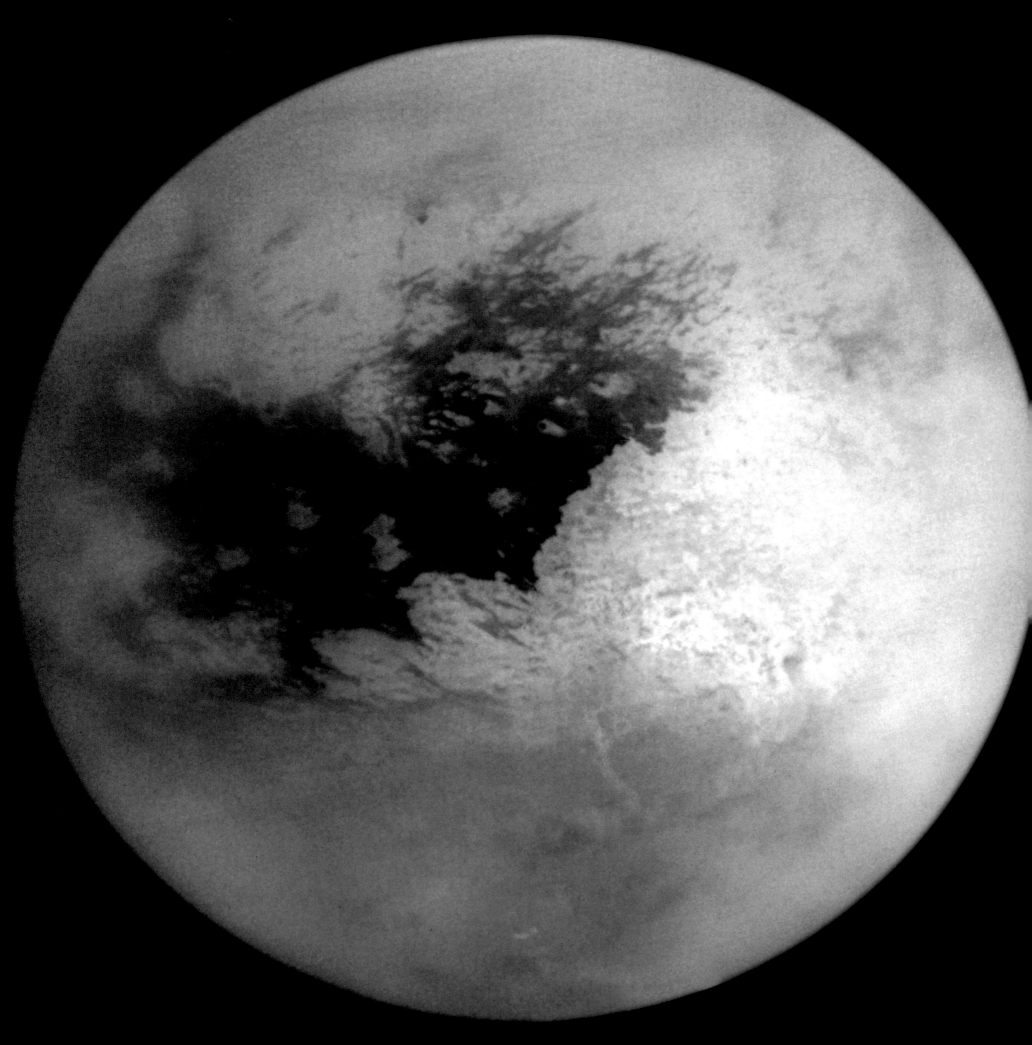

opposite This mosaic of Titan's surface was taken in near-infrared light, which penetrates the haze and reveals a surface of bright, rugged highlands and dark, smooth lowlands containing flow-like streaks.

right The long wavelengths of Cassini's radar instrument penetrate Titan's hazy atmosphere, providing radar "images" of the surface at high resolution. The images reveal river-like channels over 160 km (100 mi) long (top) and craters like this large one 440 km (270 mi) across (bottom). This crater can also be glimpsed faintly in the image at left, near Titan's right limb.

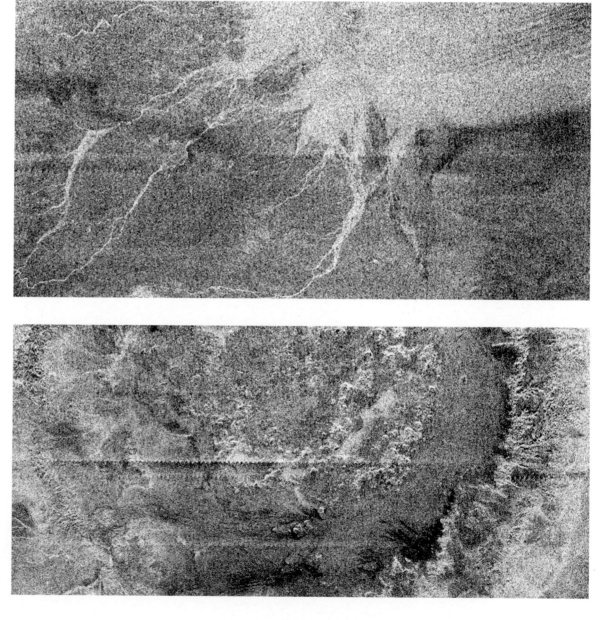

following spread Titan's planet-wide stratospheric haze, seen from the night side backlit by the Sun, is highlighted by tiny particles in the haze layer. Different colors in the large false-color image indicate different-sized particles. The unlit north pole nods towards the spacecraft, at about 11 o'clock. The inset image, taken the same way, shows distinct double haze layers over the north polar region.

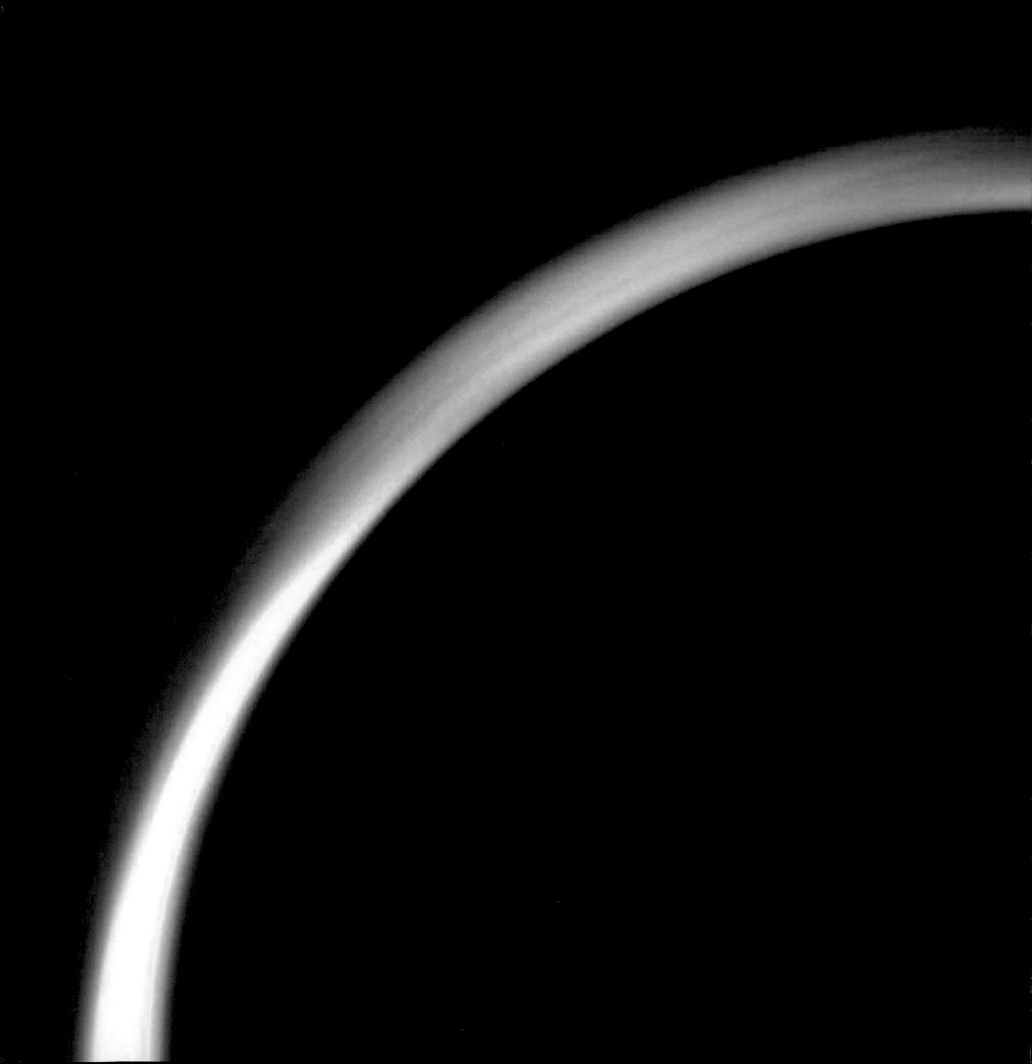

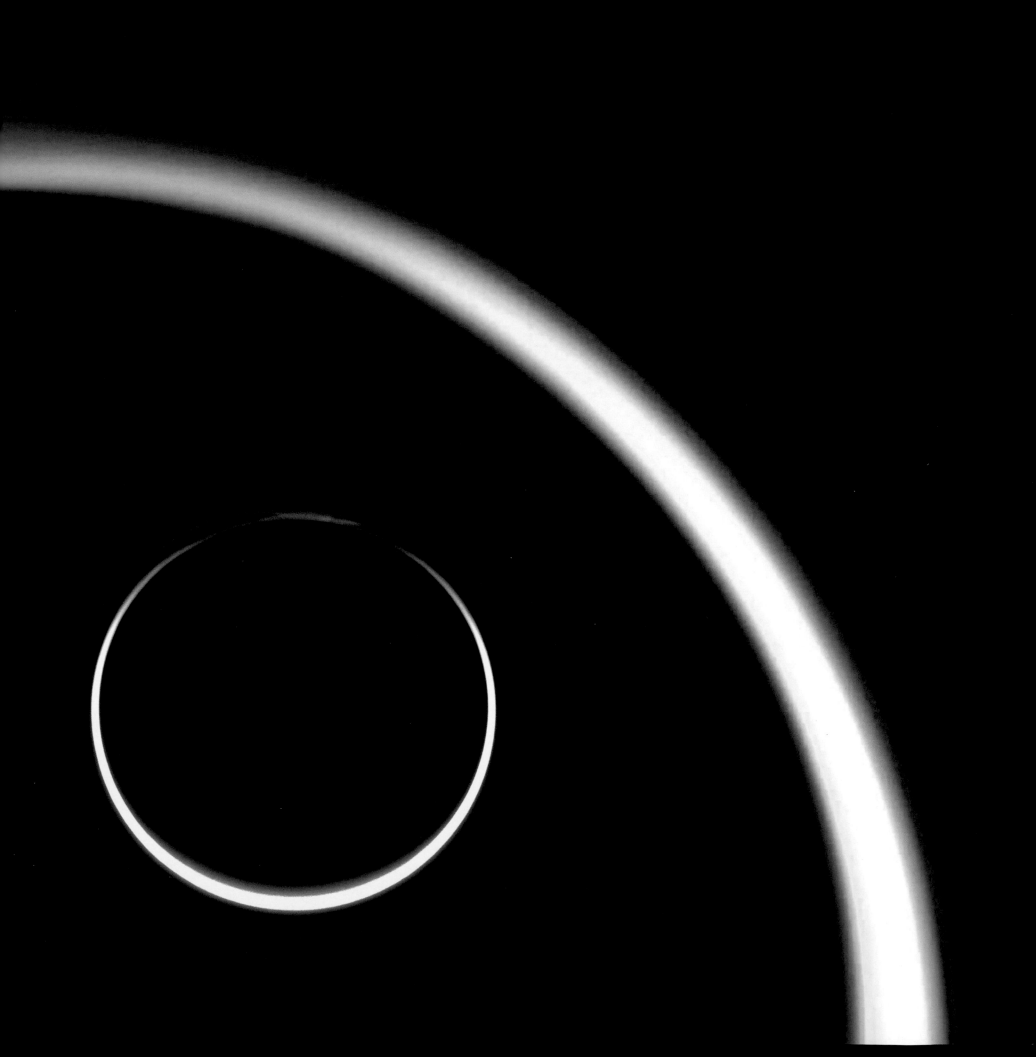

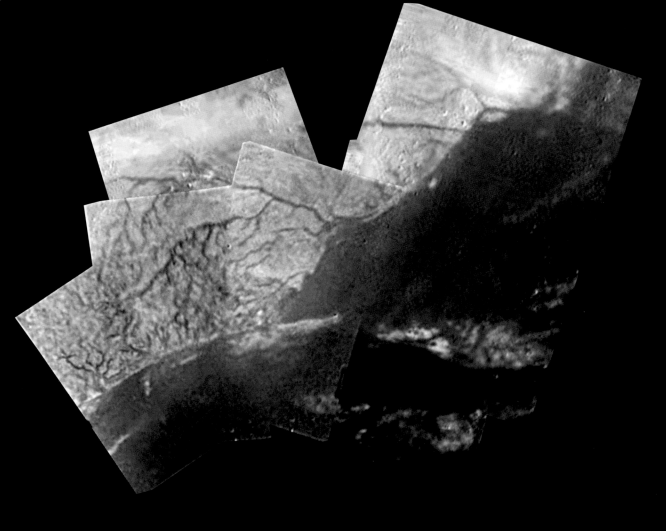

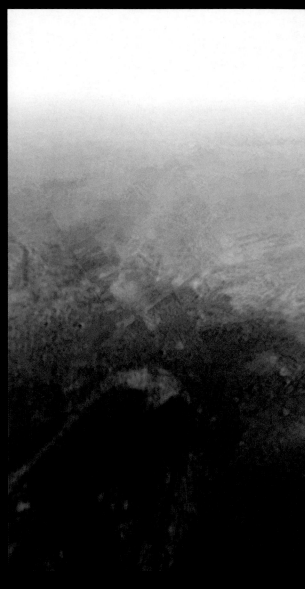

The Huygens probe sent us humanity's first views of
riverbeds carving through the lowlands of another world.
This detail of Titan's surface near the probe's landing site
was taken during descent at around 16 km (10 mi).

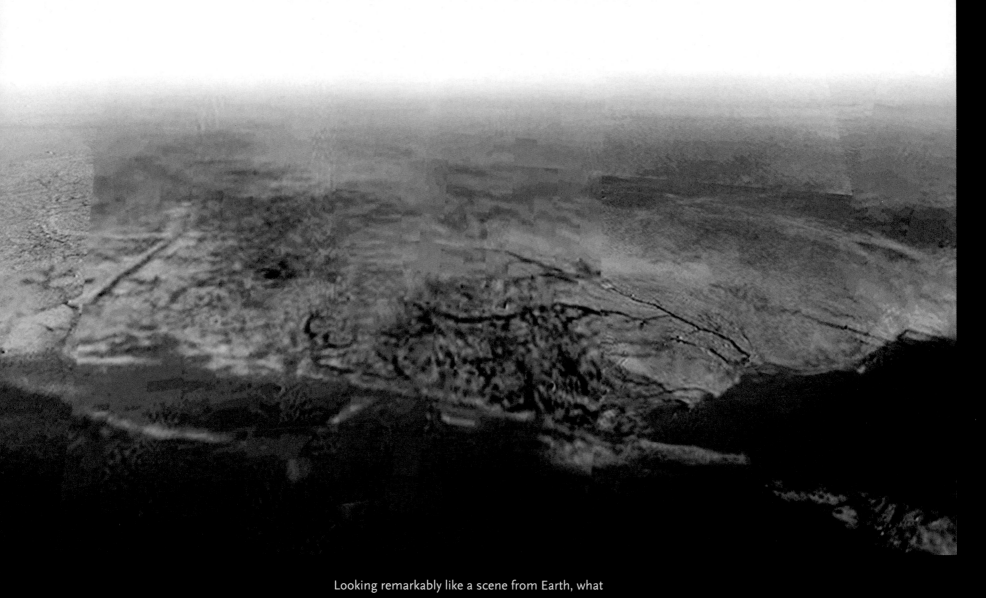

Looking remarkably like a scene from Earth, what
appeared to be rivers flowing into a frigid lake of unknown
liquids came into focus as Huygens descended toward
Titan's surface. Images and data from other instruments
have subsequently told us that the flat lowlands aren't
liquid surfaces after all.

right Touchdown! This first view from the sur-
face of another planet's moon shows that
our ambassador ended its mission in what
looks like a dry riverbed. The chunk of ice in
the foreground at left center is about half
the size of an American football. All the ice
chunks are rounded, perhaps from being
tumbled in the stream when it is active. As
the probe gathered data, it was enveloped
in methane vapor, evaporated by its warmth
from the surface on which it sat.

opposite Approaching its landing site (the small
circle, 2.5 km or 1.5 mi across), Huygens
took the images assembled in this pano-
ramic mosaic. Terrain shown on the previ-
ous pages, with its bright hills and river
channels, can be seen at upper left. To
lower right is a shadowy, mysterious
region, apparently composed of dark hills
with interspersed flat, dark, lowlands.
The probe's path of descent appears as
a series of white X's.

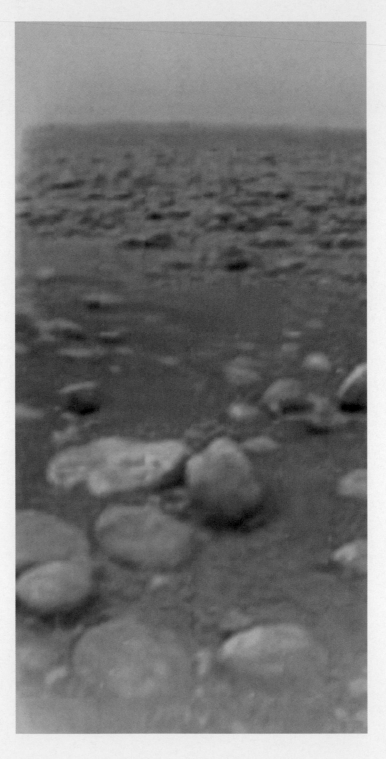

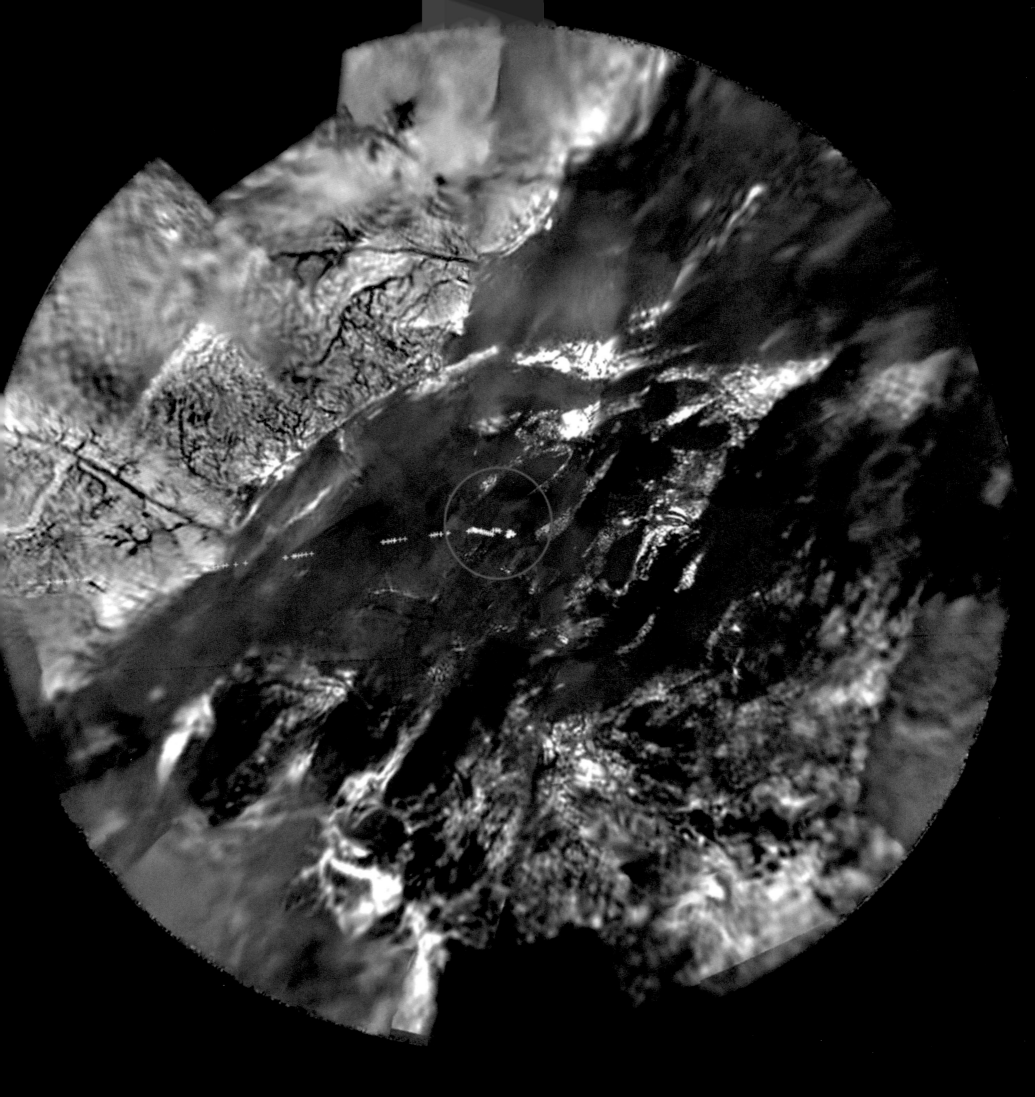

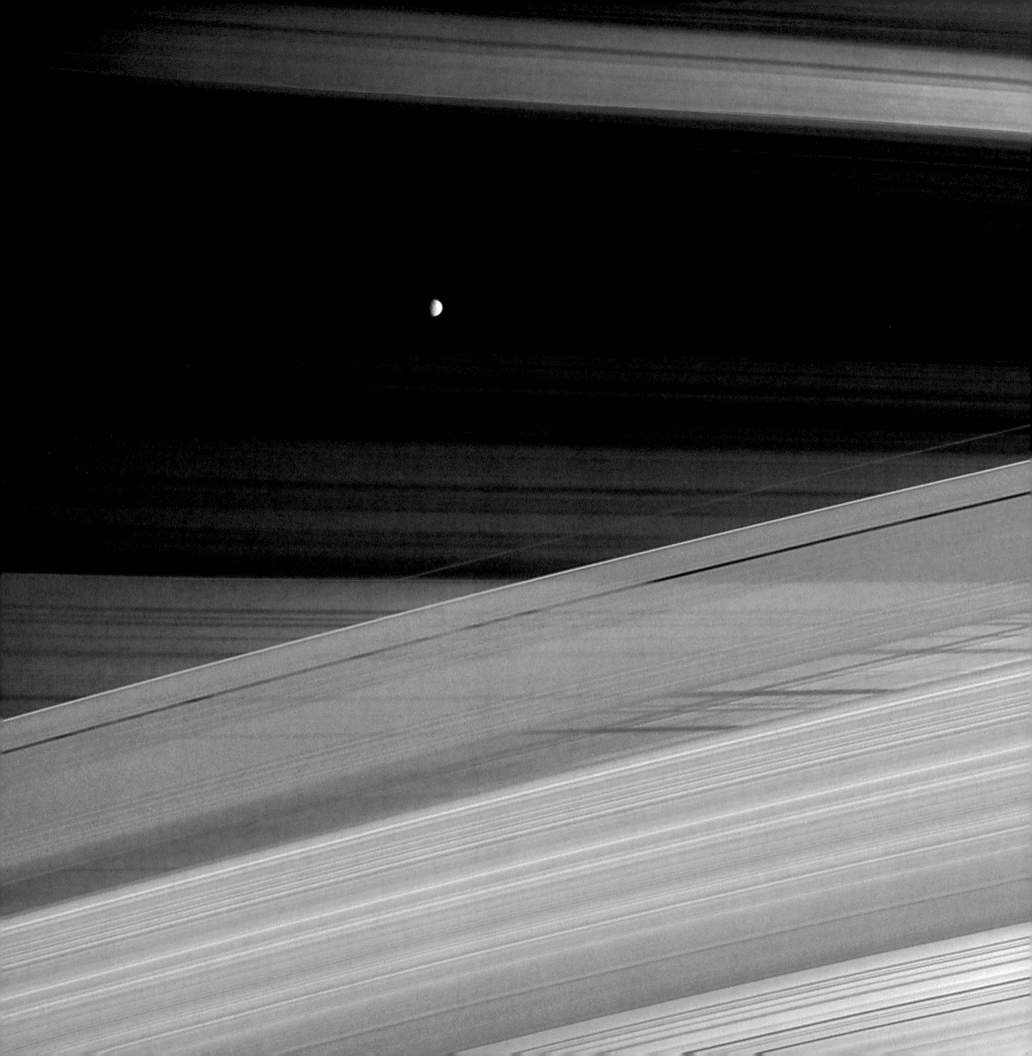

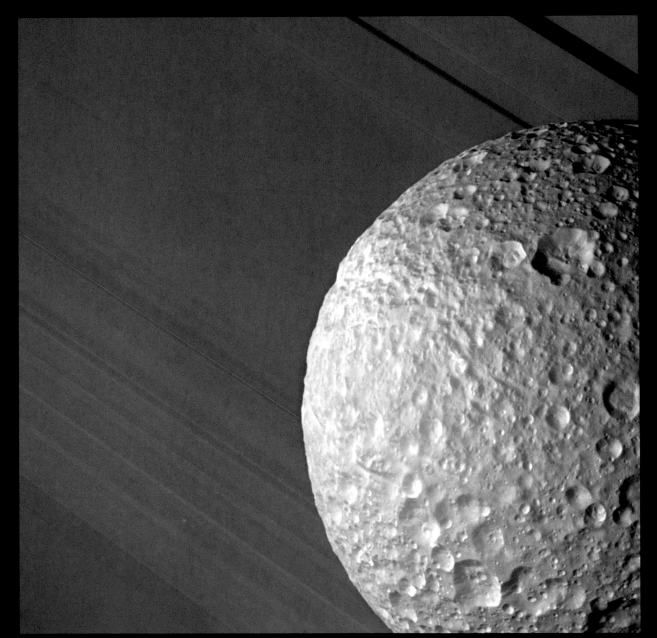

Icy, heavily cratered Mimas hangs against the broad expanse
of Saturn's rings. Even Mimas's craters have craters.

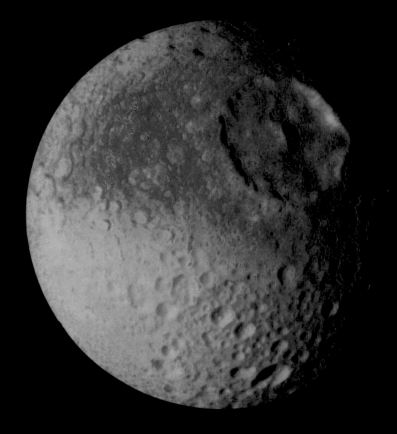

above A false-color image of Saturn's moon Mimas draws the eye
to the giant Herschel impact crater, 140 km (88 mi) wide.
Green areas represent Mimas's average surface composition;
blue areas may be water-rich material ejected from the crater.

opposite In this enhanced-color image, icy Mimas is silhouetted
against Saturn's azure northern latitudes.

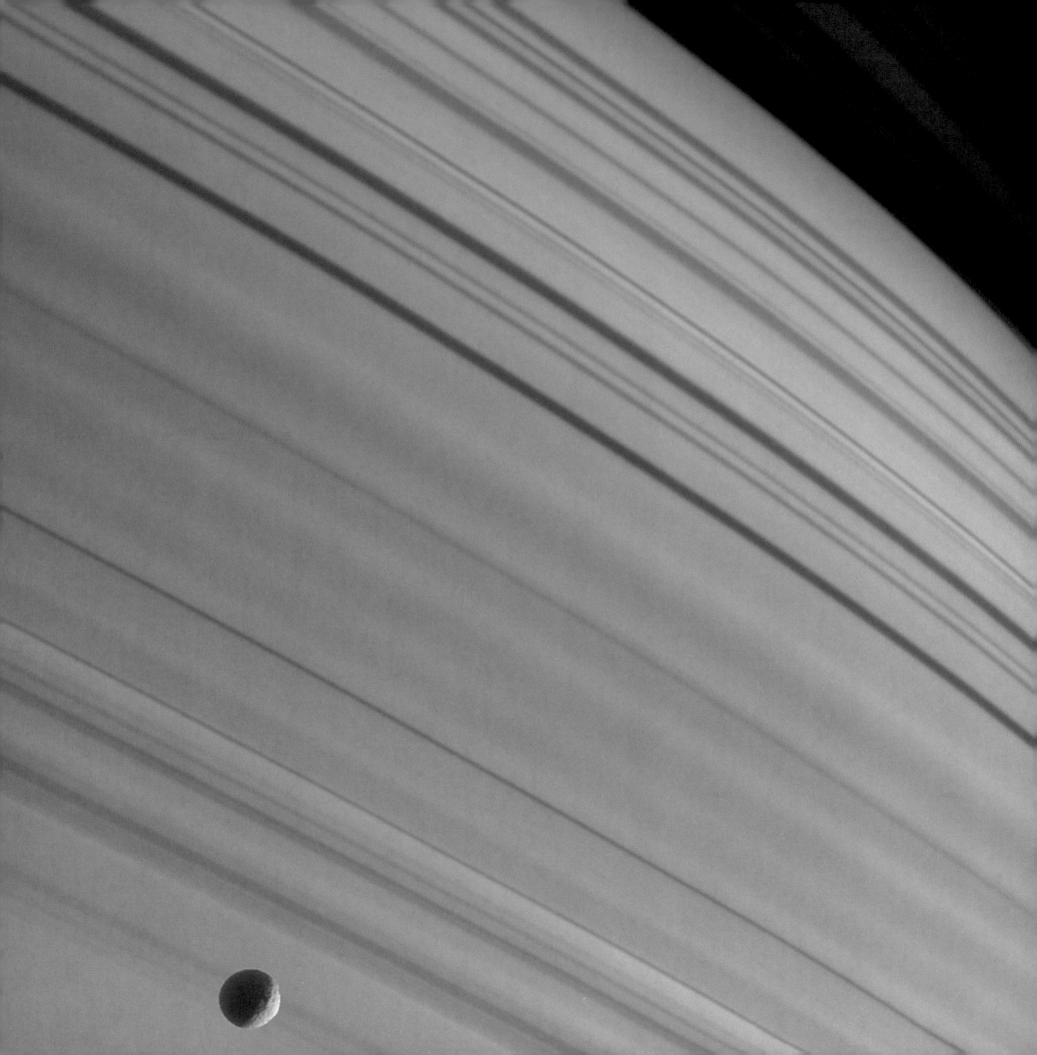

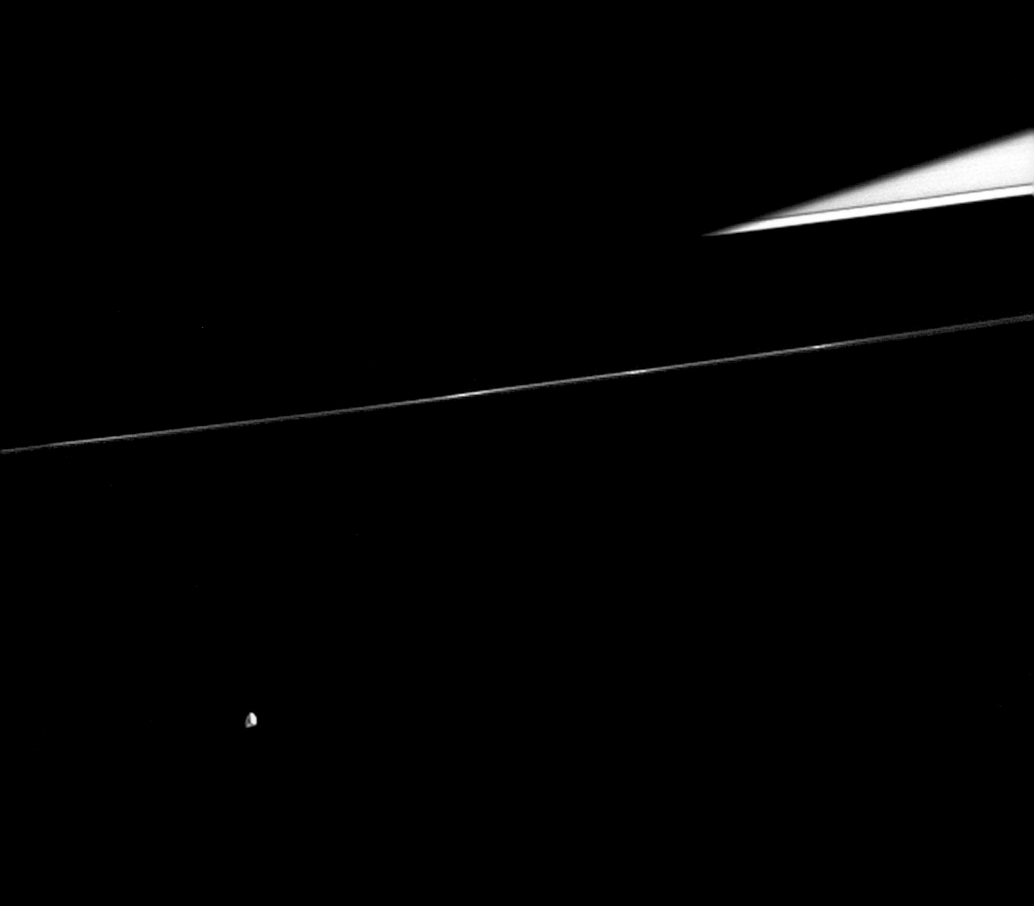

Epimetheus

opposite On its rounds of the planet, the tiny, multi-faceted ringmoon Epimetheus wanders into the light. Just visible above it is the wispy F ring, while the planet's huge shadow cuts across the ring plane, leaving only a sliver of the outer A ring in sunlight.

right On close inspection, Epimetheus is a strange and mis-shapen world. This false-color image shows only slight color variations, indicating a uniform surface composition. The tiny moon has a very low density, and may be just a pile of loosely attached rubble. It orbits so close to its larger neighbor, Janus, that the two switch orbits every eight years; they are called Saturn's "co-orbital moons."

149

Hyperion

following spread The bizarre moon Hyperion may be the remnant of a shattered larger moon. Its surface is unlike that of any other moon ever observed. On the left, the rugged, partially lit crescent. On the right, looking much like a cosmic sponge, a false-color composite reveals crisp details of cone-like craters and subtle color differences between crater walls and floors, and even within crater walls. The different colors probably represent different materials.

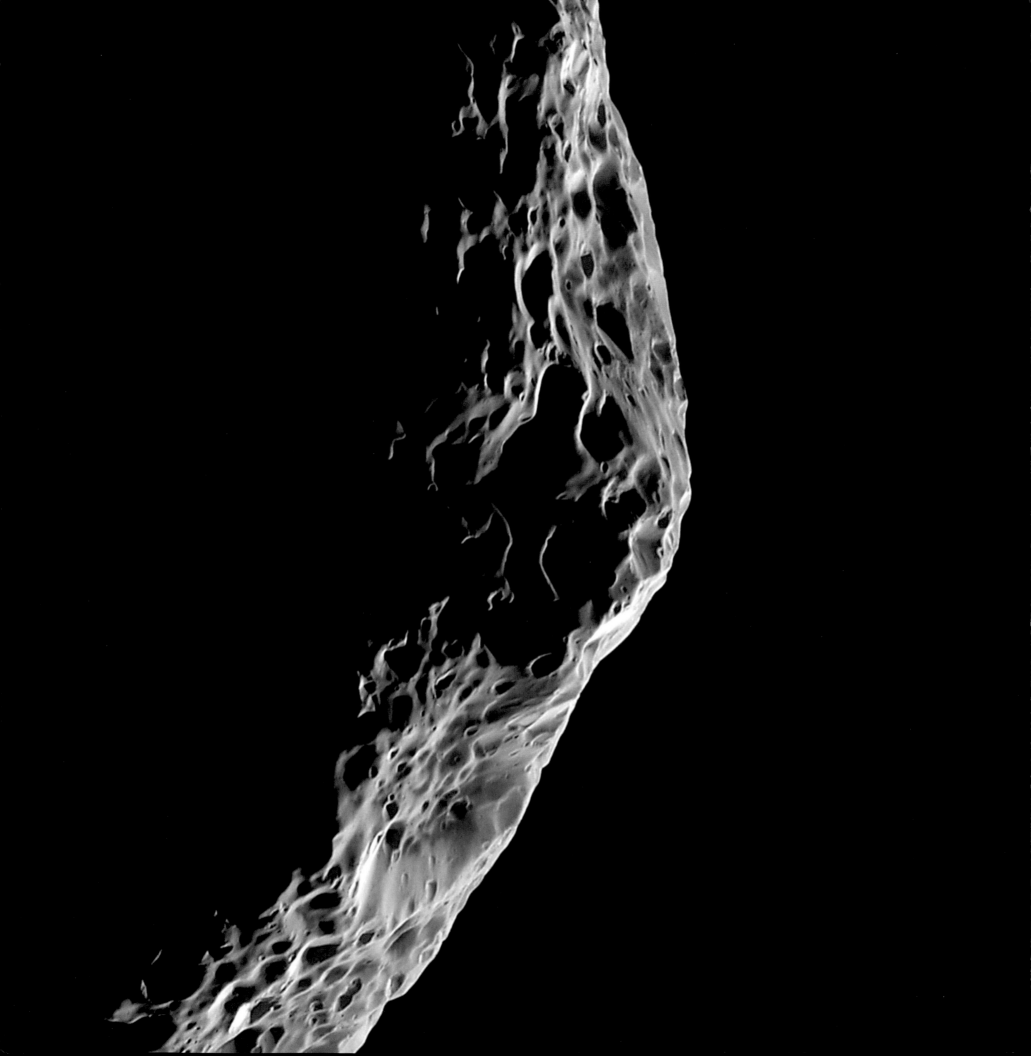

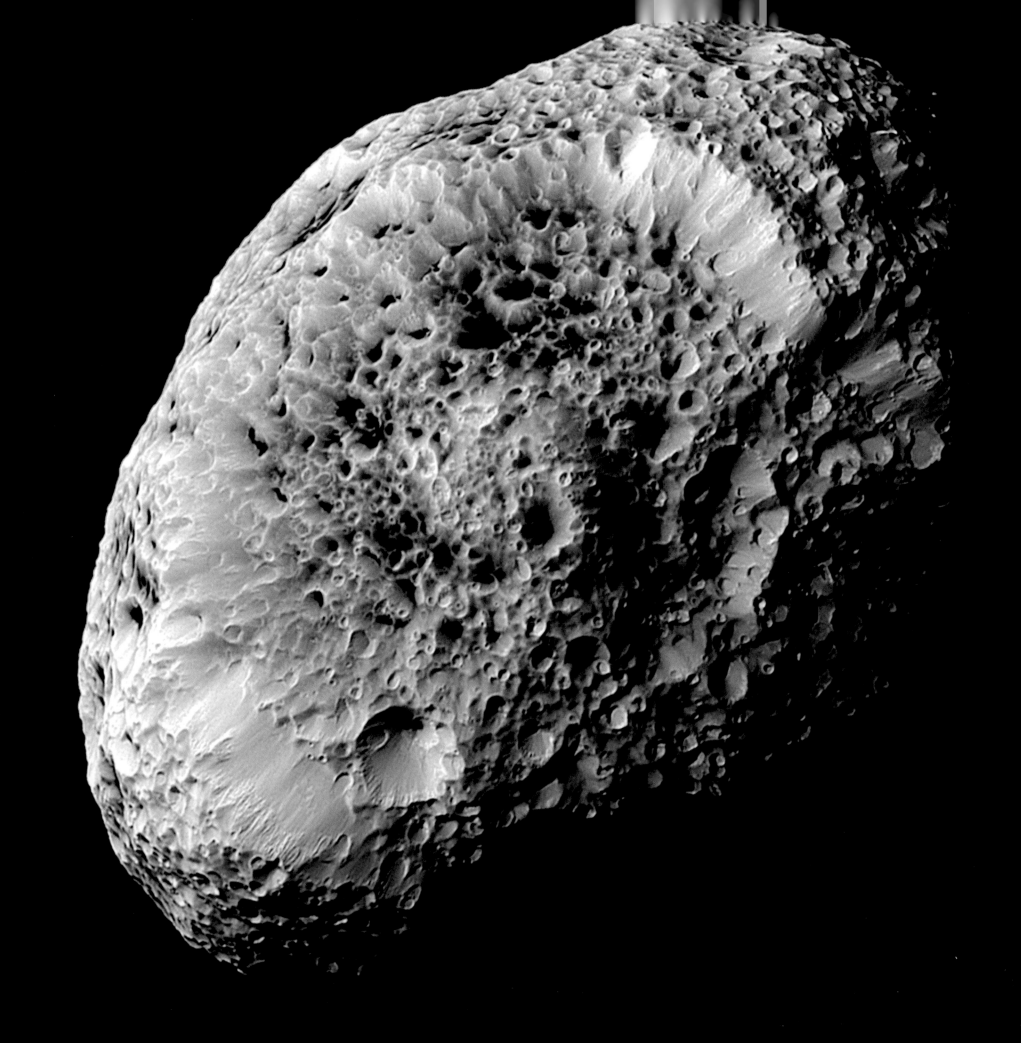

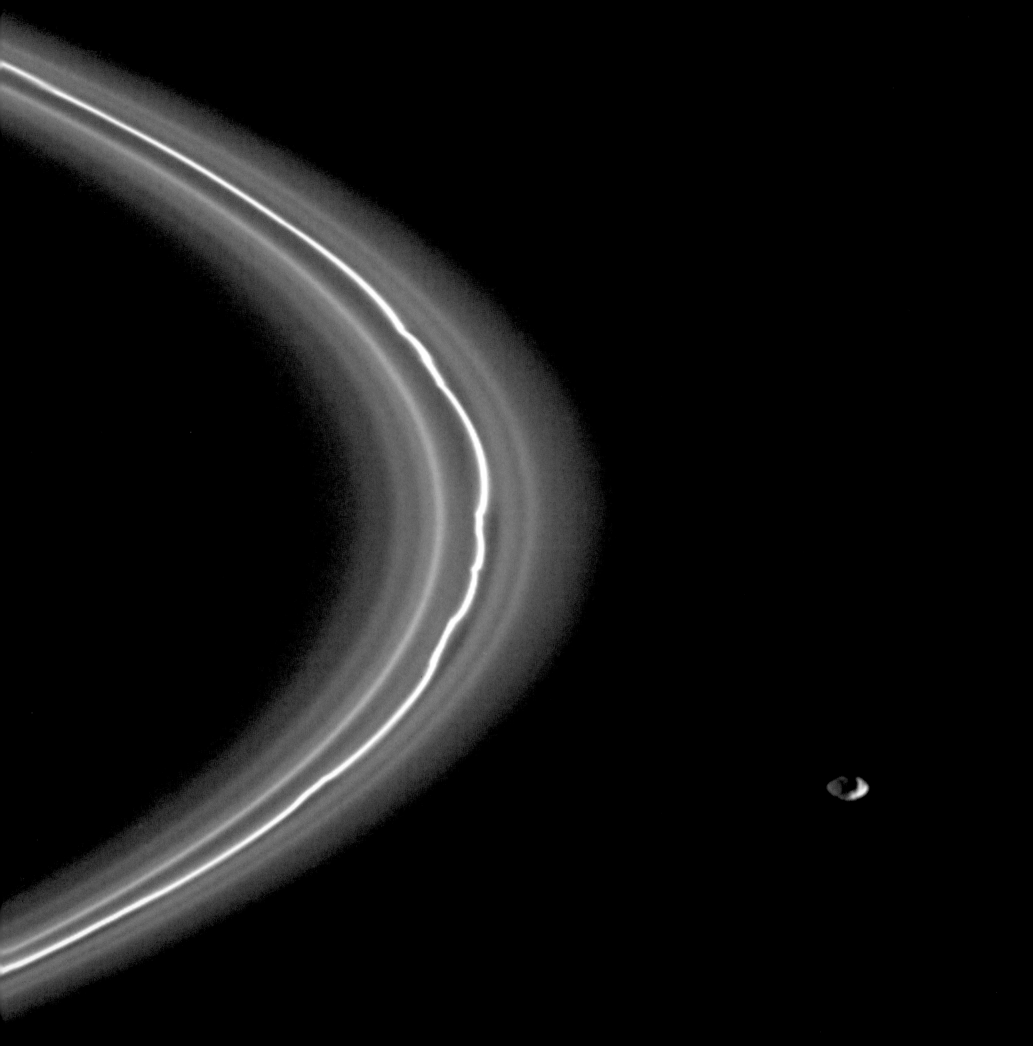

Saturn's Ringmoons

These three small ringmoons, all probably loose rubble piles rather than solid icebergs, may each have been torn apart and re-formed several times in the eons since Saturn's formation.

right, top to bottom A close-up of Janus, Epimetheus's larger "co-orbital" moon. Janus is six times larger than Atlas.

Atlas, visible as a tiny speck along the edge of the rings, orbits just outside the A ring.

Cassini's best close-up color view of Pandora shows a smooth surface covered in small particles—perhaps from the F ring—that bury impact craters as fast as they form.

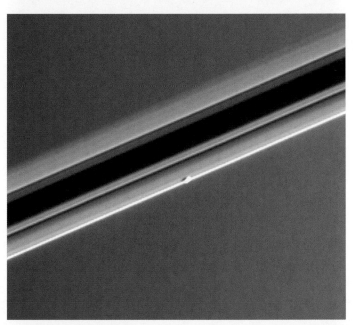

opposite Jellybean-shaped Pandora orbits outside the F ring, circling Saturn twice per day. The number and configuration of the F ring's strands have changed noticeably since Voyager's visit over 25 years ago.

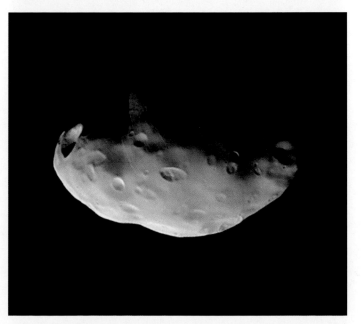

Enceladus

Saturn's icy moon, Enceladus, has been the source of a number of exciting new discoveries. The surface is made of nearly pure water ice and shows very few craters—suggesting that it is being actively resurfaced. Instead, it's laced with a complex network of glacial-looking channels and crevasses, and ropy hills hundreds of meters (yards) high. The huge, stretched-apart structures at the lower left contain fresher, more crystalline ice, as highlighted in false-color observations on the following pages.

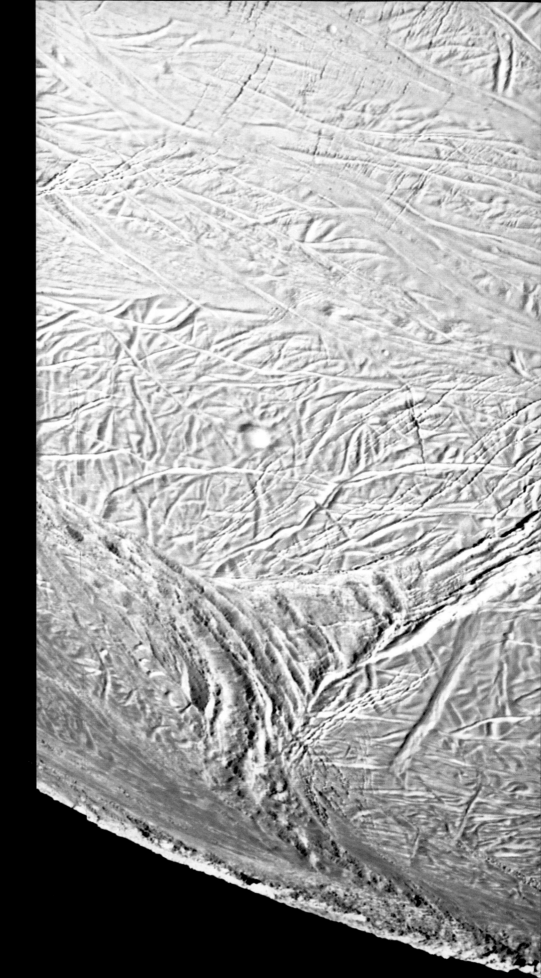

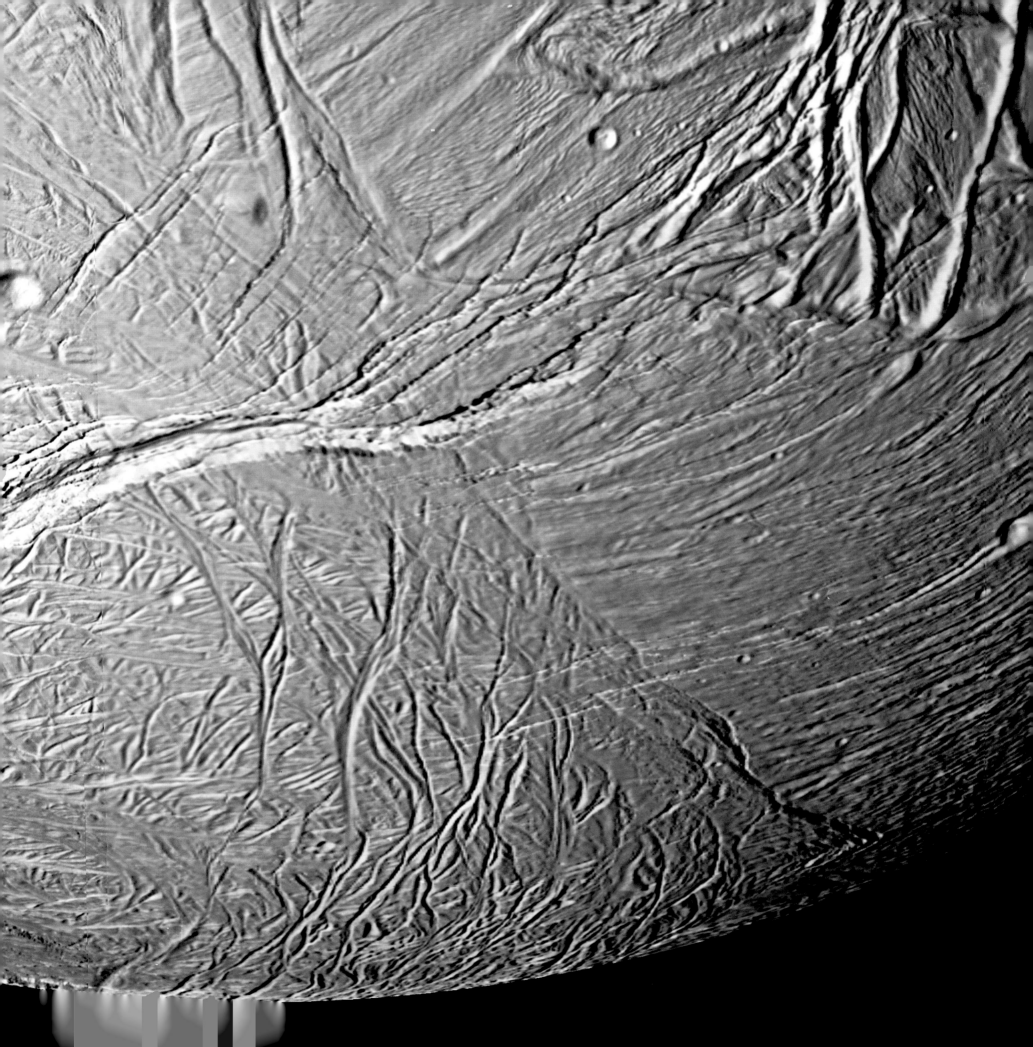

opposite The greenish blue (false color) of the "tiger stripes" on southern Enceladus indicates that they contain fresh ice. Cassini discovered that the stripes are warm enough to have liquid water not far below the surface. Since then, jets of water vapor and ice dust have been seen streaming away from this very region.

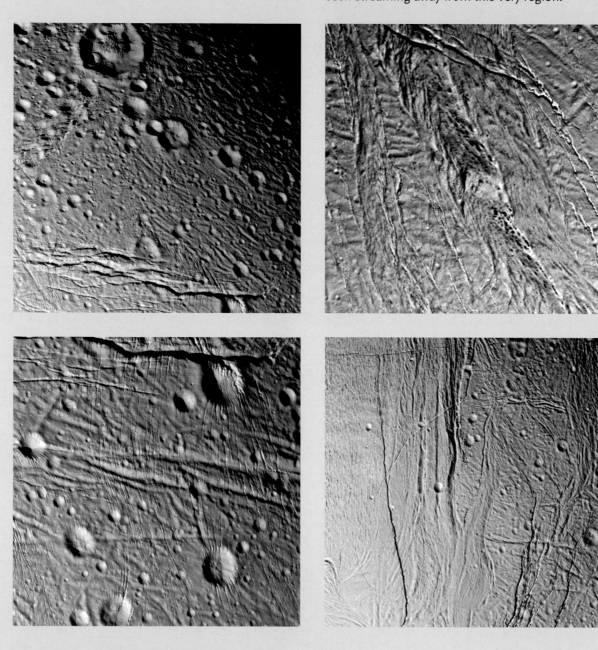

above Details of the surface in black-and-white and false color reveal both older, cratered terrain and younger, grooved, icy plains as well as an unusual fracture (top right) containing a series of dark, mysterious spots, 125–750 m (400–2,500 ft) across.

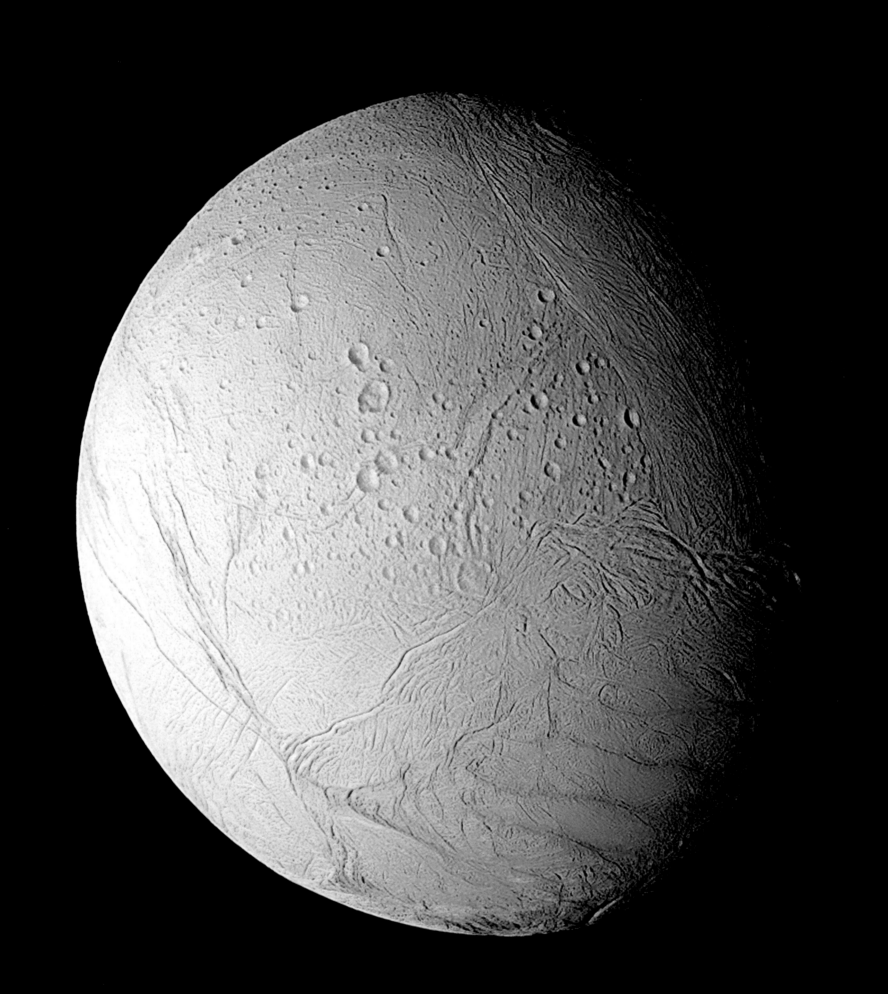

below This unique view of the leading hemisphere of Enceladus
covers terrain not seen in other, higher-resolution images.

opposite Cassini photographed Enceladus from only 1,500 km (940
mi) away. Long shadows accentuate the strangely buckled,
ice-covered terrain, showing structure down to the scale of
city blocks.

160

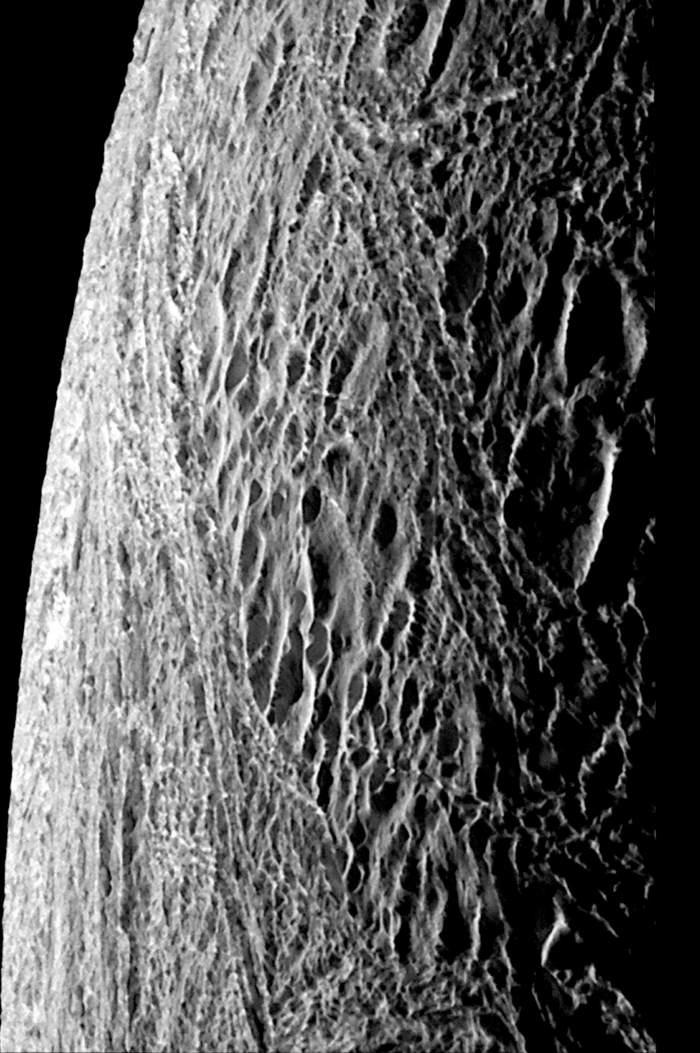

162 Dione on the left, Enceladus on the right, and Cassini
 are all orbiting nearly in the plane of Saturn's equator.
 This view emphasizes the extreme thinness of the
 rings: they're like a sheet of paper ten football fields
 across.

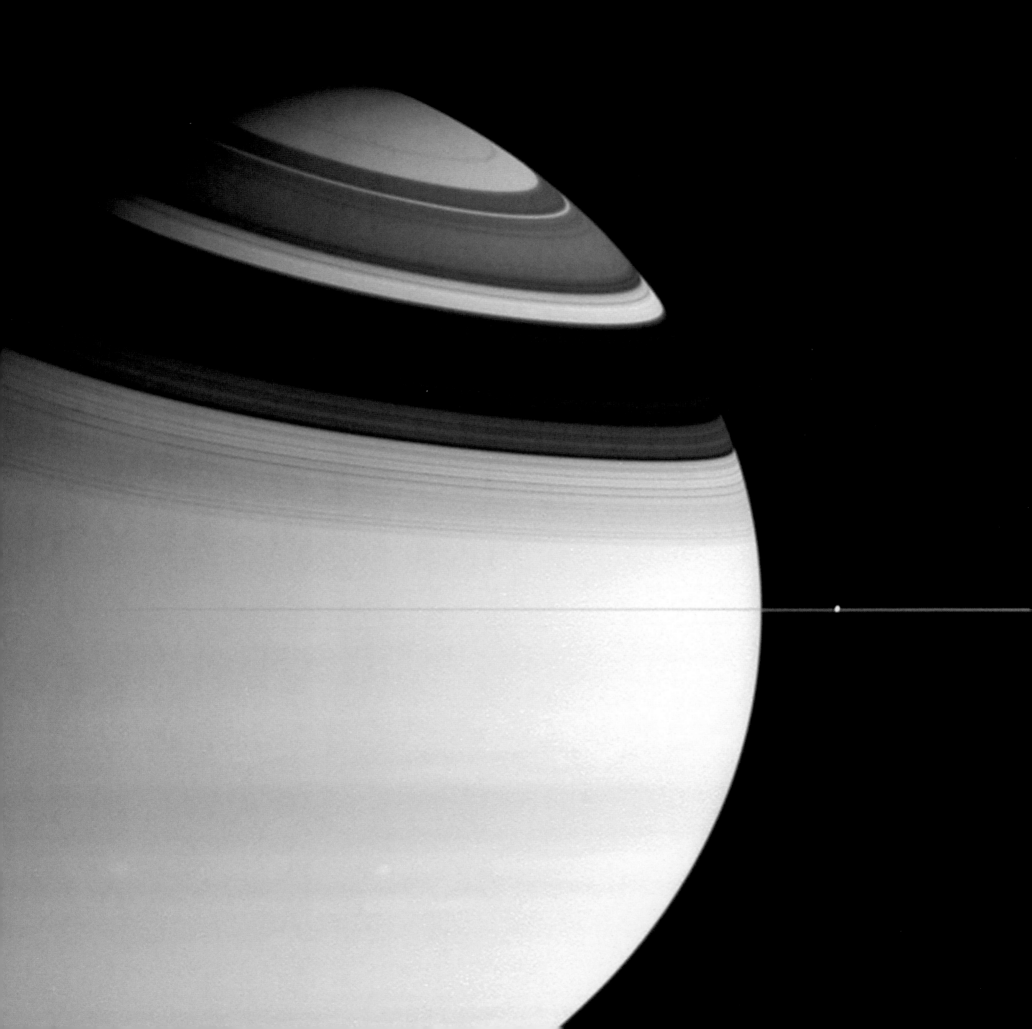

below Saturn's largest icy moon, Rhea, showing a bright, 40-km (25-mi) crater. The rays of icy ejecta around it are evidence that the surface of Rhea is darker than the material just below—possibly polluted by falling meteoroids.

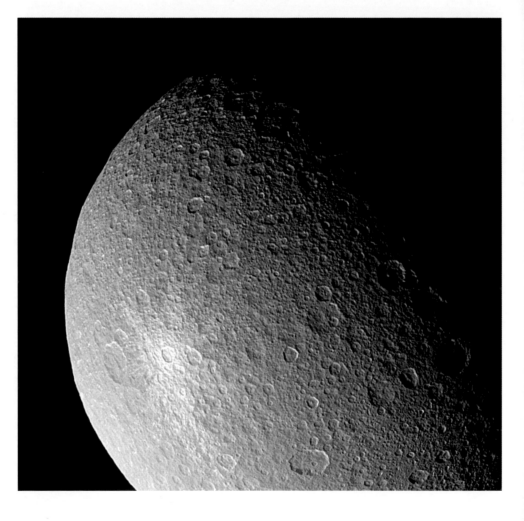

right Cassini focused past the sliver of edge-on rings to capture three of Saturn's icy moons, Mimas, Dione, and Rhea (left to right) on the far side. All three circle Saturn in just a few days in orbits slightly inclined from the plane of the rings, traveling several times faster than a speeding bullet.

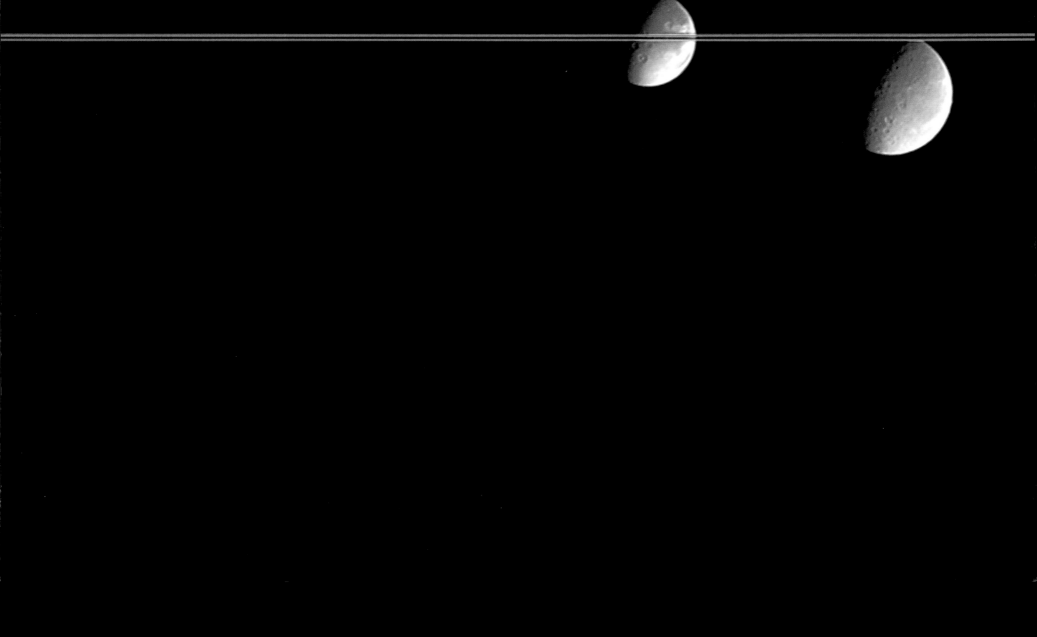

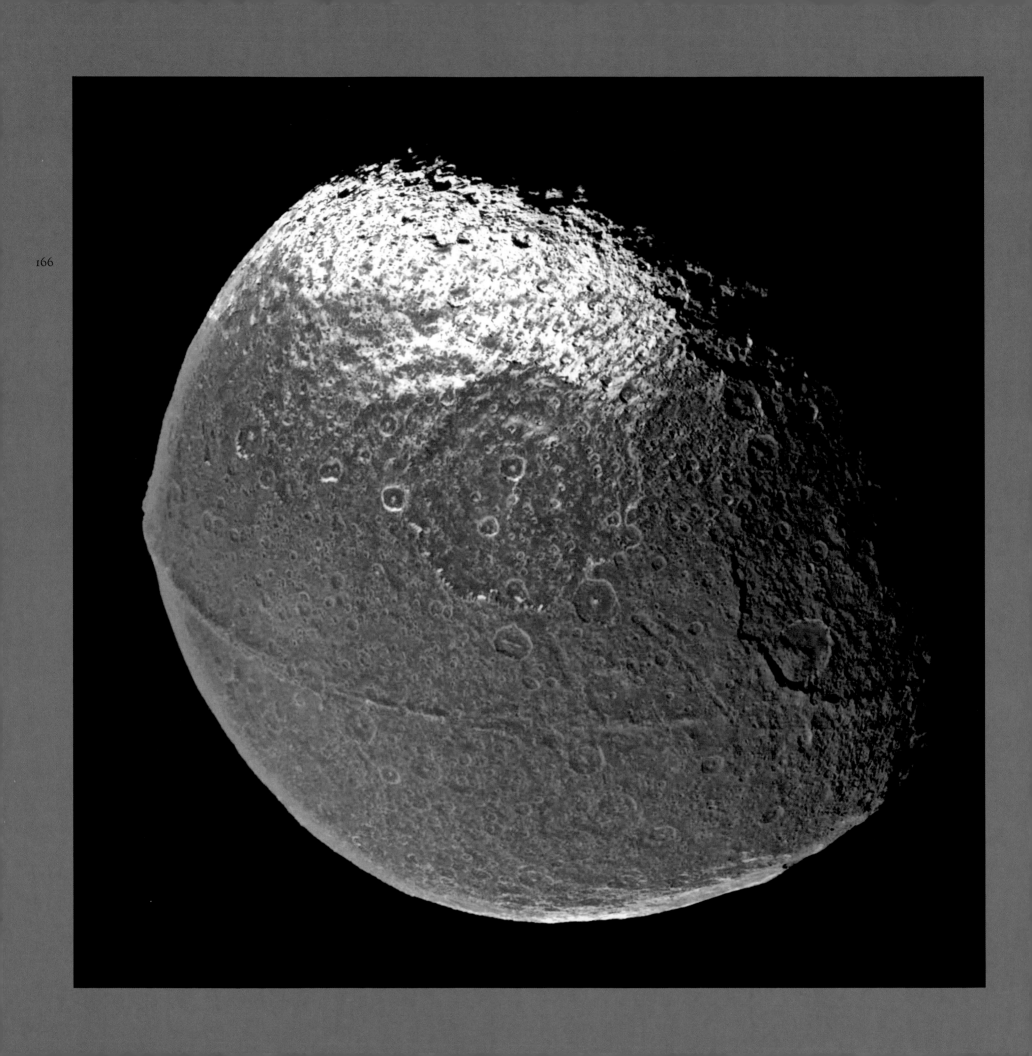

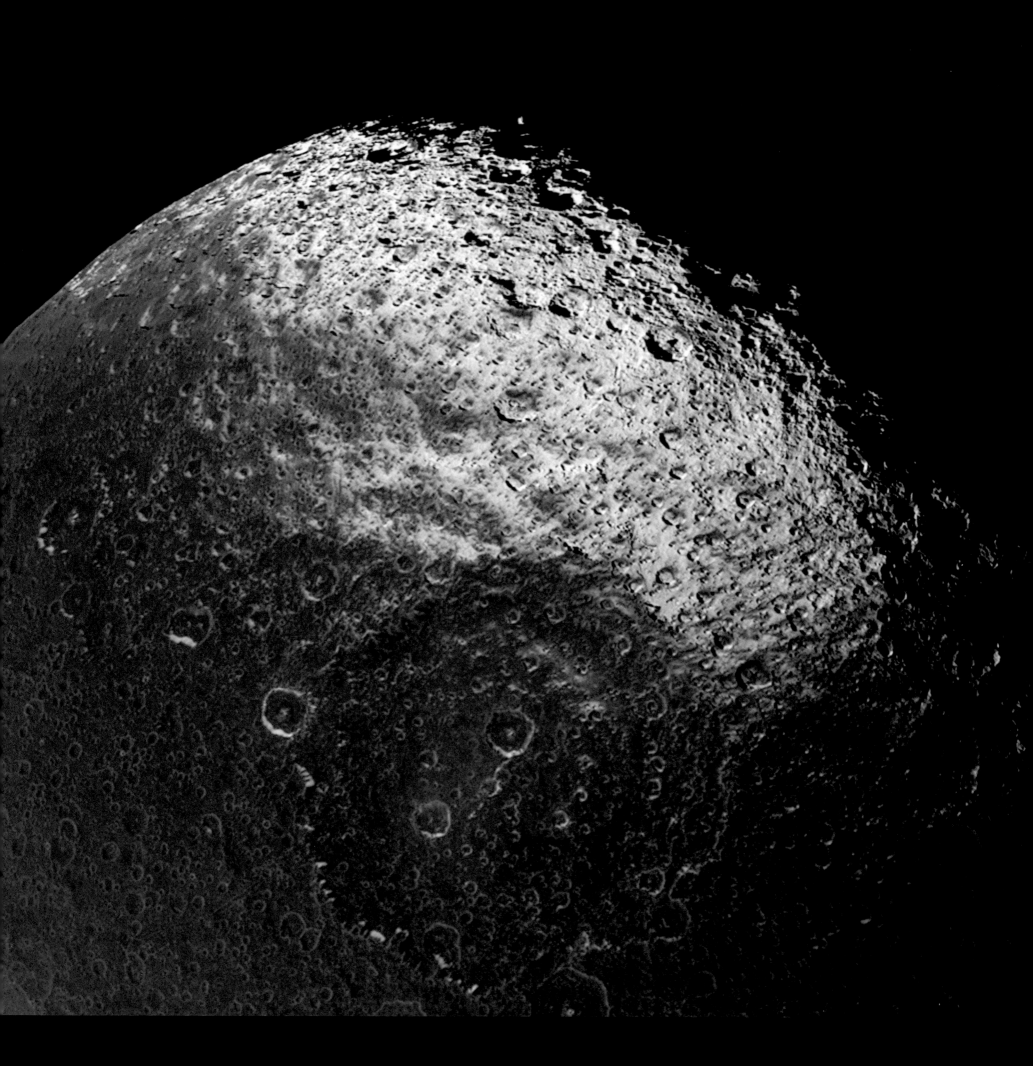

previous spread **Iapetus**

left Saturn's outermost large moon, Iapetus shows the scars of some unimaginable past cataclysm. The dark territory, Cassini Regio, and the 12-km (8-mile-)-high ridge encircling the moon's equator remain mysteries for future explorers to decipher.

right Iapetus has one light face—partially seen in the bright polar region at upper right—and another face covered with chocolate-colored, sooty material, apparently only a coating on a thick, icy interior.

Dione

opposite It is difficult to believe that this image is a natural-color one and neither enhanced nor composited; in principle, this is a sight that someday humans could see. Dione hangs in the foreground, looking more imposing than one would expect for a moon that would not span the distance from New York to Chicago.

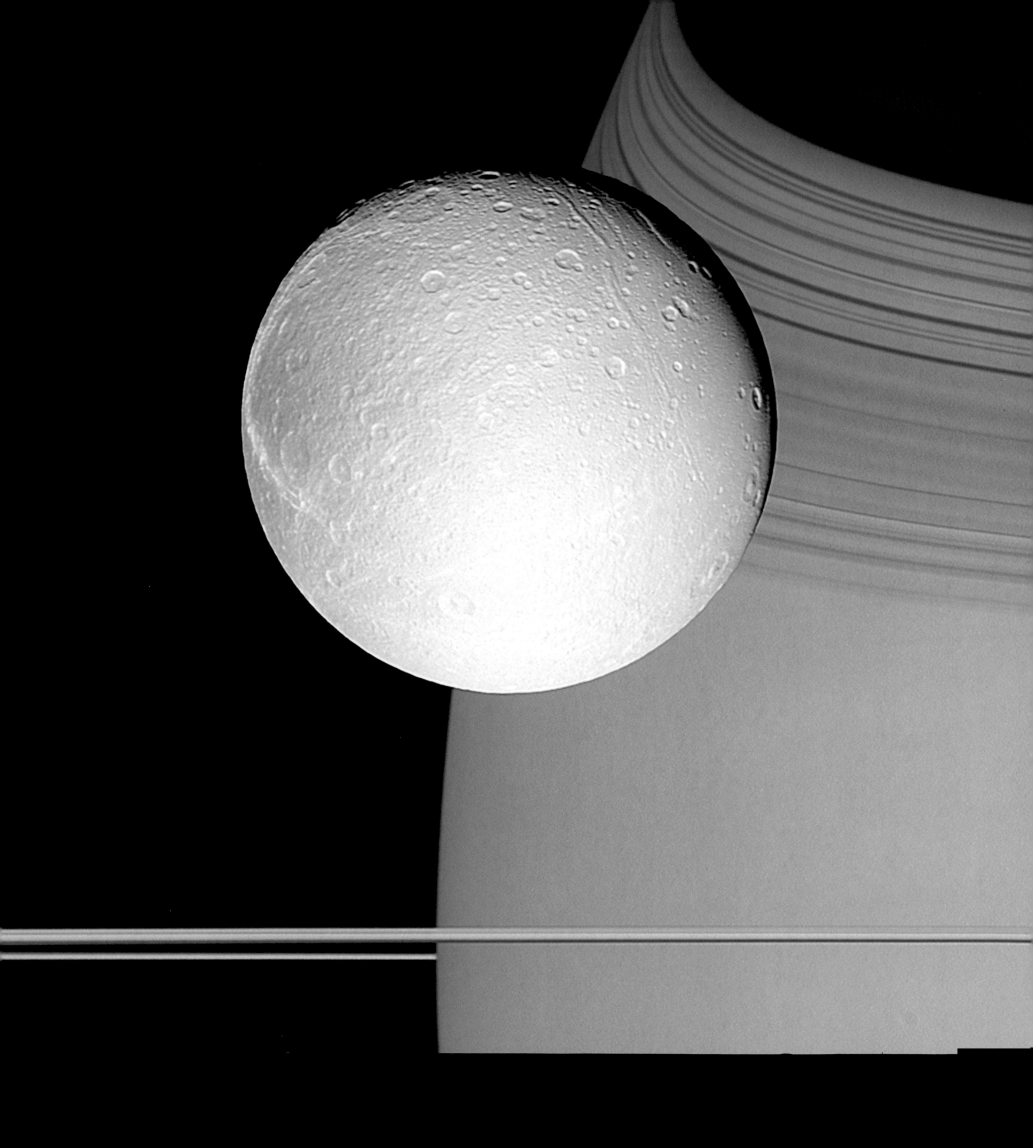

Eclipsed! In this series of four frames, Rhea passes
behind Dione in an eclipse seen only by Cassini.

Originally thought to be ice deposits, new high-resolution details of Dione's surface reveal linear, curving crevasses with ice cliffs a few hundred meters (about a quarter mile) high.

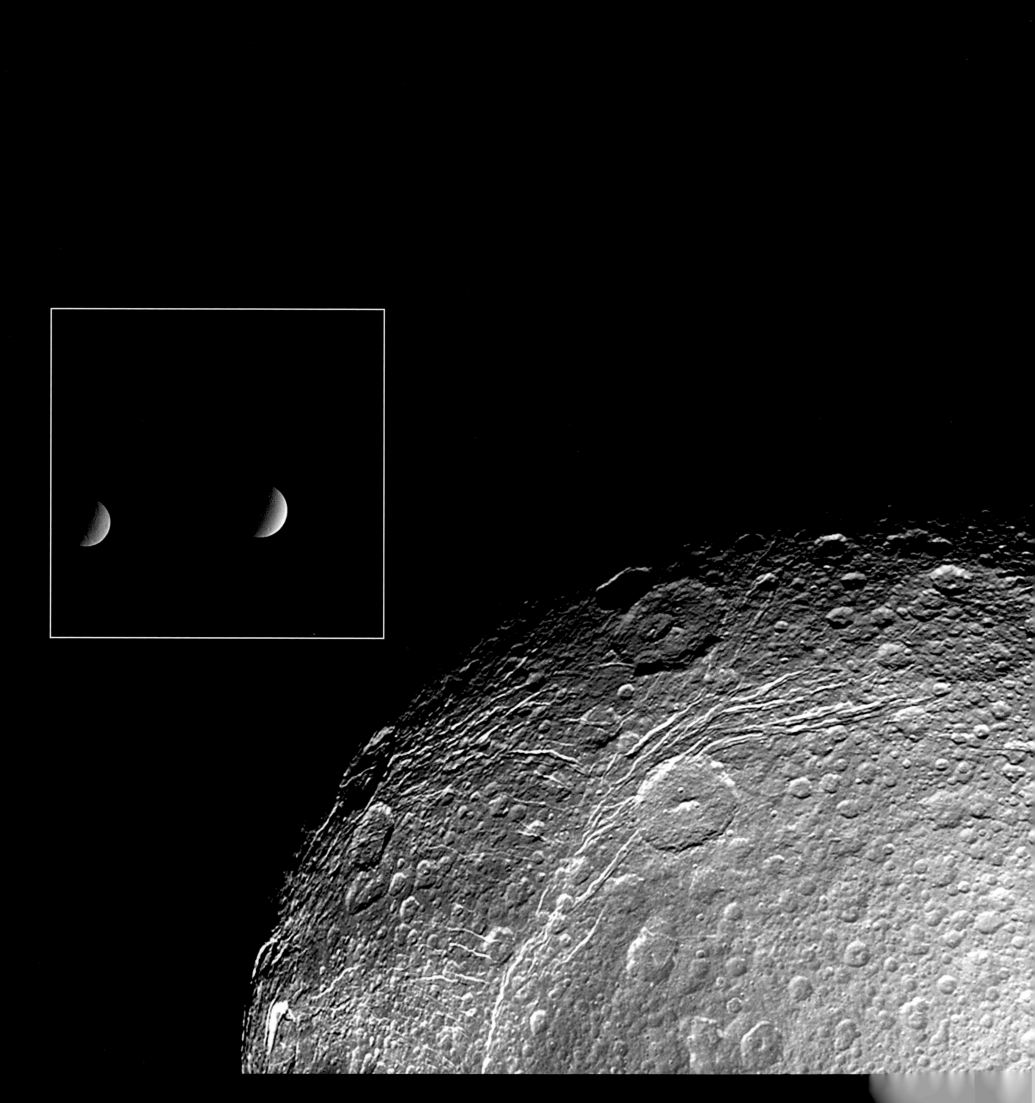

below Dione, Tethys, and tiny Pandora form a cosmic convergence,
with Dione and Pandora lying between Cassini and the rings,
and Tethys lying beyond. In reality, Dione and Tethys are moons
of similar size.

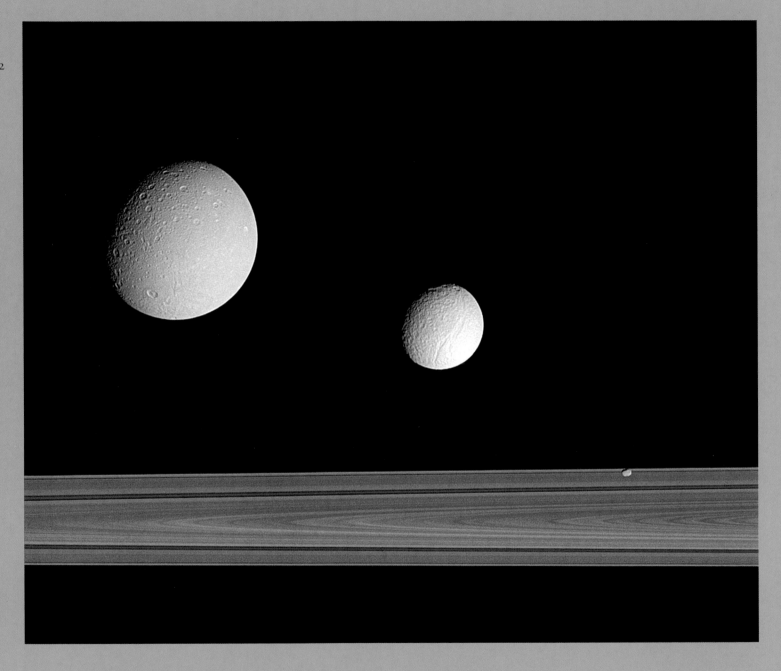

opposite Both Tethys and Dione are on the far side of the rings in this
scene. Even in this distant view, it is easy to see that the moons'
surfaces are quite different. Saturn casts its dark shadow across
the rings.

Tethys

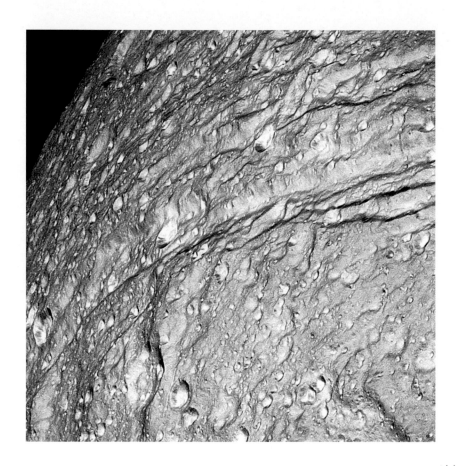

Although it is one of Saturn's larger moons, Tethys is dwarfed by the enormous size of the planet and rings. Even at this distance, a tremendous rift zone called Ithaca Chasma is visible on the icy moon—the most prominent sign of ancient geologic activity. The canyon is more than twice as deep and four times as long as the Grand Canyon in Arizona. Seen up close, Ithaca Chasma appears old and eroded by impacts.

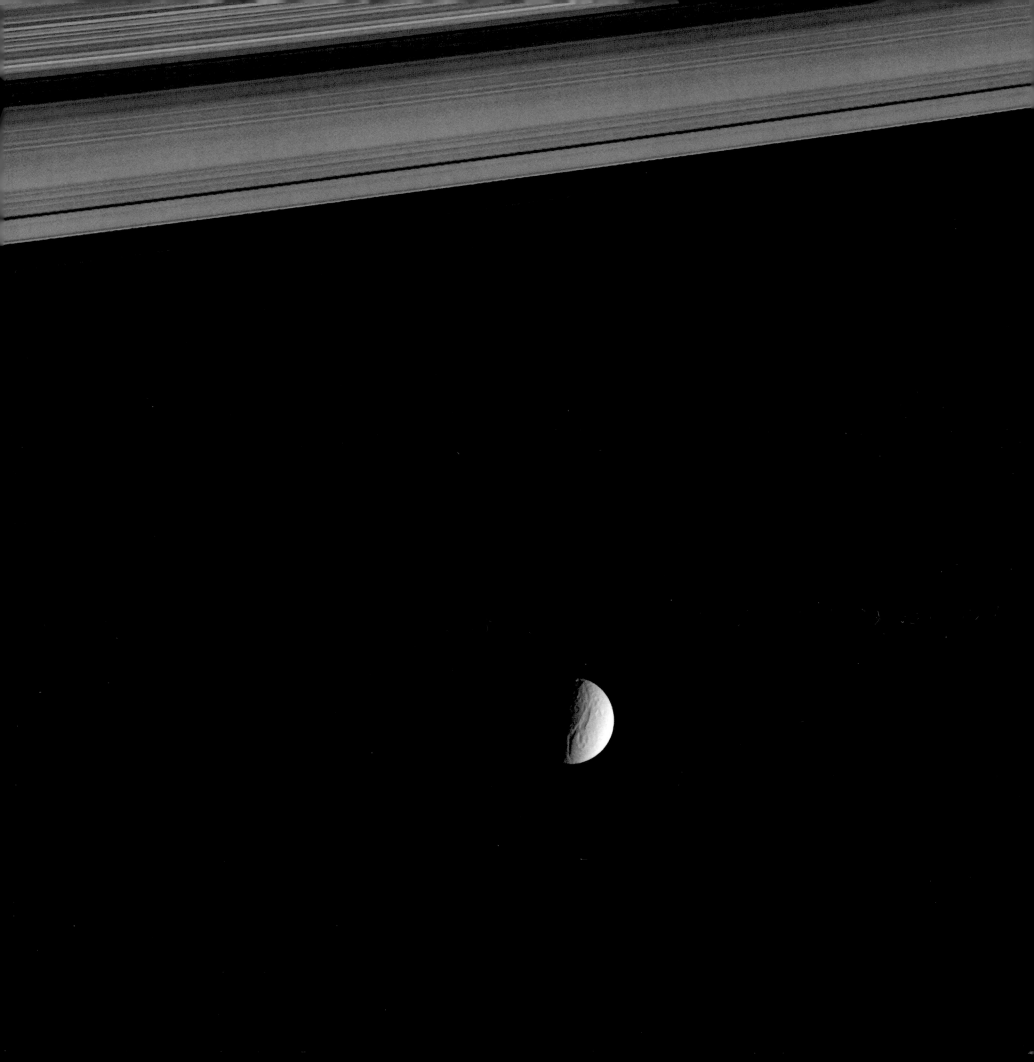

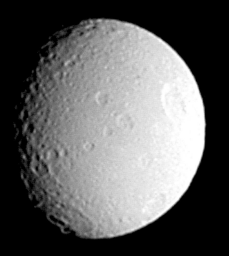
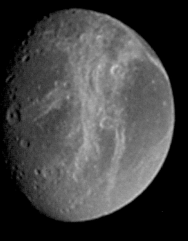

LOOKING OUTWARD

The Cassini-Huygens mission to Saturn was launched with very high hopes that have been more than realized. The 17-nation team of scientists and engineers persevered through decades of changing priorities, governments, and personnel to create, launch, and operate a nearly flawless mission. With over 34,000 images and copious quantities of scientific data returned in the first year alone, Cassini is already a resounding success. The remaining years it orbits Saturn will provide an abundance of riches, enough to keep the world's planetary scientists busy for decades, and supply all of us with a gloriously detailed portrait of our ringed neighbor that is remarkably different from the previous view.

The flood of new data from Cassini is yielding an in-depth picture of Saturn and raising new questions about the formation and evolution of the planet and its rings and moons. The key result of the entire mission may well be our increased understanding of what a dynamic and complex system Saturn, its rings, and satellites comprise. Voyager's encounter with Saturn 24 years earlier left an impression of timeless celestial serenity, but Cassini has shown us many other faces of this changeable world. For example, Saturn's entire northern hemisphere has changed to a brilliant blue as its Voyager-era peach-colored clouds apparently dissipated in the chill of the present winter. Cassini's instruments have registered giant thunderheads boiling up from the interior, "heard" lightning 10,000 times as strong as that on Earth, and found hurricane-force jet streams at several latitudes. It is clear now that ring structure and

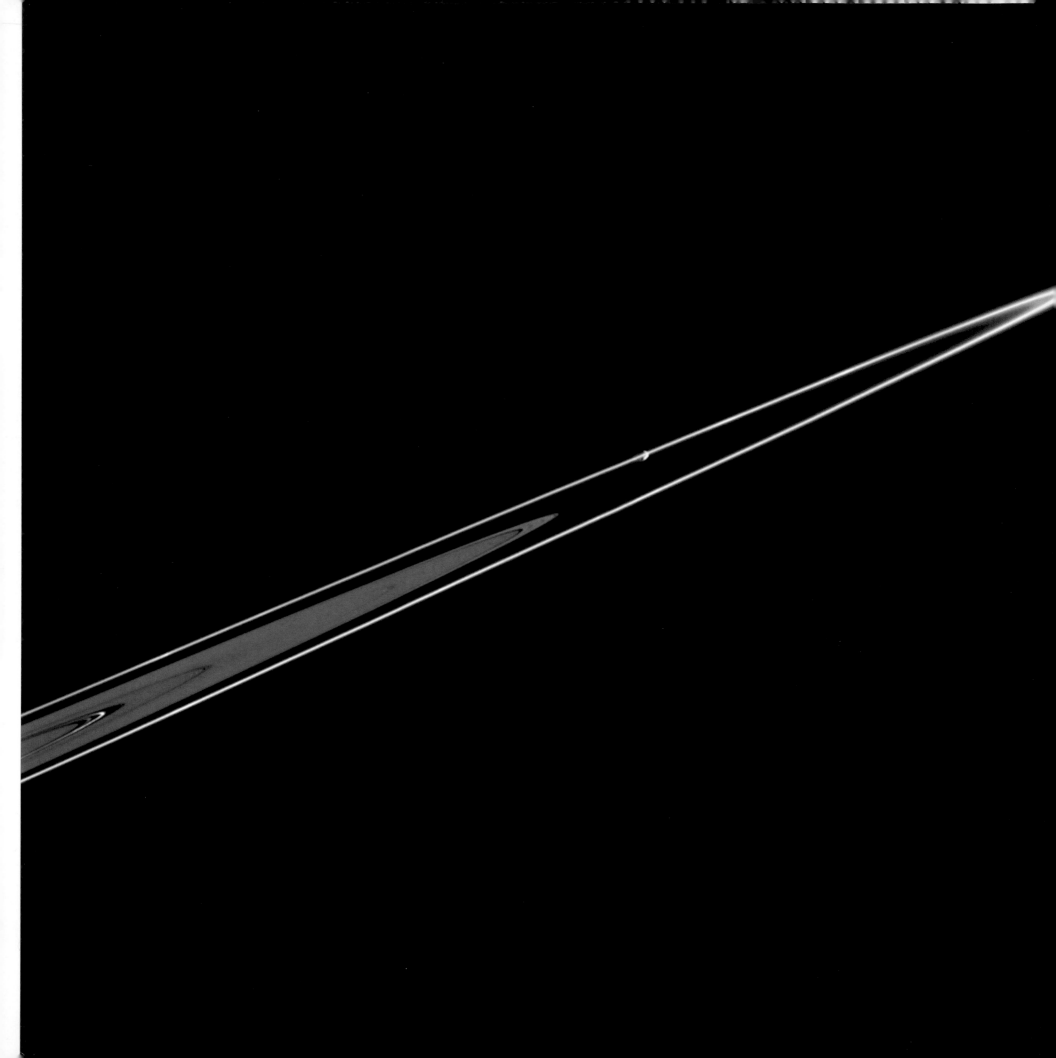

Viewed almost edge-on, the ring system appears remarkably beautiful and delicate.

LAURA LOVETT | # THE ART IN SCIENCE

In the century and a half since its invention, photography has become an inseparable part of the way we view the world. Divided as we are by geography and culture, photographs speak a universal language that everyone can understand. While it is still possible on Earth to go almost anywhere to view something firsthand, many people decide that photographs make a fine replacement for the experience of seeing it in person. With Saturn, however, photographs are our only option: they show what humans have never gazed upon in person and possibly never will. All that beauty, created by the cosmos from dust and gases, has existed several billion years until *we* evolved enough to be able to send a planetary visitor to take photographs of it and then return them to Earth, a billion miles each way.

Despite its entrenched stature in our world, however, there still exists a fundamental tension between photography as an aesthetic pursuit and photography in a more practical role as recorder of truth and reality. Since the U.S. Civil War, photography has been pressed into service to capture current events and to bring back reports of lands around the globe; the results were declared to be a foolproof record of what the camera saw. Yet experience has taught us that lots of photographs don't contain either truth or aesthetics.

In these images from Saturn, truth and beauty exist side by side, all the more remarkable because they were taken by a spacecraft a billion miles from Earth, programmed by scientists years ago.

Through their pictures, photographers try to show us their view of the world: by choosing to bring something to the foreground, they increase its importance; by framing the shot and cropping out certain things, they make us focus where they want. But in these pictures from a spacecraft, where is the artist's eye looking through the viewfinder and choosing the cropping? Are these exquisite compositions all accident—a byproduct of arranging for views that would provide scientific data? How did they know the rings would slice through the image on a perfect diagonal? Or that two moons would align just at that moment? Or didn't they care? Did the scientists of the working groups who meticulously planned every shot ever think about capturing beauty during the long weeks they calculated what the cameras would point at and when? Although they may never confess it, I can't imagine they didn't. The cameras, after all, are the closest thing on board to human perception, the next best thing to being there. And what human wouldn't want, at least for a moment, to try to capture the beauty of such a sublime world?

But capture it they did, and perhaps that was to be expected—so much of nature is beautiful, after all, as well as inhospitable, powerful, and fragile. Saturn is all of these. Gossamer strands of ice fragments, caught by the sunlight as a tiny moon wobbles by and disturbs their flow. Frozen worlds scarred by eons of impacts. Swirling storms that could swallow the Earth in one gulp. More than 40 moons circling the planet. And those brilliant bands of teal and ultramarine wrapping the northern latitudes. Who could have imagined it all? We think of Earth as such a unique place, and yet we have none of these. How much more is there, still to be found by the cameras of Cassini, guided by the photographer-scientists here on Earth as they relay commands to their spacecraft-artist at Saturn?

○ When astronauts walked on the Moon, they carried Hasselblad cameras loaded with rolls of photographic film. Since plans included bringing the men back to Earth, the film came too. Planetary missions, however, don't include return trajectories, so the imagery has always been in digital form, captured electronically, compressed and divided into digital packets, and stored until the spacecraft's main antenna could point toward Earth. Each of these digital photographs contains a finite number of pixels; enlarging them won't generate new details in the image the way rescanning a film negative will. All of Cassini's images from both cameras are single-frame shots, 1024 by 1024 pixels and no more. To generate larger images, the spacecraft is programmed to take sequential exposures of overlapping sections of the planet or moon. Once retrieved from Cassini, these are carefully tiled together into what are known as "mosaics." If the target was approaching the camera as it was being photographed, it will be increasingly larger and/or distorted in each succeeding shot, and the resulting pieces will need careful resizing and reshaping in order to align. Redundancy of exposures helps, but sometimes the puzzle can't be completed when a key piece is missing, most often due to failure of data transmission.

Once the spacecraft is ready to transmit, the images have a particularly long journey home—on average, an hour and a half. Mixed into waves of radiation, cosmic particles, radio waves, and satellite relays, packets of zeros and ones come streaming in from Saturn. Captured by the giant dishes of the Deep Space Network, these precious packets get shunted to the Jet Propulsion Laboratory in Pasadena, California, where they are turned into many different kinds of science data, and these amazing pictures. Kudos to the magicians there who can make pictures from numbers so that we can see this world, too.

Every photo of Saturn that Cassini takes is archived when it arrives on Earth by the patient folks at JPL in raw form at thumbnail size (see http://saturn.jpl.nasa.gov/multimedia/images/raw/index.cfm). With a stream of images arriving every week, over 34,000 from just the first year in orbit, editing the wealth of material has become a critical task. The Cassini Imaging Team is charged with doing so for all images from Cassini's cameras that are released to the public on

NASA's Planetary Image Atlas (http://photojournal.jpl.nasa.gov). For this book, I spent weeks meticulously going through the databank of raw image files and selecting other promising candidates, carefully collecting any frames that appeared to be part of larger images. Sometimes a mosaic was not possible to complete due to missing pieces; others produced dramatic views, including many of my favorites in this book. In no case did we substitute similar frames from a different day of the mission, nor did we invent parts that were missing unless they represented less than 2% of the image (in which case this is noted in the image credits). There is a wealth of wonderful pictures to choose from, and the scientists did such a remarkable job of composing them, no special enhancement seemed necessary. These images were integrated with those released by NASA, some of which were cropped prior to release.

Armed with 40 filters on the two cameras, the mission scientists use varying combinations or sequences of filters to yield different kinds of data. Images taken with clear filters thus become "normal" exposures that yield black-and-white photographs. Exposures of the same subject shot sequentially using the red, green, and blue filters can be made into natural-color images. Surprisingly, I found these represent a small percentage of the total taken. If the image is composed of multiple exposures, a complete mosaic must be made for each color, and these three black-and-white mosaics then colored red, blue, and green, and layered to make the color version. By far the most complex color mosaic created to date is the glorious portrait of the planet on pages 68–69, which was made from 42 overlapping shots per color.

What is most unexpected is the color that the photographs have revealed. Prior to Cassini's arrival, photographs of Saturn showed colors ranging from brown to glowing orange, with most images having decidedly yellow-tan hues for both sphere and rings. Photographs taken in the 1990s with the Hubble wide-field planetary camera were the first to display the reddish-tan shade of the rings that is now believed to be accurate. Cassini has treated us to a colorful slideshow of orangey yellows, merging into feathery teal greens in cooler light, and an ultramarine blue pole wrapped with arcs created by the rings' shadows. Who needs false color when true color is so gorgeous it leads normally staid staffers to name photographs "the face of beauty" or "nature's canvas"? After these revelations, Saturn can never more be thought of as looking like a lemon.

The tools and techniques of the artist and the scientist are usually worlds apart, but in one aspect they overlap—the need and desire to observe closely, to see what is truly there in order to determine the nature of it. In this book, a collaboration between an artist, a scientist, and an engineer, we found common ground in a database of photographs that never ceased to dazzle us all. While others may pore over these images in order to gain understanding or to make assessments about the world on view, the artist in me is forever thrilled just looking at them. It's as if the photographs speak two languages simultaneously: one of information—to those who can read it—and one that speaks to our inner selves, which find in these images a harmony and beauty so eloquent no translation is needed.

When the crew of Apollo 8 photographed the whole Earth, a blue marble wrapped in clouds and suspended in the blackness, it forever changed our perception of ourselves. That single photograph brought home to us that we are temporary visitors on a lonely outpost in the cosmos. After viewing these photographs, it's impossible anymore to think of Saturn as simply a brighter-than-normal point of light in our night sky. Now it's our neighbor, home to glittering rings, acrobatic satellites, and worlds that may harbor hidden life. Through the power of photographs and a spacecraft called Cassini-Huygens, a planet a billion miles away has now become a familiar face in our known world.

Image Credits

NOTES

Key to image listings: Page; target; image type (natural color, false color, monochrome, other); instrument and filters; date taken; distance in km (mi) to target or noted if ambiguous; resolution in km (mi) which refers to the smallest detail visible; image credits if other than NASA/JPL/SSI; image processing notes; PIA number.

Acronyms used: Cassini Orbiter Narrow Angle Camera (NAC) and Wide Angle Camera (WAC); Filters C=clear, IR=infrared, NIR=near infrared, R=red, G=green, B=blue, UV=ultraviolet, MT2/MT3=methane, CB=continuum band.

Unless otherwise noted, images are courtesy of NASA/JPL/Space Science Institute.

'PIAxxxxx' numbers are image identifiers from JPL's Planetary Photojournal. For further information about any PIA-numbered image, go to http://photojournal.jpl.nasa.gov/targetFamily/ Saturn and type this number in the box at the upper right.

DISR images are taken by the Huygens Descent Imager/Spectral Radiometer. Many of them are single-filter images that were speculatively hand colored using the best approximation of the correct colors.

COLOR

Natural color images appear in color in the book and were made from three exposures taken one each with red, green, and blue filters and/or slightly enhanced by near-IR and/or near-UV, yielding our best approximation of what we would see if we were there.

False color images appear in color in the book and were made from two or more exposures taken with filters other than the ones human eyes can see—red, green, blue, and clear. Most of these are an ultraviolet/green/infrared combination.

Single filter images appear black and white in the book and were taken with any single filter except clear, including those made from only one layer of a color file. For instance, the image on page 75 was made from an exposure taken with a blue filter.

1. Dione
False color; NAC (UV, G, IR); Sep 20, 2005; distance 2 million km (1.2 million mi); resolution 12 km (7.5 mi). PIA07627

2–3. Saturn
Natural color; NAC (R, G, B); Mar 27, 2004; distance 47.7 million km (29.6 million mi); resolution 286 km (178 mi). PIA05389. Also see pp. 58–59, nine months later.

4–5. Saturn rings
Monochrome from color image; NAC (R, G, B) Oct 6, 2004; distance 6.3 million km (3.9 million mi); resolution 38 km (24 mi). Image processing Jon Zax.

6–7. Dione and ring shadows
Natural color; WAC (R, G, B); Sep 22, 2005; distance 803,000 km (499,000 mi); resolution 48 km (30 mi). PIA07771

8–9. A and F ring, Prometheus
NAC (C); Aug 28, 2005; distance 2.3 million km (1.4 million mi); resolution 13 km (8 mi). PIA07598.

11. Iapetus
NAC (C); Jan 1, 2005; distance about 17,000 km (10,500 mi); resolution 1 km (0.6 mi). Mosaic by Paul Geissler.

12. Four moons
NAC (C); Oct 17, 2005; distance from Titan 3.4 million km (2.1 million mi), from Dione 2.5 million km (1.6 million mi); resolution on Titan 21 km (13 mi), on Dione 16 km (10 mi). PIA07644

14. Titan
False color; WAC (IR, B); Apr 16, 2005; min. distance 168,000 km (104,000 mi); resolution 10 km (6 mi). North is up and tilted 30 degrees to the right. PIA06229

18. Saturn
Natural color; NAC (R, G, B); Oct 6, 2004; distance 6.3 million km (3.9 million mi); resolution 38 km (24 mi). PIA06193 detail

19 and 21. Keeler's notebook
Courtesy of The Mary Lea Shane Archives of the Lick Observatory, University of California-Santa Cruz

23. Ed Stone
Courtesy of NASA/JPL/Caltech

25. Cassini spacecraft
Courtesy of NASA/JPL/Caltech

26. Petal plot
Courtesy of NASA/JPL/Caltech

27. Artist's concept of Huygens descent
PIA06434; courtesy of NASA/JPL/ESA

31. Robert Mitchell
Jul 1, 2004; courtesy of NASA/JPL/Caltech

32. Julie Webster and Earl Maize
Jul 1, 2004; courtesy of NASA/JPL/Caltech

33. Bridget Landry
Jul 1, 2004; courtesy of Joan Horvath

33. Rene Fradet
December 2005; courtesy of Joan Horvath

35. Percival Lowell in dome
Courtesy of Lowell Observatory Archives

36–37. Saturn's unlit ring plane
Single filter; WAC (NIR); Oct 27, 2004; distance 618,000 km (384,000 mi); resolution 33 km (21 mi). PIA06532, PIA06533

38. Saturn, Dione
Single filter; WAC (NIR); May 5, 2005; distance 1.3 million km (810,000 mi); resolution 74 km (46 mi). PIA07526

39. Rings, Pandora
NAC (C); Jul 16, 2005; distance 1.3 million km (810,000 mi); resolution on Saturn 8 km (5 mi), on Pandora 6 km (4 mi). PIA07570

40–41. Dione
NAC (C); Oct 11, 2005; distance 21,650–25,580 km (13,460–15,900 mi); resolution 100 m (330 ft). PIA07745

42–43. Saturn system
Single filter; WAC (MT2); Feb 5, 2005; distance 3.4 million km (2.1 million mi); resolution 200 km (124 mi). Mosaic by Paul Geissler.

44. Dione
Single filter; NAC (G); Feb 18, 2005; distance 1.3 million km (810,000 mi); resolution 8 km (5 mi). PIA06626

45. Saturn
WAC (C); Oct 29, 2004; distance 940,000 km (584,000 mi); resolution 52 km (32 mi). PIA06538

46. Saturn
Natural color; NAC (R, G, B); Oct 6, 2004; distance 6.3 million km (3.9 million mi); resolution 38 km (24 mi). PIA06193 detail

47. Saturn and Dione
NAC (C); Jan 29, 2005; distance 3.5 million km (2.2 million mi); resolution 20 km (12 mi). Image processing by Paul Geissler.

49. Saturn
Natural color; WAC (R, G, B); May 4, 2005; distance 999,000 km (621,000 mi); resolution 60 km (37 mi); PIA07772

50. Enceladus
False color; NAC (UV, G, NIR); Jul 14, 2005; distance less than 61,300 km (38,100 mi); resolution 350 m (1,150 ft). PIA06254 detail

51. Enceladus
NAC; Nov 28, 2005; distance 214,000 km (133,000 mi); resolution 1.3 km (0.81 mi). PIA07758

52. Dione
NAC (C); Aug 1, 2005; distance 269,000 km
(167,000 mi); resolution 2 km (1.2 mi). PIA07581

53. Dione in detail
NAC; Dec 14, 2004; Replacement of a missing
"notch" out of the limb by Jon Zax. PIA06163

54. Titan
Single filter; NAC (UV, then colorized); Jul 3,
2004; distance 789,000 km (490,000 mi); resolu-
tion 4.7 km (2.9 mi). PIA06090

55 top. Titan backlit
Single filter; WAC (V); Apr 1, 2005; distance
99,000–155,000 km (62,000–96,300 mi). Still
from movie, resolution 6–9 km (4–6 mi).
PIA06223

55 bottom. Titan's haze
NAC (UV); Oct 25, 2004; distance 326,000 km
(202,000 mi). Image processing by Paul Geissler.

57. Rings and ringmoons
Natural color; NAC (R, G, B); Jun 18, 2004; dis-
tance 8.2 million km (5.1 million mi). PIA06422

58–59. Saturn's shadow
WAC (C); Jan 17, 2005; distance 1.2 million km
(750,000 mi); resolution 66 km (41 mi). PIA06573.
Compare with the shadow as seen in March
2004 on p. 3.

60. A, B, C, rings
NAC (C); Apr 26, 2005; distance 2.3 million km
(1.4 million mi); resolution 14 km (9 mi).
PIA07513

62–63. Unlit rings
WAC (C); Oct 28, 2004; distance 373,000 km
(232,000 mi); resolution 22 km (14 mi). Mosaic
by Paul Geissler.

64. Edge-on rings
Single filter; WAC (NIR); Mar 6, 2005; distance
1.7 million km (1.1 million mi); resolution 10
km (6 mi). PIA06610

66. A, F rings
False color; NAC (UV, G, NIR); Nov 18, 2004;
distance from Saturn 4.6 million km (2.9 million
mi). Image processing by Paul Geissler.

67. Rings, Saturn shadow
WAC (C); Jul 3, 2004; distance from Saturn 1.5
million km (930,000 mi); resolution 87 km (54
mi). PIA05417

68–69. Saturn
Natural color; NAC (R, G, B); taken over two
hours on Oct 6, 2004; distance 6.3 million km
(3.9 million mi); resolution 38 km (24 mi).
PIA06193

70. Saturn through Titan's atmosphere
WAC (C); Mar 31, 2005; distance from Titan
7,980 km (4,960 mi), from Saturn 1.3 million
km (810,000 mi); resolution on Titan 320 m
(1,050 ft). PIA06225

71. Blue banding and Mimas
Natural color; NAC (R, G, B); Nov 7, 2004;
distance 3.7 million km (2.3 million mi); resolu-
tion 22 km (14 mi). PIA06142

72. Rings, planet
Single filter; WAC (R); Aug 2, 2005; distance
617,000 km (383,000 mi); resolution 37 km
(23 mi). PIA07578

73. Wave in A ring
NAC (C); Jul 1, 2004; distance 30,000 km
(19,000 mi); resolution 200 m (700 ft). PIA06093

75. Saturn's clouds, Enceladus
Single filter; NAC (B); Oct 12, 2004; distance 5.3
million km (3.3 million mi); resolution 31 km
(19 mi). PIA06530

78–79. Rings
Natural color; NAC (R, G, B); Dec 12, 2004; dis-
tance 1.8 million km (1.1 million mi); resolution
10.5 km (6.52 mi). PIA06175

82. Saturn
Single filter; WAC (IR); Oct 31, 2005; distance
1.2 million km (800,000 mi); resolution 69 km
(43 mi). PIA07648

84–85. Saturn in detail
Natural color; NAC (R, G, B); Jun 21, 2004; dis-
tance 6.4 million km (3.9 million mi). Mosaic by
Paul Geissler.

87. Rings, Tethys
Single filter; WAC (G); Jun 10, 2005; distance 1.4
million km (870,000 mi); resolution 81 km (50
mi). PIA07545, PIA07560

88. Saturn, rings, Tethys
Natural color; NAC (R, G, B); Dec 3, 2005;
distance 2.5 million km (1.5 million mi); resolu-
tion 15 km (9 mi). PIA07667

89. Dione, edge-on rings
NAC (C); Feb 28, 2005; distance from Saturn 2.6
million km (1.6 million mi). Image processing by
Paul Geissler.

90. Above the rings
Single filter; WAC (NIR); Dec 14, 2004; distance
654,000 km (406,000 mi); resolution 35 km (22
mi). PIA06557

92–93. Unlit side of rings
WAC (C); Oct 27, 2004; distance from Saturn
707,000 km (439,000 mi); resolution 46 km (29
mi). Mosaic by Paul Geissler.

94. Unlit side of rings
WAC (C); Jun 8, 2005; distance 433,000 km
(269,000 mi); resolution 22 km (14 mi).
PIA07559

96–97. Saturn, rings edge-on
Single filter; WAC (NIR); Feb 28, 2005; distance
2.6 million km (1.6 million mi); resolution 160
km (99 mi). Mosaic by Paul Geissler.

98–99. Saturn in color
Natural color; NAC (R, G, B); Oct 6, 2004; dis-
tance 6.3 million km (3.9 million mi); resolution
38 km (24 mi). PIA06193 detail

100. Saturn's north pole
Natural color; WAC (R, G, B); Dec 14, 2004;
distance 719,200 km (446,900 mi); resolution 39
km (24 mi). PIA06177

101. Saturn's atmosphere
Natural color; NAC (R, G, B); Oct 6, 2004; dis-
tance 6.3 million km (3.9 million mi); resolution
38 km (24 mi). PIA06193 detail

102. Cassini Division
Natural color; NAC (R, G, B); May 18, 2005;
distance from Saturn 1.6 million km (990,000
mi); resolution 9 km (6 mi). PIA07631

103. Enceladus, rings
Natural color; NAC (R, G, B); Apr 5, 2005; dis-
tance 2.2 million km (1.4 million mi); resolution
13 km (8 mi). PIA06653

104–105. Saturn's jet streams
Single filter; WAC (MT2); Feb 5, 2005; distance
3.3 million km (2.1 million mi); resolution 200
km (120 mi). Image processing by Paul Geissler.

107. Rings
Natural color; NAC (R, G, B); Jun 21, 2004;
distance 6.4 million km (3.9 million mi); resolu-
tion 38 km (24 mi). PIA05421

108–109. A, F rings
WAC (C); Jul 1, 2004; distance 198,600 km
(123,400 mi); resolution 12 km (7.5 mi). Mosaic
by Paul Geissler. See also pp. 114–115 of the
same region.

110. F ring, Prometheus
NAC (C); Jun 29, 2005; distance 1.5 million km
(930,000 mi); resolution 9 km (6 mi). PIA07558

111. F ring detail
NAC (C); Oct 29, 2004; distance 782,000 km
(486,000 mi); resolution 4.7 km (2.9 mi).
PIA06143

112. Keeler Gap, Daphnis
NAC (C); May 2, 2005; distance 594,000 km
(369,000 mi); resolution 6 km (4 mi). PIA06237

113. Encke Gap
NAC (C); Jul 20, 2005; distance 2.1 million km
(1.3 million mi); resolution 13 km (8.1 mi).
PIA07591

114–115. A ring close-up
NAC (C); Jul 1, 2004; distance 198,600 km
(123,000 mi); resolution 1.2 km (0.7 mi). Mosaic
by Paul Geissler. See also pp. 108–109.

116–117. Four ring details
NAC (C); Oct 29, 2004; distance 822,000 km
(511,000 mi); resolution 5 km (3 mi). Image
processing by Paul Geissler.

118–119. Radar image of rings
False color; radar transmission made into image; May 3, 2005. Three simultaneous radio signals at wavelengths of 0.94, 3.6, and 13 cm (0.37, 1.4, 5.1 in)(Ka-, X-, and S-band) were sent from Cassini through the rings to Earth; resolution 10 km (6.2 mi); NASA/JPL. PIA07960

120. Saturn's clouds
Monochrome and false color; NAC (top: CB, bottom: MT3); Feb 8, 2005; distance 3 million km (2 million mi). The two black-and-white images here, plus one other, were combined to create the false color image in the center. Image processing by Paul Geissler.

121. Saturn and Dione
Natural color; WAC (R, G, B); Dec 14, 2004; distance 603,000 km (375,000 mi); resolution 32 km (20 mi). PIA06155

122. Cloud tops
NAC (C); Feb 27, 2005; distance 2.6 million km (1.6 million mi). Image processing by Paul Geissler.

123. Cloud patterns
top left. NAC (CB); Feb 6, 2005.
top right, bottom right. NAC (MT3); Feb 4, 2005.
bottom left. NAC (MT3); Feb 8, 2005
Distance 2.8 million km (1.7 million mi). Image processing by Paul Geissler.

124–125. Saturn's jet streams
Single filter; NAC (NIR); Oct 9, 2004; distance 5.9 million km (3.7 million mi); resolution 69 km (43 mi). PIA06502

126. Iapetus
NAC (C); Dec 31, 2004; distance 129,000 km (80,000 mi); resolution 700 m (2,300 ft). Image processing by Paul Geissler.

127. Titan
Single filter; NAC (near-UV); Oct 24, 2004; distance 1 million km (600,000 mi); resolution 6 km (4 mi); speculatively colorized. PIA06123

128 left. Enceladus
False color; NAC (UV, G, NIR); Jul 14, 2005; distance 112,100 km (69,700 mi); resolution 670 m (2,200 ft). PIA06249 detail

128 center. Tethys
False color; NAC (IR, G, UV); Sep 24, 2005; distance 18,400–19,000 km (11,400–12,000 mi); resolution 213 m (700 ft). PIA07737

128 right. Hyperion
False color; NAC (IR, G, UV); Sep 26, 2005; distance 62,000 km (39,000 mi); resolution 360 m (1,200 ft). PIA07740 detail

129 left. Iapetus
NAC (C); Dec 31, 2004; distance 123,400 km (76,690 mi); resolution 740 m (2,430 ft). PIA06171

129 center. Phoebe
NAC (C); Jun 11, 2004; distance 263,000 km (163,000 mi); resolution 72 km (45 mi). Image processing by Paul Geissler.

129 right. Titan
DISR; Jan 15, 2005; altitude 16 km (10 mi); resolution 40 m (130 ft); ESA/NASA/JPL/ University of Arizona. PIA07236

133. Titan's surface
DISR; Jan 14, 2005; altitude 8 km (5 mi); resolution 20 m (66 ft). ESA/NASA/JPL/University of Arizona. PIA07230

134. Titan
Natural color; WAC (R, G, V); Apr 16, 2005; distance 173,000–168,200 km (108,000–104,500 mi); resolution 10 km (6.2 mi). PIA06230

135. Titan's atmosphere
Natural color; WAC (R, G, B); Mar 31, 2005; distance 9,500 km (5,900 mi); resolution 400 m (1,300 ft). PIA06236

136. Titan's surface
Single filter; NAC (NIR); Feb 2005; distance 226,000–242,000 km (140,000–150,000 mi); resolution 1.3 km (0.81 mi). PIA06185; processed to remove effects of Titan's atmosphere and restore flattened side of limb.

137. Titan surface details
Orbiter Radar Instrument; Feb 15, 2005; resolution 300 m (980 ft). The seams running across the images are created when matching up the different radar beams to assemble the full image. NASA/JPL. Top: PIA07366, bottom: PIA07365

138–139. Titan's stratosphere
False color; WAC (V, B, G); Oct 26, 2004; distance 108,000 km (67,100 mi); resolution 6.6 km (4.1 mi). PIA06987

139 inset. Titan's atmosphere
Single filter; WAC (B); Feb 15, 2005; distance 134,000 km (83,300 mi); resolution 8 km (5 mi). PIA06184

140. Titan surface detail
DISR; Jan 14, 2005; altitude 16 km (10 mi); resolution 40 m (130 ft); ESA/NASA/JPL/ University of Arizona. Mosaic by Anthony Liekens.

140–141. Titan's surface from above
DISR; Jan 14, 2005; images taken by the Titan probe from many altitudes and viewing geometries, and merged into a single view which was then colorized; ESA/NASA/JPL/University of Arizona. Image processing and mosaic by Dr. René Pascal, Bonn, Germany.

142. Titan, on surface
DISR; Jan 14, 2005; colorized using actual probe observations of the light at the surface; ESA/ NASA/JPL/University of Arizona. PIA07232

143. Titan surface from above
DISR; Jan 14, 2005; altitude 17–8 km (11–5 mi); resolution 40–20 m (130–66 ft); ESA/NASA/ JPL/University of Arizona. PIA06438

144. Ring shadows, Mimas
NAC (C); Oct 15, 2004; distance 4.7 million km (2.9 million mi); resolution 28 km (17 mi). PIA07515

145. Mimas against rings
NAC (C); Aug 2, 2005; distance from Mimas 68,000 km (42,000 mi); resolution 400 m (1,300 ft). PIA06412

146. Mimas
False color; NAC (UV, G, IR); Aug 2, 2005; distance 228,000 km (141,000 mi). PIA06257

147. Mimas, Saturn's north pole
False color; NAC (NIR, G, UV); Jan 18, 2005; distance 1.4 million km (870,000 mi); resolution on Saturn 8.5 km (5.3 mi), on Mimas 7.5 km (4.7 mi). PIA06176

148. Epimetheus, F ring
NAC (C); Aug 31, 2005; distance from Epimetheus 2.1 million km (1.3 million mi); resolution 13 km (8.1 mi). PIA07596

149. Epimetheus
False color; NAC (NIR, G, UV); Mar 30, 2005; distance 74,600 km (46,400 mi); resolution 900 m (3,000 ft). PIA06226

150. Hyperion
NAC (C); Sep 26, 2005; distance 32,300 km (20,100 mi); resolution 190 m (630 ft). PIA07739

151. Hyperion
False color; NAC (NIR, G, UV); Sep. 26, 2005; distance 62,000 km (39,000 mi); resolution 360 m (1,200 ft). PIA07740

152. Pandora
NAC (C); May 4, 2005; distance 967,000 km (601,000 mi); resolution 6 km (4 mi). PIA07523

153 top. Janus
Single filter; NAC (G); Aug 2, 2005; distance 541,000 km (336,000 mi). resolution 6 km (4 mi). PIA07580

153 middle. Atlas
NAC (C); Feb 18, 2005; distance 914,000 km (568,000 mi); resolution 10 km (6 mi). PIA07516

153 bottom. Pandora
False color; NAC (IR, G, UV); Sep 5, 2005; distance 52,000 km (32,000 mi); resolution 600 m (2,000 ft). PIA07632

154. Phoebe
NAC (C); Jun 11, 2004; distance 263,000 km (163,000 mi), resolution 60 km (37 mi). Image processing by Paul Geissler.

155. Phoebe
NAC (C); Jun 11, 2004; distance 16,000–12,500 km (10,000–7,750 mi); resolution 74 m (243 ft). PIA06073. Missing notch in limb restored by John Zax.

156–157. Enceladus
NAC (C); Feb 17, 2005; distance 26,140–17,430 km (16,230–10,820 mi); resolution 105–150 m (344–490 ft). PIA06191

158. Enceladus details
top left. False color; NAC (UV, G, NIR); Mar 9, 2005; distance 21,300 km (13,200 mi); resolution 130 m (430 ft). PIA06210
top right. NAC (C); Feb 17, 2005; distance 21,208 km (13,170 mi); resolution 125 m (410 ft). PIA06188
bottom left. NAC (C); Mar 9, 2005; distance 11,900 km (7,400 mi); resolution 70 m (230 ft). PIA06217
bottom right. False color; NAC (UV, G, NIR); Mar 9, 2005; distance 25,700 km (16,000 mi); resolution 150 m (490 ft). PIA06209

159. Enceladus
False color; NAC (UV, G, NIR); Jul 14, 2005; distance 112,100 km (69,610 mi); resolution 670 m (2,200 ft). PIA06249. See also p. 52.

160. Enceladus leading hemisphere
Single filter; NAC (NIR); Jan 15, 2005; distance 367,000 km (228,000 mi); resolution 2 km (1.2 mi). PIA06581

161. Enceladus close-up
WAC (C); Feb 17, 2005; distance 1,500 km (930 mi); resolution 90 m (300 ft). Image processing by Paul Geissler.

162–163. Saturn, Dione, Enceladus
Single filter; WAC (B); Feb 28, 2005; distance 2.6 million km (1.6 million mi); resolution 154 km (96 mi). PIA06606

164. Rhea
NAC (C); Apr 14, 2005; distance 247,000 km (154,000 mi); resolution 1 km (0.6 mi). PIA06648

164–165. Mimas, Dione, Rhea
Single filter; NAC (B); Mar 15, 2005; distance from Saturn 2.4 million km (1.5 million mi); resolution 14 km (8.7 mi). PIA06642

166. Iapetus equatorial ridge
NAC (C); Dec 31, 2004; distance 172,400 km (107,100 mi); resolution 1 km (0.6 mi). PIA06166

167. Iapetus
False color; NAC (NIR, G, UV); Dec 31, 2004; distance 172,900 km (107,400 mi); resolution 2 km (1.2 mi). PIA06167

169. Dione, Saturn
Natural color; WAC (R, G, B); Oct 11, 2005; distance from Dione 39,000 km (24,200 mi); resolution 2 km (1.2 mi). PIA07744

170–171. Rhea eclipsed by Dione
NAC (C); Feb 20, 2005; distance from Dione 1.5 million km (930,000 mi), from Rhea 2.3 million km (1.4 million mi); resolution on Dione 9 km (6 mi), on Rhea 14 km (9 mi). Image processing by Paul Geissler.

171. Dione
NAC (C); Dec 14, 2004; distance 156,000 km (97,000 mi); resolution 1 km (0.6 mi). PIA06156

172. Dione, Tethys, Pandora
Single filter; NAC (B); Sep 22, 2005; distance from Saturn 1.2 million km (750,000 mi); resolution on Dione and Pandora 5 km (3 mi), on Tethys 9 km (6 mi). PIA07628

173. Tethys, Dione, rings
NAC (C); Sep 12, 2005; distance from Saturn 2.4 million km (1.5 million mi); resolution on the two moons 17 km (11 mi). PIA07623

174. Tethys detail
NAC (C); Sep 24, 2005; distance 32,300 km (20,000 mi); resolution 190 m (620 ft). PIA07734

175. Rings, Tethys
NAC (C); Aug 24, 2005; distance 2.2 million km (1.3 million mi); resolution 13 km (8 mi). PIA07607

176. Dione, Tethys
NAC (C); Mar 7, 2005; distance from Tethys 1.5 million km (930,000 mi), from Dione 1.6 million km (990,000 mi); resolution on Tethys 9 km (6 mi), on Dione 10 km (6 mi). PIA06629

180. Pandora, A, F ring
NAC (C); Feb 18, 2005; distance from Pandora 1.2 million km (750,000 mi); resolution 7 km (4 mi). PIA06618

192. Saturn, Titan
WAC (R, G, B); Dec 14, 2004; distance 719,000 km (447,000 mi); resolution 43 km (27 mi). PIA06164

Diameters of Saturn's Largest Moons

Pan	20 km (12 mi)
Atlas	37 x 34 x 27 km (23 x 21 x 17 mi)
Prometheus	149 x 100 x 68 km (92.5 x 62 x 42 mi)
Pandora	110 x 88 x 62 km (68.3 x 55 x 39 mi)
Epimetheus	138 x 110 x 110 km (85.7 x 68 x 68 mi)
Janus	194 x 190 x 154 km (120 x 118 x 95.6 mi)
Mimas	418 x 392 x 383 km (260 x 243 x 238 mi)
Enceladus	512 x 494 x 489 km (318 x 307 x 304 mi)
Tethys	1071 x 1056 x 1052 km (665 x 656 x 653.3 mi)
Telesto	30 x 25 x 15 km (19 x 16 x 9.3 mi)
Calypso	30 x 16 x 16 km (19 x 9.9 x 9.9 mi)
Dione	1118 km (694.3 mi)
Helene	36 x 32 x 30 km (22 x 19 x 19 mi)
Rhea	1528 km (948.9 mi)
Titan	5150 km (3198 mi)
Hyperion	360 x 280 x 225 km (223 x 174 x 140 mi)
Iapetus	1436 km (891.8 mi)
Phoebe	220 km (136 mi)

INDEX

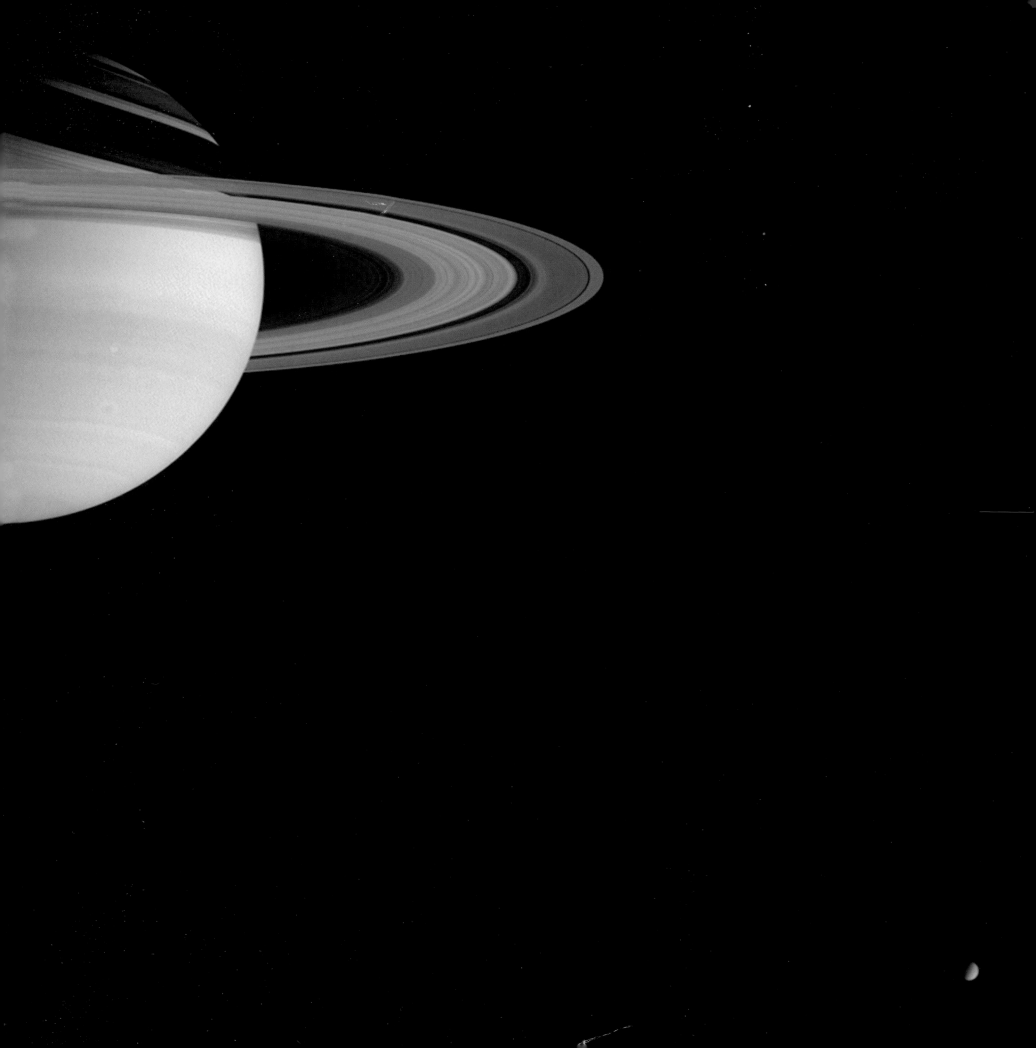